LAWRENCE ALLOWAY

WITHDRAWN
No longer the property of the
Boston Public Library.
Sale of this material benefits the Library

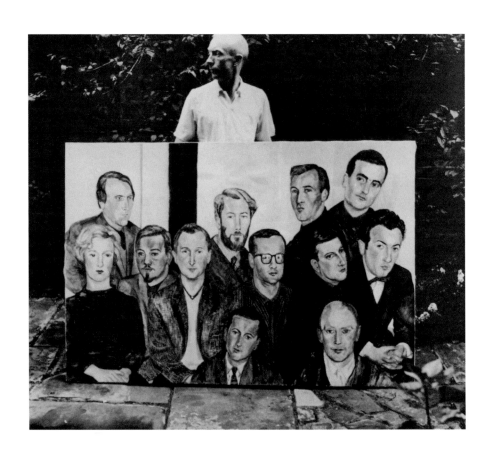

Getty Research Institute
Issues & Debates

Lawrence Alloway

CRITIC AND CURATOR

EDITED BY
Lucy Bradnock, Courtney J. Martin, and Rebecca Peabody

THE GETTY RESEARCH INSTITUTE PUBLICATIONS PROGRAM
Thomas W. Gaehtgens, *Director, Getty Research Institute*
Gail Feigenbaum, *Associate Director*

© 2015 J. Paul Getty Trust
Published by the Getty Research Institute, Los Angeles
Getty Publications
1200 Getty Center Drive, Suite 500
Los Angeles, CA 90049-1682
www.getty.edu/publications

Nola Butler, *Manuscript Editor*
Jeffrey Cohen, *Designer*
Stacy Miyagawa, *Production Coordinator*
Diane Franco, *Typesetter*
Stuart Smith, *Series Designer*

Distributed in the United States and Canada by the University of Chicago Press
Distributed outside the United States and Canada by Yale University Press, London

Type composed in Minion and Trade Gothic
Printed in China

Library of Congress Cataloging-in-Publication Data
Lawrence Alloway : critic and curator / edited by Lucy Bradnock, Courtney J. Martin,
 and Rebecca Peabody.
 pages cm — (Issues & debates)
 Includes bibliographical references and index.
 ISBN 978-1-60606-442-9
 1. Alloway, Lawrence, 1926–1990. 2. Art critics—United States. I. Bradnock, Lucy, editor.
II. Martin, Courtney J., editor. III. Peabody, Rebecca, editor. IV. Getty Research Institute,
issuing body. V. Series: Issues & debates.
 N7483.A45L39 2015
 709.2—dc23
 2014042855

Front cover: Lawrence Alloway, photographed at the Solomon R. Guggenheim Museum,
New York, 1960s. See p. 70, fig. 1.
Back cover: Roy Lichtenstein, *Ice Cream Soda,* 1962. See p. 77, fig. 4.
Frontispiece: Lawrence Alloway, photographed with Sylvia Sleigh's *The Situation Group,*
painted in 1961. Photo: Robert Freeman.

CONTENTS

ACKNOWLEDGMENTS

This volume is indebted to the hard work, ingenuity, and imagination of a number of people. Chief among them, of course, are Lawrence Alloway, whose life, work, and thinking have provided such fruitful material for thought and discussion, and his wife, Sylvia Sleigh.

Our gratitude is owed to the staff of the Special Collections of the Getty Research Institute (GRI), whose acquisition, processing, and cataloging of the Alloway Papers and the Sleigh Papers facilitated the primary research upon which this volume is based. We would also like to thank the following people who worked with us at the GRI: Rachel Barth, Nola Butler, Michele Ciaccio, Donna Conwell, Janelle Gatchalian, Annette Leddy, Marcia Reed, Janae Royston, Sarah Zabrodski, Raquel Zamora, and Rebecca Zamora. Our thanks are also due to Douglas John of the Sylvia Sleigh Estate for his invaluable support of this project.

In addition to the contributors to this book, who have worked imaginatively and thoughtfully to explore the many facets of Alloway's work, we thank those members of the *Lawrence Alloway: Critic and Curator* research project, Alex Kitnick, Stephen Moonie, and Chris Stephens, whose scholarly conversation greatly enriched both the project and the publication. The participants of two academic events made vital contributions to the scholarship on Alloway. The first, a conference titled "Lawrence Alloway Reconsidered," was held at Tate Britain in 2011 and included insightful papers by Richard Leslie, Anne Massey, Stephen Moonie, Julian Myers, Shelley Rice, Catherine Spencer, Eric Stryker, and Peter Stanfield. The second, the workshop "Criticism and Curating: The Productive Lawrence Alloway," was convened at Tate Britain in June 2013 as part of the *Art Writers in Britain* series. Our thanks go not only to the speakers, Helle Brøns, Alex Coles, and Lucy Steeds, and the other scholars who contributed to lively debate and discussion but also to Jennifer Mundy and Christopher Griffin, who spearheaded the larger project. Finally, the anonymous peer reviewer who generously provided a constructive assessment of our work greatly strengthened the book, and for this we are grateful.

Neither this project nor this book would have happened without the guidance and insight of Glenn Phillips, who expanded the scope of the project at an early stage to encompass a broader view of archival work and the import of Alloway's material. He deftly gestured toward many of the scholarly pursuits contained herein.

— Lucy Bradnock, Courtney J. Martin, and Rebecca Peabody

ANDREW PERCHUK

FOREWORD

The Lawrence Alloway Papers are part of an extraordinary collection of archives of mid-twentieth-century critics and curators housed at the Getty Research Institute (GRI). These archives, which include the papers of such renowned figures as Clement Greenberg, Barbara Rose, Harold Rosenberg, and Marcia Tucker, offer a unique window into an art world in which intellectual labor held sway and the market played a much smaller role than it does today.

Lawrence Alloway's career is characterized by his rare ability to move within a wide range of roles, from freelance art critic and member of the Independent Group to deputy director of the Institute of Contemporary Arts in London and then curator at the Solomon R. Guggenheim Museum in New York to, finally, professor of art history at the State University of New York at Stony Brook. This diversity of positions was mirrored in the variety of art forms he wrote about and curated, including science fiction, abstract expressionism, pop art, assemblage, land art, photorealism, happenings, Fluxus, mail art, and film.

Unlike Greenberg's teleology of an ever-increasing movement of modern art toward flatness and the delimitation of flatness, Alloway's watchword was *topicality,* a concept he describes in "Network: The Art World Described as a System" as being "hounded" by and which he believed invalidated "the traditional separation of closed high art and popular culture." Alloway's emphasis on topicality is directly related to the idea of art as a communicative act, and his conception of significant art intervening in contemporary culture helps explain not only his openness to pop art but also his interest in feminist art.

Alloway's definition of art as communication is connected to his lifelong study of information theory; he was well acquainted with the works of Norbert Wiener and other theorists associated with cybernetics. One application of cybernetics to art history is found in the work of George Kubler, with his attention to patterns, codes, and sequencing as a way of making sense of art, but Alloway's stress was primarily on *networks,* a word featured in the title of his book of essays, *Network: Art and the Complex Present* (1984). For Alloway, art and popular culture were part of a continuum, a network in the cybernetic sense of a system of circular causality controlled by feedback. The shifting

locations of art and popular culture in a series of networks on this continuum explain the complexity that Alloway considered the defining characteristic of both the present day and his conceptualization of the task of the art critic to engage with this plurality.

The essays in this volume do a remarkable job of taking on the plurality that Alloway championed. Much of the credit for this success is due to the three volume editors—Lucy Bradnock, Courtney J. Martin, and Rebecca Peabody—who shepherded the project from its beginnings as a deep study of the Alloway archive through an intensive workshop to the finished texts that make up this book. My thanks go to them, the authors, and the exceptional staff at GRI Publications.

COURTNEY J. MARTIN

INTRODUCTION

Lawrence Alloway (1926–90) is a figure whose lifework has often been summarized by a single accomplishment. For many, he is the curator/critic who coined the term *pop art* in the late 1950s. This description, while apt, is incomplete and reduces the British-born critic, curator, and teacher to one achievement early in his career. What this description fails to acknowledge is the depth of Alloway's engagement beyond pop art with a range of art, artists, institutions, publications, and places, from his late teens in London in the 1940s to his death in New York in 1990. Yet, this reduction also reveals a great deal about Alloway's centrality to the theorization of popular culture in the middle of the twentieth century. His career was fueled by curiosity, energy, and imagination, which led him around the world in pursuit of art and its makers. As a critic and a curator, he strove to foreground the relevance of art and artists to culture by taking what he himself described as a "permissive approach."[1]

Alloway's permissive conflation of high and low objects, values, and ideas can be viewed as a direct result of his biography. Born and raised in Wimbledon, a London suburb, Lawrence Reginald Alloway had a sporadic education due to an early bout of tuberculosis. The lengthy absences from formal education that his illness necessitated lent him an intellectual independence and self-reliance that would serve him well in the undefined role of unaffiliated art critic and curator.

His lack of a university degree would come to define him and, later, be defined by him as evidence that his professional success was due to sheer work ethic rather than academic connections, and, similarly, as proof that he lacked the "snobbery" that a university pedigree might have afforded him. Because he did not attend university, Alloway started work at an early age. Alloway was a published critic by the age of eighteen, after having spent a year or more submitting writing samples and proposals for articles to art journals, little magazines, and newspapers. When he was appointed director of the Institute of Contemporary Arts (ICA) in 1954, following sustained engagement with the institution via the Independent Group (IG), he was not yet thirty. He reached midcareer well before middle age.

Originators and promulgators of the aesthetic of the everyday, described by them "as found," the IG was a collective of artists, architects, critics, writers, and others interested in culture to varying degrees of specificity. Initially drawn together by the founders of the ICA—the writer E. L. T. Mesens, the artist and poet Roland Penrose, and the art critic Herbert Read—as an entity affiliated with the institution, the IG eventually emerged as a singular vehicle for substantial intellectual production in London in the early to mid-1950s. Alloway was at the center of this group, but he was, admittedly, one of a collective. He drew, equally, from the established career of Read and those of near contemporaries, such as John McHale.[2] The term *popular-art-fine-art continuum* was a product of the IG collective, yet it was Alloway who wrote extensively about it and came to be identified with it. In its abbreviated form, *pop art,* this democratized idea was articulated by the artwork of IG colleagues such as Richard Hamilton, Nigel Henderson, and Eduardo Paolozzi. Pop art, or, more specifically, the expanded popular-art-fine-art continuum, became a kind of working manifesto for Alloway. Art could and should be presented in a way that allowed viewers to comprehend a specific art object as part of a larger cultural conversation. From the late 1960s to the 1980s, as he made a conscious effort to write about black artists, women artists, feminism, and social justice, his idea of the popular became more political.

It was during his tenure with the IG that Alloway's calling as a curator became evident. When or under what circumstances he first embraced the term *curator* is not known, but it is clear that he understood the need for exhibitions of art to have a definite conceptual shape, guided by an external set of ideas working in concert with the interrelated organization of art objects. Perhaps the most cited of his exhibitions is *This Is Tomorrow* (1956), the IG-led Whitechapel Gallery installation that combined the efforts of several collaborators, including architects, artists, designers, and writers. With its multisensory displays of art, furniture, and interactive objects, the exhibition inaugurated the new aesthetic of pop art as much as it announced a new form of exhibition design. Alloway learned how to be a curator through his involvement in this and other IG/ICA shows. For example, the installation *an Exhibit* (1957), which the artists Richard Hamilton and Victor Pasmore invited Alloway to join, required him to document their processes rather than explicate his own concepts. Alloway's documents, ephemera, and writings reveal that he realized that the role of the curator was in a transitional moment internationally, shifting from anonymous management (signified by the preferred title of the time, *keeper*) to a position of singular vision and notoriety, as exemplified by the Swiss curator and art historian Harald Szeemann. Later, Alloway would model his curatorial self in this new, celebrated manner.

When Alloway initially came to prominence, he was readily identified by his Englishness (a characterization that he preferred to British), but when he moved from London to New York in 1961 to work first at Bennington College and later at the Solomon R. Guggenheim Museum, his hiring was based on his complete devotion to American art. As an art critic in London, he had ingested abstract American painting whole, swallowing with it the new approaches to art criticism being developed in the United States by Clement Greenberg. However, Alloway's curatorial record at the Guggenheim is marked by an international-ism that extended beyond New York and London artists. Years after Alloway's death, the Guggenheim's former director Thomas Messer described Alloway's role at the museum as defining the avant-garde, an important qualification for a curator working in New York in the 1960s.[3] In turn, his exhibition catalog essays contained much of the same critical language as his art criticism, and his exhibitions were as much about ideas as they were about their stated subjects. His first show at the Guggenheim, in 1962, for the Spanish artist Antoni Tàpies, presented *tachisme* as a response to American abstract painting. Similarly, *Six Painters and the Object* (1963), a show that focused as much on pop art's concep-tual origins as it did on its objects, is widely recognized as one of the first major museum exhibitions of pop art in the United States.

Alloway's transformation into a critic-curator seems to have been always evolving. After leaving the Guggenheim in 1966 to teach and to write, he actively pursued both practices (curating and criticism). The publication of *The Venice Biennale 1895–1968: From Salon to Goldfish Bowl* (1968) marked a reorientation of his career toward book-length, international projects. Later, he developed an academic curriculum on art criticism that relied heavily on curatorial concerns. From 1969 to 1981, he developed courses at the State University of New York at Stony Brook (now Stony Brook University) that may have been some of the earliest in the country to teach art criticism and exhibitions as part historiog-raphy and part practice. Alloway was an early theoretician of the disciplinary boundaries of each of these inchoate fields, just as he had been one of the first critics to recognize the need for new approaches to art to accommodate post-war Western aesthetic tastes. What he cheekily called "permissiveness" moved art out of its insularity and into a number of other areas, including education and sociology. As a result, Alloway has lately been linked to the construction of visual culture as related to, but distinct from, cultural studies. At the same time, many of the ideas that he promoted in his writing and teaching—contemporary art history, the histories of art criticism and exhibitions—have been taken on by traditional art historians.

Alloway's participation in the collective work of the IG set in motion a lifetime of collaboration with artists. While he might have been charged with

indifference toward his institutional colleagues, he was acquiescent to the point of complicity with artists. Remnants of his teaching style preserved in course notes found among his papers archived at the Getty Research Institute (GRI) portray him in a more balanced role, one of genuine pedagogical engagement and generosity. Perhaps in his attempt to level art discourse by way of the popular, he created a subtle, but discernable, hierarchy of artists, students, and colleagues, ranked in that descending order.

It is clear from this historical vantage that Alloway's decisions align with those of other museum workers of his generation who sought professional success through unprofessional (at the time) means, such as self-promotion and institutional agitation. Less clear is the result that institutional untethering, prolific public appearances, and combative exchanges in text had on Alloway. On his way toward ubiquity in the art world of his time, he marginalized his achievements, resulting in a diminished role in the historicity of the art world to come. The term *cultural worker* did not exist in Alloway's time, but this appellation properly encompasses his interest and involvement in a wide variety of aesthetic outlets while also acknowledging the very real effort he expended (as a curator, public lecturer, teacher, and writer) to reorient the contemporary art world. Critiques of British culture, like those of the IG, became national issues in Britain after World War II. By the late 1950s, Alloway's contemporary Raymond Williams outlined a set of ideals about the evolution of British culture that would form the basis of the academic field of cultural studies. Though Alloway does not place his writing within an academic discipline, his lifelong endeavor to examine how art functions and to actively participate in its functioning is the work of cultural studies and visual culture.

Despite his numerous writings, extensive exhibition record, distinguished teaching portfolio, and countless anecdotal interactions with artists for more than forty years, Alloway is a largely undertheorized figure, even within the art world—that small microcosm that he wrote about so extensively.[4] The essays in this volume seek to address Alloway's presence in and absence from these areas (criticism, curating, and education) through primary research in the Lawrence Alloway Papers. The archive arrived at the GRI in the 1990s, shortly after his death, and the transfer of items to Los Angeles from his home and office in New York was facilitated by his widow, Sylvia Sleigh (1916–2010). The Welsh-born Sleigh, a noted painter and feminist art activist, played an active role in preserving Alloway's personal and professional material. The archive's richness is derived, in part, from the long correspondence between the couple. In addition to her stewardship, the archive reveals, in multiple places, that Sleigh was crucial to Alloway's aesthetic and professional development. Older by a decade, she corrected and added to his knowledge of art from their first meeting in 1943,

when he was a student in a University of London extension course and she was a working artist. What might have manifested as an imbalance in some relationships seems to have strengthened theirs. She was an active and enthusiastic partner in their frequent conversations about art and read much of his writing. Once in New York, it was Sleigh who led the way into the avant-garde, particularly toward numerous feminist artists whom Alloway ultimately included in his writings and exhibitions.

This volume of essays traces its beginnings to several years of work by a group of scholars (academics and curators alike) who came to the GRI to work with the Lawrence Alloway Papers. Through the auspices of the research project *Lawrence Alloway: Critic and Curator,* directed initially by Rebecca Peabody and Glenn Phillips of the GRI and myself, and later joined by Lucy Bradnock, we invited researchers to spend time in the archive reviewing aspects of the papers that were little explored, which opened up their scholarship to new lines of inquiry.

One discovery revealed that Alloway's interactions with a wide variety of artists (from Victor Pasmore to Richard Hamilton, Alice Neel, and Donald Judd) were not restricted to London and New York, the two cities where he spent most of his life. He was, for example, just as personally engaged with Jean Dubuffet, Lucio Fontana, Asger Jorn, and Antoni Tàpies as he had been with John McHale and Barnett Newman, the two artists who defined large parts of his career in each of his home cities. Similarly, extant elements of an unpublished manuscript on William Hogarth shed light on Alloway's deeper investment in writing art history before turning to the field for which he was best known, art criticism. The structure of the project allowed researchers the time and intellectual space to fully explore the material in a manner that complemented the expansive quality of Alloway's thinking and writing. We were fortunate to be supported in this endeavor by the GRI's director, Thomas W. Gaehtgens, and deputy director, Andrew Perchuk.

The researchers read Alloway's many published and unpublished texts and letters, digested his often prescient and savvy ideas, viewed numerous photographs and films, and listened to his recordings. So, too, did we track the pace of his life through his letters to Sleigh and others, and through the datebooks she used to organize their social calendar. These datebooks are a mix of the mundane (appointments for household services) and the exotic (dinners and parties with artist luminaries); when read together with his published writing, a passionate, compelling figure who lived for art and artists emerged. Much like the high/low aesthetics that entranced him, the archive is as lofty as it is grounded—capable of being both serious and silly. The archive facilitated many serendipitous moments, such as the surprise of hearing and seeing Alloway

on audio and video recordings. For a man so immersed in American culture, and so interested in all that New York's avant-garde had to offer, his speech remained spectacularly English in cadence, tone, and dialect.

Perhaps the most unique aspect of this project was the range of the researchers' experience. Some came to the archive with a vast knowledge of Alloway, while others knew of him only generally. Through our many visits to the archive over the years, most of us found that Alloway's teaching, writing, and curating overlapped with our own scholarship in natural and unexpected ways. As a result, there is also a great sense of collaboration and collective engagement among the researchers. The Alloway project, including this volume, serves as an example of the scholarship that unencumbered exploration can yield.

The nine diverse essays presented here reveal new facets of Alloway's practice. Expanding on other scholars' research on Alloway's colleagues at the ICA and within the IG, Victoria Walsh turns her focus to the formation of Alloway's critical thinking in the late 1940s and early 1950s as the basis for the varied concerns that sustained his writing and teaching career. In her analysis, we glimpse Alloway, too young and perhaps also physically ineligible for military service, as a student under the tutelage of the British art historian Charles Johnson during World War II. At this time, Alloway morphed into a leader of the IG and matured into his roles as teacher and writer. Rebecca Peabody also investigates Alloway's early career, including his work on the IG exhibition *This Is Tomorrow*. Her essay takes on one of the least theorized but most common subjects of Alloway's criticism and nonfiction writing: science fiction. She argues for readers to take Alloway's interest in science fiction seriously as a constitutive aspect of his critical formation.

While this publication is not meant to be a comprehensive treatment of Alloway, several of the authors look across time and space to situate aspects of his practice in the history of art. Jennifer Mundy, for one, examines Alloway's long teaching career, from his itinerant lecturing in British museums to his work at Stony Brook, developing the curriculum for the first advanced degree in art criticism in America. She suggests that any consideration of Alloway's art criticism must take into account the legacy of his teaching as well as *Art Criticism,* the journal that he cofounded with the American art critic and art historian Donald Kuspit.

Alloway is well known for the publication *Violent America: The Movies, 1946–1964* (1971), a survey of American action films that explores the range of the genre from its narrative structures to its cinematic formalism. Film, like science fiction, was a combination of the personal and the professional for Alloway, inextricably linked to his main preoccupation: America. Lucy Bradnock turns to Alloway's avid consumption of film, as both a fan and a critic, and the ways in

which he grappled with filmic devices and the social spaces of movies, arguing that film was integral to Alloway's intellectual formation.

Joy Sleeman and Beatrice von Bismarck both make use of the archive's vast repository of primary material on individual artists with whom Alloway had generous professional and deep personal engagements. Sleeman explores Alloway's writing on earthworks as an outgrowth of his friendship with Robert Smithson. She argues that Alloway and Smithson had a two-way relationship in which Alloway learned as much from Smithson as Smithson learned from him. Her essay situates Alloway's articulation of earthworks as an indication of his full entry into the examination of conceptual art, a field that he—prior to writing about Smithson—had given only cursory attention. Here, we see Alloway reconsidering his initial thoughts on Smithson after experiencing *Spiral Jetty* (1970) and in the wake of Smithson's early death.

In the period after he left the Guggenheim, Alloway embarked on many experimental projects, which points up the increasing presence of independent curators in the art world as well as the growing acceptance of the curator-as-artist. Beatrice von Bismarck's research into *Artists and Photographs* (1970), the Alloway-curated box of conceptually inspired and photo-based multiples, finds Alloway at the center of the emerging debate about the relationship between media and their products and the place of the serial object in traditional museum and collecting practices. Alloway wrote the essay that accompanied the objects in the project and, as von Bismarck argues, advanced his first analysis of photography. Unlike film, photography was a recent interest, one guided by meeting artists such as Smithson who relied upon photographic reproduction for the dissemination of otherwise inaccessible works. Von Bismarck shows that Alloway was as much a participant in the multiple as he was an organizer of the project, thereby blurring the traditional roles of exhibition catalog essayist and exhibition curator.

Alloway's interaction with artists can be characterized as generative, but records of numerous public and private battles found in the archive confirm that his interactions with art institutions, as either a worker or a critic, were fraught. Taking Alloway's time at the ICA as a starting point, Michael Lobel shifts Alloway's best-known accomplishment, pop art, in a new direction, examining it not as a closed dialogue between the United States and Britain but as a more open, international conversation. In turn, my essay takes a critical look at the theoretical underpinnings of Alloway's final exhibition at the Solomon R. Guggenheim Museum, *Systemic Painting* (1966), a show mired in his professional ambitions and competition with other leading American curators. Julia Bryan-Wilson returns to Alloway's art criticism to examine the tumultuous state of New York art museums and cultural institutions in the late 1960s and 1970s.

While we are indebted to the work on Alloway that preceded and supported many of the essays in this volume, ours is the first effort to use his archive to place this complex, contradictory figure as integral to mid-century art and criticism. This is not a definitive effort that will provide neat, tight conclusions about Alloway or his professional life. There is still too much to be uncovered about him and the art historical periods of which he was a part. Instead, we offer these essays as an initial exploration, suggesting the great scholarly potential of this archive and the ongoing cultural impact of its subject.

Notes

1. Lawrence Alloway, "The Long Front of Culture," *Cambridge Opinion* 17 (1959): 25.
2. See Lawrence Alloway, "Retrospective Statement," in David Robbins, ed., *The Independent Group: Postwar Britain and the Aesthetics of Plenty,* exh. cat. (Cambridge, Mass.: MIT Press, 1990).
3. Thomas Messer, interview by Andrew Decker, "Oral History Interview with Thomas M. Messer, 1994 October–1995 January," 10 October 1994–25 January 1995, online transcript, Archives of American Art, Smithsonian Institution, http://www.aaa.si.edu/collections/interviews/oral-history-interview-thomas -m-messer-11803.
4. Since the initiation of this project, Alloway has gained more critical attention. Some of this attention is directly related to the GRI. In February 2011, Shelley Rice and Reva Wolf, both former students of Alloway's, organized "Lawrence Alloway: Visual Culture and Contemporary Practice," a panel at the College Art Association's annual conference in New York. That spring, Jennifer Mundy (in her role as head of collection research at Tate) and I co-organized a daylong seminar at Tate Britain on Alloway titled "Lawrence Alloway Reconsidered," which generated an issue of the online research journal *Tate Papers* (no. 16, 1 October 2011), which we coedited. In June 2013, I was invited by Tate Research to convene a workshop on Alloway titled "Criticism and Curating: The Productive Lawrence Alloway" as a part of the *Art Writers in Britain* series. This workshop allowed five scholars to correspond with a group of art critics, art historians, and curators.

 A great deal of this research has benefited from two publications devoted to Alloway. Richard Kalina's *Imagining the Present: Context, Content, and the Role of the Critic* (London: Routledge, 2006) was the second volume of Alloway's writing and the first edited by someone other than Alloway himself. Nigel Whiteley's recent monograph on Alloway, *Art and Pluralism: Lawrence Alloway's Cultural Criticism* (Liverpool: Liverpool University Press, 2012), has set his life and work into a context that many of us greatly appreciate.

VICTORIA WALSH

LAWRENCE ALLOWAY
Pedagogy, Practice, and the Recognition of Audience, 1948–1959

In the annals of art history, and within canonical accounts of the Independent Group (IG), Lawrence Alloway's importance as a writer and art critic is generally attributed to two achievements: his role in identifying the emergence of pop art and his conceptualization of and advocacy for cultural pluralism under the banner of a "popular-art-fine-art continuum." While the phrase "cultural continuum" first appeared in print in 1955 in an article by Alloway's close friend and collaborator the artist John McHale, Alloway himself had introduced it the year before during a lecture called "The Human Image" in one of the IG's sessions titled "Aesthetic Problems of Contemporary Art."[1] Using Francis Bacon's synthesis of imagery from both fine art and pop art (by which Alloway meant popular culture) sources as evidence that a "fine art–popular art continuum now exists," Alloway continued to develop and refine his thinking about the nature and condition of this continuum in three subsequent texts: "The Arts and the Mass Media" (1958), "The Long Front of Culture" (1959), and "Notes on Abstract Art and the Mass Media" (1960).[2]

In 1957, in a professionally early and strikingly confident account of his own aesthetic interests and motivations, Alloway highlighted two particular factors that led to the overlapping of his "consumption of popular art (industrialized, mass produced)" with his "consumption of fine art (unique, luxurious)."[3] First, for people of his generation who grew up interested in the visual arts, popular forms of mass media (newspapers, magazines, cinema, television) were part of everyday living rather than something exceptional. The appreciation of art subsequently took place in a considerably expanded visual culture that rendered the formalist tradition of art appreciation somewhat dislocated from contemporary culture, given its emphasis on the exclusive value of the work on its own terms. Such a tradition of art criticism, exemplified by Roger Fry and Herbert Read, seemed to remove the artwork from the everyday. As Alloway saw it for his own generation: "We were born too late to be adopted into the system of taste that gave aesthetic certainty to our parents and teachers. Roger Fry and Herbert Read were not my culture heroes.... Significant form, design, vision, order, composition etc. were seen as high level abstractions.... The effect

of all these redundant terms was to make the work of art disappear in an excess of 'aesthetic distance.'"[4] In 1961, the year Alloway left England for America, he continued to critique British art critics who failed to recognize the impact that mass media had had upon the appreciation of the visual arts and the extent to which the public no longer felt intimidated by the traditional distinctions in value between "high" and "low" art; as Alloway put it, "the spectator can go to the National Gallery by day and the London pavilion by night, without getting smeared up and down the pyramid." Alloway concluded that "spectator mobility...is not recognized by art criticism and art theory, which is still written about one spot on the continuum, and one spot only."[5]

While Alloway's self-reflexive analysis of his critical position came out of changing patterns of cultural consumption in the 1950s, wider historical appraisal has also connected his critical position to his interests in information theory, communication theory, and cybernetics.[6] Alloway's embrace of these theories in the mid-1950s, particularly as reflected in the IG sessions he convened at the Institute of Contemporary Arts (ICA) with John McHale in 1955, provided him with a strong theoretical framework from which to develop a new critical paradigm that demonstrated the value of both traditional forms of art produced through the unique and original labor of the individual artist (for example, painting, sculpture, drawing) and contemporary art produced from ready-made popular culture that was already imbued with cultural meaning and value. As Alloway observed, "What is needed is an approach that does not depend for its existence on the exclusion of most of the symbols that people live by....All kinds of messages are transmitted to every kind of audience along a multitude of channels. Art is one part of the field: another is advertising."[7]

But while Alloway's interest in new theories of visual communication and information exchange undoubtedly enabled him to refine his critical formulations of cultural experience and value, research into Alloway's archive suggests that the foundations for Alloway's popular-art-fine-art continuum were in fact forged earlier through his pedagogical practice in the early 1950s and his research and writing for a major, self-initiated monograph on William Hogarth—a rites-of-passage project that, in the end, failed to find a publisher. Alloway's letters to the artist Sylvia Sleigh, whom he married in 1954, along with other historical data, reveal that the confluence of Alloway's teaching practice with his writing on Hogarth sparked an interest in the changing relationship between art and culture. The changes brought about by mass communication and the democratization of spectatorship encouraged him to challenge contemporary epistemologies of taste and aesthetics—terrain that had traditionally belonged to the British social elite and had been extended through patterns of patronage and the tradition of British "public" school

education, which was historically defined by its high tuition and restricted admission policies based on family ties and social status.

Pedagogy and Practice

Alloway had a checkered history in terms of formal education. Although the stratification of British society based on education and privilege decreased after World War II, it continued to have a significant influence on social and cultural interaction, not least in terms of professional employment and intellectual credibility. In 1937, at the age of eleven, Alloway contracted tuberculosis; finding himself bedridden, he took advantage of the fact that his father owned a bookshop and became an avid reader, later enrolling at the Wimbledon School of Art in 1940. Though the war curtailed his formal studies, Alloway pursued his passion for scholarship, subsequently attending evening courses at the University of London in 1943, with the ambition of becoming a poet and author. Succumbing to illness again, and falling behind with the necessary course work, Alloway transferred to a course in art history taught by Charles Johnson, who would go on to write *The Language of Painting* in 1949. Johnson's lectures, which took place at the National Gallery in London, provided unique training in art history in terms of their art historical scope (French and English contemporary painting; Flemish, Dutch, and Spanish seventeenth-century art; and the art of Renaissance Italy) and because they were delivered in the absence of the works of art themselves; the collection was safely stored outside of London, away from potential bomb damage. This presentation of knowledge through verbal description and photographic reproduction introduced Alloway to the idea of reading paintings primarily as images rather than as material objects.

Most importantly for Alloway, Johnson regularly recommended his student as a lecturer. Johnson's help was much appreciated by Alloway, whose daily letters to Sleigh at the end of the 1940s invariably carry some reference to the endless challenge of trying to secure work, stave off hunger, keep warm, and secure financial credit. The collective pathos of these communications is perhaps most poignantly captured in his request to Sleigh in November 1949 for two clothing coupons to buy socks for the cold winter days and nights.[8] The strain of filling out applications and going to interviews, along with the disappointment of missing out on teaching jobs due to his lack of university education, is also palpable in these letters. Despite these setbacks, it is clear that Alloway developed a high level of interest in the lecturing opportunities he did secure. As his letters note, the work included lecturing at the National Portrait Gallery in 1948, at the National Gallery from 1948 to 1954, and at Tate Gallery from 1951 to 1954. To fulfill these varied positions, Alloway had to

acquire significant bodies of art historical knowledge, ranging from the work of Hieronymus Bosch, Diego Velázquez, Francisco de Zurbarán, and Dutch genre painters to contemporary artists such as Francis Bacon, Reg Butler, Victor Pasmore, and William Turnbull. He also had to master the knowledge sufficiently to communicate it effectively in person. He wrote to Sleigh in August 1952, "Darling I must do some more work on [Marcel] Duchamp. He is terribly difficult to explain impartially to a popular audience."[9]

Methodical in approach, Alloway assiduously researched everything he could find on his subjects, regularly visiting the national library collection and archives of the National Gallery, the Tate Gallery, and the Victoria and Albert Museum, and in one instance, in November 1949, exclaiming to Sleigh, "I am preparing vast preparatory notes for [Jacques-Louis] David—I shall soon be an expert...on him." By 1951, as Alloway continued to amass an extensive bibliography, he also began to reveal his own sense of critical judgment, writing to Sleigh, "You know what [Paul] Valéry says, 'It is by no means the mischievous who do most harm in this world; it is the awkward, the negligent and the credulous.' Valéry's aphorism makes one terribly impatient with most of the books one has to read in the course of duty getting lectures ready and so on."[10] Knowledge acquisition was a necessary skill, but as the comment to Sleigh about lecturing on Duchamp highlights, Alloway was also aware of the need to communicate with his audiences directly. While much of the lecturing he undertook was for educated public audiences who regularly attended the wide array of gallery lectures on offer in London, he also encountered through his work for social and educational initiatives—including the Arts Council of Great Britain, the Society for Education in Art, and the Working Men's Institute—nonspecialist audiences, of varying social classes, who had different levels of interest in the visual arts. In 1951, Alloway lectured throughout London and beyond, often traveling by train to Birmingham, Newcastle, Redcar, and Middlesbrough (fig. 1).

Alloway kept two newspaper reviews that provide an important insight into his teaching methods. The reviews, titled "Public Duty to Understand" and "Few Have Seen Painting," focus on a lecture he gave at the Institute of Adult Education in Harpenden, a small town in Hertfordshire, in 1949. The pieces indicate that Alloway's audience was very small (and predominantly female), although this did not affect the seriousness of his pedagogical intent, which was obvious to those present.[11] As the reviews noted, Alloway put forward a series of arguments and dictums that overrode traditional norms of art appreciation based on the principles of connoisseurship and received taste. He instead transferred the responsibility of art appreciation to the grounded experience and visual analysis of the individual spectator: "It is only if you work mentally at a picture that you begin to understand it. It means hard work on your part but

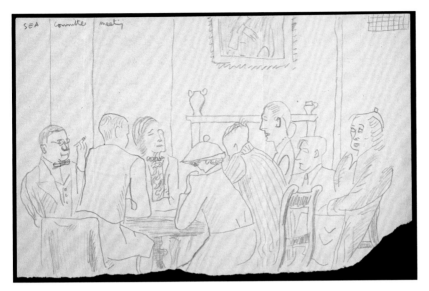

Fig. 1.
Drawing of a Society for Education in Art committee meeting, from a letter by Lawrence Alloway to Sylvia Sleigh, 15 July 1952. Los Angeles, Getty Research Institute.

if you do this work I recommend, you get a greater understanding of painting." Crucially, by encouraging his nonspecialist audience to have confidence in developing their own modes of aesthetic judgment through active looking, Alloway was adamant that the distinction between "classical" and "modern" painting would break down.

In short, Alloway was arguing that a continuum of aesthetic value could be formed through the active spectatorship of the viewer if he or she adopted an empirical and interpretive approach to the work of art. This approach would allow meaning to be generated through a network of associative imagery, rather than through recourse to established norms of aesthetic judgment based on existing canonical forms of knowledge, such as art history. In this formulation, the production of aesthetic and cultural value was reassigned to the individual spectator—who was considered a legitimate actor in the creation of meaning— rather than produced and mediated through the epistemological concerns of specialists. The latter conception, for Alloway, produced only the "aesthetic distance" of Fry's and Read's models of art education and criticism. But as Alloway emphasized, according to his newer model, "one had to be broad-minded" and "to have high standards," standards that were based on both visual curiosity and historical awareness and that would support the reading of objects across historical and contemporary culture, rather than within a fixed historical time frame. For Alloway, this disruption of the formalist and modernist model of art appreciation (as defined by Fry and Read, respectively) was underpinned by his reading of Erwin Panofsky, whose writings on iconology were circulating through journal articles in the late 1940s and early 1950s. By 1951, in his article "Meaning in the Visual Arts," published in the *Magazine of Art,* Panofsky had laid

the groundwork for a reading of the art object as a form of expanded cultural production, inherently defined by the condition of social reception rather than aesthetic intentionality. This new interpretive framework dismantled the fundamental tenets of a paradigm of art based on connoisseurship and taste, which inevitably led to the destabilization of the category of art itself. As Panofsky wrote:

> The modern assumption that a work of art is produced in order to express the experiences of its maker and thereby give pleasure to the beholder is not true of the majority of such works.... Yet a chair, an automobile or even a typewriter may be designed and constructed with the intent of pleasing... the eye, in addition to serving its practical purpose and, in so far as this intent is present, such objects may be classified as works of art.... Most works of art, then, confront us with a multitude of intentions other than that of pleasing the beholder. All these intentions are conveyed to us simultaneously and are simultaneously reactivated or re-created by ourselves.[12]

Hogarth

In addition to shaping his pedagogical method, Alloway's embrace of Panofsky's ideas also informed his use of a descriptive, ethnographic approach to writing on art. This allowed him not only to interpret art from his own self-educated perspective but also to maintain an intellectual vivacity. As he wrote to Sleigh in 1949, during the throes of writing what he hoped would be his major tome on William Hogarth (fig. 2), "Writing is really for me a process of discovery like a poem. I make up my mind as I write and the things that have occurred to me about Hogarth are thus not too stale."[13] The adoption of this open-ended, accumulative type of descriptive writing, rather than predetermined analysis, allowed Alloway to draw from his store of ideas, making associations between historical and contemporary reference points. Along with his pedagogical practice, Alloway's unpublished manuscript on Hogarth, written between 1949 and 1951, is key to understanding his intellectual formation at this time, as well as his dogged interrogation and rejection of the aesthetic as the domain of an elite cultural class. Initially prompted by a commission in 1949 from the art book publisher Phaidon for a book on Hogarth's drawings, Alloway's interest in Hogarth gained momentum as he learned more about the eighteenth-century artist's commitment to new industrial modes of print production and circulation—modes that had significant parallels with the state of mass media during the late 1940s and early 1950s. But he was also motivated by a desire to revive

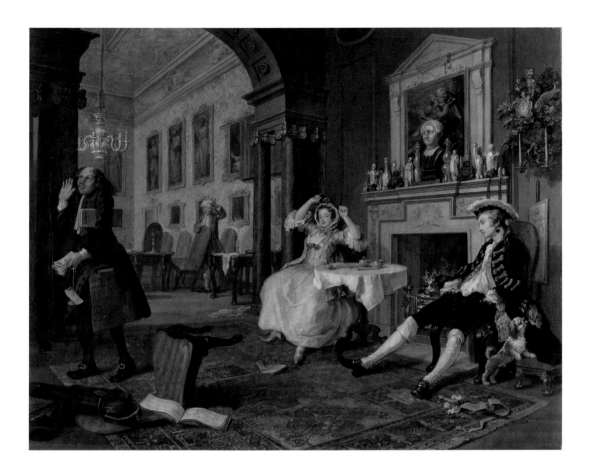

Hogarth's reputation as an erudite and sophisticated artist and theorist. Hogarth had been historically undermined by the artist Joshua Reynolds, whose writings dismissed Hogarth's claims to the position of a serious history painter on account of his choice of contemporary subject matter over mythological and biblical tales. Equally, Reynolds's belief in the elevated and educational value of art, as he outlined in his *Discourses on Art* (1770), relegated, by implication, Hogarth's topical paintings of everyday life to the status of genre painting, further discounted because of its popular appeal. Alloway's aim to retrieve Hogarth from this historical position is clear in his forceful opening remarks:

Fig. 2.
William Hogarth
(English, 1697–1764).
Marriage à-la-mode: 2,
The Tête à Tête, 1743, oil on
canvas, 69.9 × 90.8 cm
(27½ × 35¾ in.).
London, National Gallery.

> Bearing in mind the image of Hogarth as a half-educated cockney
> which has received currency we may remark that he was nevertheless
> familiar with Le Brun's theory of the passions, the principles of Venetian
> colouring, mannerist art theories, French baroque portraiture, and
> Dürer's anatomy.... Those who think of Hogarth solely as the exponent
> of the topical and the satirical need to be reminded that he could
> write appreciatively of the Apollo Belvedere, the Farnese Hercules.[14]

Appointing himself as an archdefender of Hogarth, whom he described as "the champion and exponent of modern art, of popular art,"[15] Alloway built a series of arguments that sought not only to validate Hogarth's historical importance but also to demonstrate the value and relevance of his work in the contemporary moment. First, Alloway recontextualized Hogarth's treatise *The Analysis of Beauty* (1753) within a history of aesthetics that included the writings of Charles Alphonse Du Fresnoy, Gian Paolo Lomazzo, and Roger de Piles to demonstrate how familiar Hogarth was with the literature. Second, he relocated *The Analysis of Beauty* within the formation of aesthetic discourse in England from Joseph Addison's *Eleven Essays on Imagination* to John Locke, the Earl of Shaftesbury, and, most notably, Jonathan Richardson, whose "Essay on the Whole Art of Criticism as It Relates to Painting and an Argument in Behalf of the Science of the Connoisseur" (1719) established the principles of taste and connoisseurship in England. This latter repositioning was a further riposte to the kind of historical marginalization that Hogarth's reputation as a painter and writer had suffered through Reynolds's dismissive writings.

Hogarth's challenge to history painting was, of course, manifested through his introduction of contemporary, nonreligious, and nonmythological subject matter, or as Alloway termed it, his *topicality,* which, Alloway argued, was "better satisfied in the streets, taverns, prisons, of London," where "the emotions of the characters are personal and private rather than heroic."[16] Alloway supported Hogarth's rejection of the most dominant types of cultural activity, such as opera and pantomime, at the extremes of the spectrum. Instead, Hogarth retained his determination to establish a new category of painting, the "conversation piece," and chose to create serial engravings of his modern subjects, which Alloway identified as prefiguring the means and methods of contemporary popular mass media, which also bypassed historical patterns of elitist patronage of the arts. Throughout the Hogarth manuscript, Alloway consistently drew attention to the artist's commitment to the audience, not an imaginary ideal audience but a collection of actively engaged spectators comparable to a theater audience. Hogarth made no assumptions about this group in terms of their ability to make aesthetic judgments, for as Alloway noted of Hogarth's approach, "Taste is extended to the general public, away from the virtuosi: a blacksmith is allowed to be a discriminating judge of two naked boxers and Hogarth observes gallantly, 'the ladies always speak skillfully of necks, hands and arms.'"[17]

As a project of historical retrieval, Hogarth also represented a kind of alter ego for Alloway, sharing a position of social and cultural marginalization—due, in Alloway's case, to his repeated failure to secure teaching jobs and his frustrated attempts to find permanent work as a reviewer. Like Hogarth,

Alloway located himself outside the epistemological traditions of taste and connoisseurship, as well as the fine art conventions of aesthetic production. And like Hogarth, and, indeed, through Hogarth's example, Alloway was beginning to build his own aesthetic theory, one that extended beyond specialized knowledge and established modes of practice.

Theory and Practice: The Institute of Contemporary Arts and the Independent Group

After starting the Hogarth manuscript in 1949, Alloway began to expand his network of professional contacts and friends through visits to the Institute of Contemporary Arts (ICA), which moved to new premises on Dover Street in central London in 1950. The following year, some of the younger members of the ICA approached the institute's management with proposals to arrange informal discussion groups, from which the now well-documented Independent Group (IG) emerged.[18] Alloway's initial impressions of the ICA and its young members were mixed, as his letters to Sleigh detail. In 1951, he wrote that despite the IG's colorful cast of characters, he found the ICA dreary and often felt apathetic about his visits there. Indeed, he recalled Eduardo Paolozzi's epidiascope lecture, a seminal moment in the history of the IG, as "a flop. Eduardo Paolozzi showed a collection of material—marine biology, early aeroplanes, and what have you—but the discussion never got started. Reyner Banham spent most of the evening sniggling at Paolozzi's scrapbook as it was flashed on the screen."[19]

The potential usefulness of association with the ICA to his career kept him engaged, but paid lecture work elsewhere always took precedence over existing offers of unpaid talks at the ICA. On one occasion, this situation offered a welcome alibi, as he wrote to Sleigh in 1951, following his withdrawal from a talk on Herbert Read: "So I shall not be there after all. At least I won't have to read *Education through Art,* which I was dreading."[20] This rejection of Read and Read's support of British neo-romanticism and universal art values did, however, find an outlet in July 1953 when Alloway gave a lecture titled "British Painting in the 1950s." As he reported to Sleigh, "Despite a charge of Puritanism and over-intellectualism (who me?), I was complimented…by [Richard] Hamilton.… [Roland] Penrose was nice too, though I think a little bit taken aback by some of my views. I really knocked [John] Craxton, [Keith] Vaughan, [Josef] Herman, [Martin] Froy and [William] Scott. My candour caused some comment, I think."[21] Alloway's personal and professional confidence was also undoubtedly enhanced in August 1953 when he secured his first major contract, a position with *Art News* writing pieces for $75 a month. Alloway had met with the publisher of the journal, who, according to Alloway, praised

his writing style, which he found "much superior (to his American taste) to most British criticism. He likes my informal style…it looks like my admiration for American critical pure style is beginning to show."[22] Like Hogarth, Alloway was learning how to be both inside and outside the establishment, and the endorsement from an American journal, rather than an English one, clearly helped to consolidate his sense of belonging and not-belonging.

In June of that year, Alloway was invited to join the ICA's advisory committee, which included the architecture critic and design historian Reyner Banham and the art critic Robert Melville as members and which led the planning of the group's lecture program. As Alloway wrote, he "had a very pleasant time with [the cofounder of the ICA] E. L. T. Mesens and Robert Melville saying my values were 'anti-values' and Robert saying 'I have an erratic interest in inferior objects.'"[23] In September 1953, following the resignation of the art historian Toni del Renzio, Roland Penrose asked Alloway to serve on the exhibitions subcommittee alongside the art critics Melville and Peter Wilson. On the suggestion of another critic-member David Sylvester, he was also invited to give a talk on Paul Klee's *Pedagogical Sketchbook* in October 1953.[24] In January 1954, with his profile and credibility well established, his first major ICA exhibition proposal, *Collages and Objects,* was confirmed for December of that year, and his friend John McHale was appointed to design the show.

Also in January 1954, in a letter to Sleigh, Alloway alluded to his first public use of the continuum concept: "My seminar went fairly well: half fine, half popular art. John [McHale] worked the epi[diascope] very well. It wasn't the success my sci-fi lecture was but it was ok by seminar standards."[25] The momentum of Alloway's interest in the relationship between fine art and popular culture manifested itself most significantly in 1955, however, when he co-convened the second series of IG sessions with McHale, this time focusing on the theme of mass media and communication. In addition to discussing Hamilton's paintings and Banham's analysis of car styling and iconography, Alloway and McHale organized two other sessions. The second, on advertising and led by Alloway, was listed as "sociology in the popular arts…intensive, multi-layered analysis of one advertisement as exemplar of descriptive method with performance as referent."[26] Behind this series of talks lay Alloway's interest in the expanding field of information and communication theory, which focused on demonstrating how meaning was not fixed within either the object or the subject of communication but in the process and mode of communication itself. Alloway's research in the field led him to invite speakers from the Communications Research Centre, University College London (UCL).[27]

The UCL's Research Centre published a book of multidisciplinary papers in early 1955, bringing together biology, medicine, economics, linguistics,

sociology, classics, and the visual arts. Titled *Studies in Communication* and edited by the philosopher A. J. Ayer (who also took part in sessions at the ICA), the book included an essay by Rudolf Wittkower, "Interpretation of Visual Symbols in the Arts," in which painting was understood, in the tradition of Panofsky, as a "field of communication." This rendering of the work of art as "a field of enquiry," with the critic as an anthropologist whose job it was to identify patterns of communication for tracing and decoding art, significantly reoriented the historical and modernist paradigm of the art object as a self-referential entity, shifting the epistemological base of both art history and art criticism to a hybrid form of cultural analysis. For Alloway, information and communication theory provided all the theoretical armature he needed to support his concept of a popular-art–fine-art continuum. The theory crystallized both his thinking and his writing as a curator and a critic—a fact that came to the fore the following year, 1956, with the exhibition *This Is Tomorrow*.

**Fields of Communication: *This Is Tomorrow* (1956)
and *an Exhibit* (1957)**

Alloway had two roles to play in the exhibition *This Is Tomorrow*, which took place at the Whitechapel Art Gallery in London in 1956. First, he was invited by the exhibition's organizer, Theo Crosby, to write an introductory essay for the catalog; second, he participated in the exhibition itself as part of Group 12, which also included del Renzio and the architect Geoffrey Holroyd.[28] As indicated by Alloway's essay and his contribution to Group 12, it is clear that he maximized both opportunities to publicly advocate key principles of the aesthetic theory that he had first begun to formulate in his writing and teaching practice in the late 1940s and early 1950s—namely, the role and responsibility of the spectator and the legitimacy of popular art. As Alloway wrote in the catalog introduction, the spectator had a "responsibility" and an essential role to play in determining the meaning of the exhibition.[29]

Building on the ICA sessions on communication theory, Group 12's contribution must have seemed both esoteric and challenging to visitors; it was presented through an aesthetic informed by the social sciences and included diagrams, symbols, and coded forms of visual communication. The collaborative nature of the installation was clear, but in terms of conceptualization and content, it benefited especially from the input of Holroyd, who had traveled in the United States in 1953. While there, he had enjoyed direct contact with the architects and designers Charles and Ray Eames, and he had been present at a screening of their film *A Communication Primer* (1953).[30]

Returning to London in the summer of 1954, Holroyd shared the new theories of communication that were circulating in the States with his London colleagues in architecture and design circles, which subsequently led to both a screening of the Eameses' film at the ICA in April 1956 and an article written by Alloway on the creative couple, which was published just before *This Is Tomorrow* opened. In the article, Alloway cited Johan Huizinga's seminal text *Homo ludens* (1938; published in English, 1949) and emphasized the value of play as a strategy to engage the spectator and to open up non-instrumentalized forms of communication.[31] Extending the logic of collage, and adapting the contemporary trend of the "tackboard," or bulletin board, Group 12's installation referred to the dynamic and fluid nature of image interpretation and meaning making that contemporary modes of communication produced, and the group actively sought to embrace the popular, the topical, and the everyday through the changing display of clippings from daily newspapers.[32] The accompanying exhibition catalog reproduced flowcharts from the mass communications specialist Wilbur Schramm's book *The Process and Effects of Mass Communication* (1954), annotated by explanatory captions, such as "All communication depends on the transmission of signs.... In an efficient communication system the field of accumulated experience must be similar to encoder and decoder...because without learned responses there is no communication."[33] These excerpts highlighted new models of communication analysis (illustrated by the diagrams), which underpinned the difference between pre– and post–mass communication.

Fig. 3.
Interior spread from Group 12's contribution to *This Is Tomorrow* catalog.
From *This Is Tomorrow*, exh. cat., Whitechapel Art Gallery, London, 1956.

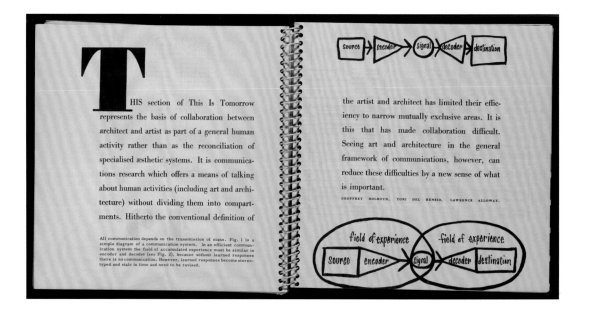

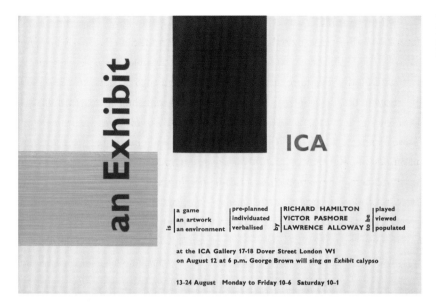

Fig. 4.
Invitation to the opening
of *an Exhibit*, ICA Gallery,
London, 1957.

As Reyner Banham noted in his review of *This Is Tomorrow,* collectively, the exhibition seemed intent on "category-smashing," while certain installations, such as that of Group 12, presented themselves particularly as "an invitation to smash all boundaries between the arts, to treat them all as modes of communicating experience" (fig. 3).[34] But as Banham also noted, Group 12's approach resonated closely with the conceptual ethos of Group 2's contribution, which was created by the artists Hamilton and McHale and the architect John Voelcker, and which also presented different modes of human perception and visual communication. It is perhaps not surprising that Banham drew this connection between Group 2 and Group 12, since he was close to both Alloway and Hamilton through the first half of the 1950s and shared their mutual interest in the relationship between the arts and mass media. Indeed, Banham had convened the first IG meetings and, like Alloway, had identified Hamilton during his first solo exhibition at the Hanover Gallery in London in 1955 as an artist vigorously committed to mediating and interpreting the imagery and conditions of popular visual culture.[35] Given their interest in the new conditions of visual communications, it is not surprising that in 1957 Alloway and Hamilton worked together on another exhibition, a collaboration with the abstract artist Victor Pasmore, *an Exhibit* (fig. 4).

Conceived as a game, an artwork, and an environment, *an Exhibit,* which opened at Newcastle University's Hatton Gallery before traveling to the ICA, included in its design thin acrylic panels of varying degrees of transparency suspended at varying heights by nylon thread within a rectangular grid. The overall arrangement was also variable, as demonstrated at the exhibition's

two venues. Hamilton used the commercially available gray, black, and white acrylic, as well as transparent sheets. Several sheets of Indian red acrylic, a color Pasmore used in his work, were also included. The arrangement was determined by Hamilton and Pasmore only during installation (fig. 5). Hamilton designed the grid and the components, Pasmore produced the colored-paper cutouts that attached to the blank panels, and Alloway wrote instructions for visitors on how to navigate the space. The invitation highlighted each of the collaborators' intentions: for Hamilton, the exhibition was designed as "a game" "pre-planned" to be "played"; for Pasmore, it was an "artwork" "individuated" to be "viewed"; and for Alloway, it was "an environment" "verbalised" to be "populated." Incorporating the Eameses' participative design principles, Huizinga's philosophy of play, and a synthesis of communication theory and cybernetic "feedback systems," *an Exhibit* can also be read, despite its radical conceptual appearance, as the ultimate distillation and embodiment of Hogarth's genre-bending conversation piece: a compelling assemblage of signs, symbols, and spaces open to multiple interpretations by the actively engaged spectator (fig. 6).[36] As the appointed spokesman for the installation, Alloway undoubtedly enjoyed creating an opening gambit in the exhibition catalog: "The meaning of an Exhibit is now dependent on the decisions of visitors, just as at an earlier stage it was dependent on the artists who were the players. It is a game, a maze, a ceremony completed by the participation of all visitors. Which routes will they take, will they move through.... an Exhibit is a test and an entertainment; are you maze-bright or maze-dim?"[37] To prevent the installation from seeming like an exercise in purely formal aesthetic experience, the opening event (at the ICA) included a moment of seemingly frivolous popular culture—a calypso, likely written for the occasion by Alloway himself:

> If you want to know how to play
> Read the verbalisation of Lawrence Alloway
> With Calypso playing its contemporary part
> In the Institute of Contemporary Arts[38]

The following year, 1958, Alloway took his first trip to the United States. As his letters convey, he was overwhelmed by what he found as he traveled across the country, hosted in style, chauffeured in luxury, and enjoying the warmth and color of both the climate and the conversations he encountered with artists and critics, including Hans Namuth, Barnett Newman, Harold Rosenberg, Mark Rothko, and William Rubin. The easy access to artists and critics and the informality of the conversations, which seemed to range widely across art as part of a wider popular culture, clearly connected with what he had

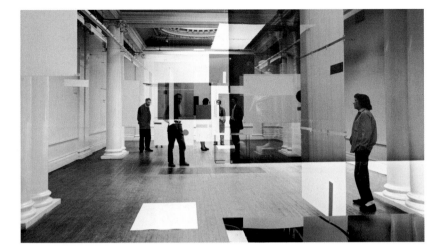

Fig. 5.
Victor Pasmore (left) and
Richard Hamilton (middle)
installing *an Exhibit* at the
Hatton Gallery, Newcastle
upon Tyne, 1957.

Fig. 6.
The final installation design
for *an Exhibit,* Hatton Gallery,
Newcastle upon Tyne, 1957.

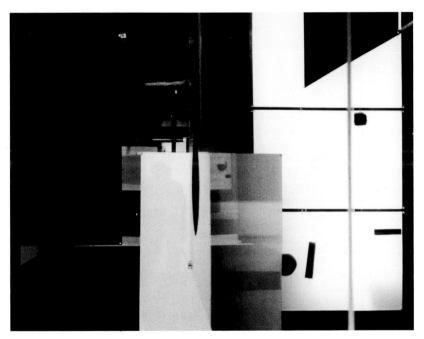

been seeking in his personal statement for the Royal College of Art journal *ARK*: "What is needed is an approach that does not depend for its existence on the exclusion of most of the symbols that people live by.... The new role of the spectator or consumer, free to move in society defined by symbols, is what I want to write about."[39] Arguably for Alloway, the cultural conditions in the United States supported the idea of a popular-art-fine-art continuum more than the cultural conditions in England, and they more closely resonated with his aspirations toward cultural pluralism. In the years that followed the writing of his Hogarth manuscript, Alloway continued to develop his interest in aesthetics and theory-building alongside other interests, including the currency

of popular imagery, its distribution and circulation through new industrial forms of reproduction, and the new conditions of spectatorship through which it was encountered and consumed. As he had written in 1950, "Hogarth is a painter who works on the principle applied by Professor Cleanth Brooks to poetry, namely the inclusive both—and, not the exclusive either-or. How else shall we allow for the abundance of his art?"[40] In the United States, Alloway seemed to feel he no longer had to choose between either/or but could begin to relax into a more fluid and expansive style of writing and, indeed, curating.

Notes

This essay is dedicated to Nigel Whiteley, without whose generosity of spirit—intellectually, academically, and personally—my knowledge of the Independent Group, and Alloway in particular, would be significantly impoverished. I am also grateful to Courtney J. Martin, Rebecca Peabody, and Lucy Bradnock for inviting me to join the Alloway research project, and to the staff of the Getty Research Institute who ensured that the experience of archival research was both immensely productive and highly enjoyable.

1. John McHale cited Alloway's use of the term *cultural continuum* in his article "Gropius and the Bauhaus," *Arts,* 3 March 1955; reprinted in David Robbins, ed. *The Independent Group: Postwar Britain and the Aesthetics of Plenty,* exh. cat. (Cambridge, Mass.: MIT Press, 1990), 182. See also Lawrence Alloway Papers, Getty Research Institute, Los Angeles, acc. no. 2003.M.46, box 30, folder 5.

2. See Lawrence Alloway, "The Arts and the Mass Media," *Architectural Design* 28, no. 2 (February 1958); "The Long Front of Culture," *Cambridge Opinion* 17 (1959); and "Notes on Abstract Art and the Mass Media," *Art News and Review* 12 (1960).

3. Lawrence Alloway, "Personal Statement," *ARK* 19 (Spring 1957).

4. Alloway, "Personal Statement."

5. Lawrence Alloway, "Artists as Consumers," *Image* 3 (1961): 15.

6. Alloway, "Personal Statement."

7. Alloway, "Personal Statement."

8. Lawrence Alloway to Sylvia Sleigh, 2 November 1949, Alloway Papers, box 2, folder 7.

9. Lawrence Alloway to Sylvia Sleigh, 6 August 1952, Alloway Papers, box 5, folder 8.

10. Lawrence Alloway to Sylvia Sleigh, 7 September 1951, Alloway Papers, box 4, folder 9.

11. Press clippings, Alloway Papers, box 2, folder 3.

12. Erwin Panofsky, "Meaning in the Visual Arts," *Magazine of Art,* February 1951, 45–50.

13. Lawrence Alloway to Sylvia Sleigh, 7 September 1949, Alloway Papers, box 2, folder 8.

14. Lawrence Alloway, "Hogarth Manuscript," unpublished manuscript, 1949–51, Alloway Papers, box 14, folder 4.

15. Alloway, "Hogarth Manuscript."

16. Alloway, "Hogarth Manuscript." As Nigel Whiteley has observed regarding Alloway's idea of "topicality": it "could refer to up-to-dateness, social commentary,

the exploration of current themes and ideas, or cultural understanding." Nigel Whiteley, *Art and Pluralism: Lawrence Alloway's Cultural Criticism* (Liverpool: Liverpool University Press, 2012), 461.

17. Alloway, "Hogarth Manuscript."

18. Anne Massey, *The Independent Group: Modernism and Mass Culture in Britain, 1945–59* (Manchester: Manchester University Press, 1995); and Robbins, *The Independent Group.*

19. Lawrence Alloway to Sylvia Sleigh, Alloway Papers, box 5, folders 2 and 12.

20. Lawrence Alloway to Sylvia Sleigh, 7 September 1951, Alloway Papers, box 4, folder 9.

21. Lawrence Alloway to Sylvia Sleigh, 23 July 1953, Alloway Papers, box 6, folder 7.

22. Lawrence Alloway to Sylvia Sleigh, 9 August 1953, Alloway Papers, box 6, folder 8.

23. Lawrence Alloway to Sylvia Sleigh, 20 June 1953, Alloway Papers, box 6, folder 6.

24. Lawrence Alloway to Sylvia Sleigh, 30 October 1953, Alloway Papers, box 6, folder 10.

25. Lawrence Alloway to Sylvia Sleigh, January 1954, Alloway Papers, box 7, folder 1.

26. See Massey, *The Independent Group,* 143. For a full list of the session talks, see Massey, *The Independent Group,* 142–44.

27. See Whiteley, *Art and Pluralism,* 54.

28. For a full overview of all the installations, see Robbins, *The Independent Group,* 134–59.

29. Lawrence Alloway, "Design as a Human Activity," introduction 1 to Theo Crosby, ed., *This Is Tomorrow,* exh. cat. (London: Whitechapel Art Gallery, 1956), n.p.

30. See Robbins, *The Independent Group,* 189.

31. Lawrence Alloway, "Eames' World," *Architectural Association Journal,* July–August, 1956.

32. For a detailed overview of Group 12's installation, see Robbins, *The Independent Group,* 147.

33. Group 12 text, Theo Crosby, ed., *This Is Tomorrow,* exh. cat. (London: White-chapel Art Gallery, 1956), unpaginated.

34. See Reyner Banham, "This Is Tomorrow," *Architectural Review,* September 1956, 186–88.

35. See Lawrence Alloway, "Re Vision," *Art News and Review,* 22 January 1955; and Reyner Banham, "Vision in Motion," *Art,* 5 January 1955.

36. For an account of other IG exhibitions engaged with principles of cybernetic feedback systems, see Victoria Walsh, "Reordering and Redistributing the Visual: The Expanded 'Field' of Pattern-Making in *Parallel of Life and Art* and *Hammer Prints,*" *Journal of Visual Culture* 12, no. 2 (August 2013).

37. Richard Hamilton, Victor Pasmore, and Lawrence Alloway, "an Exhibit," in *an Exhibit: Richard Hamilton, Victor Pasmore, Lawrence Alloway,* exh. leaflet/poster. (Newcastle: Hatton Gallery, 1957).

38. "Exhibit Calypso," unpublished manuscript, Richard Hamilton archive, Richard Hamilton Estate.

39. Alloway, "Personal Statement."

40. Alloway, "Hogarth Manuscript."

REBECCA PEABODY

SCIENCE FICTION AS MUSE
Lawrence Alloway and the Art of Speculative Criticism

Lawrence Alloway's enduring affection for science fiction is a well-known component of his biography—one he actively cultivated as part of his public persona and discussed in his private correspondence. In response to a 1973 interview question about the relevance of popular culture to his intellectual and creative development, for example, Alloway quickly reduced all of mainstream entertainment to one of his preferred manifestations: science fiction.

> I think in a way [popular culture] helped. It may have helped me *not* to seal off earlier areas of interest. I always *loved* science fiction when I was a kid, and since I didn't go through college or university, I wasn't under pressure to drop my sort of equivalent of high school culture. Whereas if you go to university, you're under strong pressure to *break* with all that "foolishness"—and start on Brecht or something.[1]

Scholars have taken Alloway's seriousness about science fiction seriously as well, frequently pointing out the genre's importance within Alloway's work. In an article devoted to science fiction, Eugenie Tsai notes its importance to the members of one of Alloway's early intellectual affiliations: "Science fiction fascinated Independent Group (IG) members as a genre that was particularly in touch with the radical technological changes that were underway in postwar culture."[2] Yet, while many writers have noted Alloway's fondness for science fiction, it is often used as an example in the service of a larger argument rather than being made the primary focus of consideration. This situation parallels one of Alloway's own strategies; science fiction makes frequent brief appearances in many of his seminal writings. Science fiction, in the form of cybernetics, for example, is used to illustrate the pedagogical function of media in "The Arts and the Mass Media" and to demonstrate the ways in which media support personalized interpretations in "The Long Front of Culture."[3] However, Alloway also engaged with the genre in more substantial, ongoing ways. In his private life, science fiction offered a form of rejuvenation as well as a creative outlet.[4] In his professional life, it was useful in building a pro-American, popular

culture-loving persona and in providing terms and concepts to describe art-works. It also served as exhibition content, the subject of reviews and critical analysis, and even merited a spot on the itinerary for his State Department-sponsored trip to the United States.[5]

The aim of this essay, then, is to look more closely at some of the ways in which science fiction threaded through Alloway's creative and critical engage-ments—to make it the center of consideration, rather than using it as an example. I argue that science fiction occupied a sustained, complex, and evaluative place in Alloway's thinking; it was a muse, a methodology, even a pedagogy, which can be seen by its shifting object positions. In fact, looking closely at Alloway's engagement with the genre opens up a productively recursive loop: his love of science fiction influenced the formation of significant theories and models, such as information theory and the cultural continuum, by pressing him to find ways of explaining the visual world that included his own preoccupations. At the same time, his theories were constructed in such a way that they neces-sitate a consideration of popular culture (such as science fiction) alongside art. This essay focuses on three examples of Alloway's engagement with sci-ence fiction—the value of juxtaposition, the visuality of science fiction, and the genre's function within a broader cultural sphere—before drawing some parallels between Alloway and others who used science fiction in their creative and critical work, and between art history, where Alloway is traditionally con-sidered, and other disciplines in which his work might productively intervene. At stake is a fuller understanding of the extent to which Alloway's critical work and creative passions were productively intertwined and mutually generative.

The Value of Juxtaposition

In an unpublished essay, probably dating from around 1956, Alloway argues for an understanding of science fiction that moves beyond generic and aesthetic conventions and instead situates the genre as a pedagogical methodology: "SF assimilates aspects of the technical change[s] of our century. To the multitu-dinousness of scientific progress it brings the promise of 'theoretical coher-ence' . . . the basic achievement is constant—the assimilation, in popularized, easy to handle forms, of current science. This process contradicts the accusation of critics who regard SF as an 'escape into the beyond.'"[6] An example that illus-trates this assessment can be found in the form of Robby the Robot, a character who appears repeatedly in Alloway's projects throughout 1956.

In July of that year, Alloway reviewed the just-released film *Forbidden Planet* for the BBC's *Third Programme* radio broadcast.[7] *Forbidden Planet,* the first big-budget science-fiction film from Metro-Goldwyn-Mayer (MGM), combined

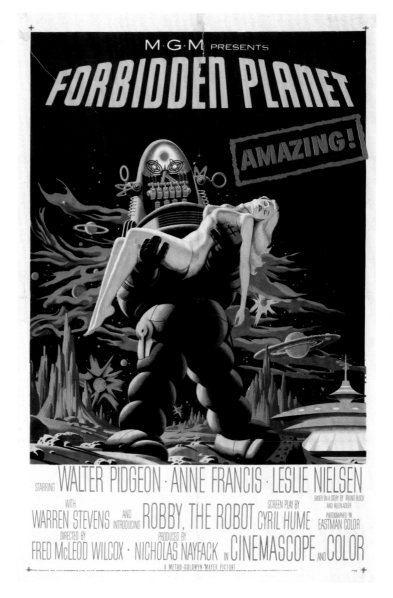

advanced special-effects technology with a plot that, for many, recalled William Shakespeare's *The Tempest* (fig. 1). The story recounts the adventures of a space crew on a rescue mission to a faraway planet where, twenty years earlier, another ship had crashed. The sole survivor, Dr. Morbius, along with his daughter, Altaira, has in the meantime created a new and idyllic life studying traces of the planet's former inhabitants, the Krell. Morbius and Altaira are protected from unwelcomed rescue by Robby the Robot—an indigenous, artificially intelligent life form created by Morbius.

In his review, Alloway points out the comparison with *The Tempest,* and while he does not disagree with the parallel, he criticizes the "pretentious

commentary" of film critics who do not yet know their way around the genre, as evidenced by their failure to focus on more interesting aspects of the film. In just a few pages, Alloway highlights several of those aspects: beginning with the "tour de force" special effects and the "brilliant" sound track. He also posits *Forbidden Planet* as a meditation on the effect of new technologies on modern life. Alloway notes:

> You can see very clearly from *Forbidden Planet* what the appeal of science fiction is: it dramatizes the fact that we live in a world transformed by science, a world in which all aspects of our lives have been effected [*sic*] by advancing technology. . . . Robbie [*sic*] the Robot is a descendant not only of Krell technology but of current toys: just on the American market is a remote-controlled mechanical man who says, "I am Robert Robot, the mechanical man. Drive me and steer me wherever you can."[8]

In the film, Robby was built by Morbius using Krell technology, as was a monster—actually a projection of Morbius's subconscious—who also inhabits the planet. And while Robby prevents Morbius from being rescued against his will, he cannot save him from himself, in the form of his other creation, the monster. Alloway's reflections on Robby's ontological status reveal the dual possibilities invested in the robot in 1950s America: he is either a harmless mechanical extension of human ingenuity or a fundamentally alien being (as evidenced by his Krell ancestry). Beyond his interest in the robot's shifting identity, Alloway is focused on the techniques of familiarization, noting how Robby, along with the film's other technological marvels, fits comfortably into moviegoers' knowledge of domestic innovations, such as children's toys, mechanized kitchens, and the early stages of automation: "The writers and art directors of the film have taken care to root the wonders of 22nd century and alien technology in familiar aspects of the 20th century. It is the whole world of science that is the source of *Forbidden Planet*'s marvels."[9] This process is key to Alloway's enterprise, provoking viewers to notice the impact of science and technology on their own transformed lives.

A month later, in August 1956, *This Is Tomorrow* opened at the Whitechapel Art Gallery in London. A collaborative endeavor, the exhibition included the work of a significant contingent of IG members—an interdisciplinary assortment of artists, writers, architects, critics, and scholars among whom Alloway counted himself, and whose meetings were hosted by the Institute of Contemporary Arts (ICA) in London from the early to the mid-1950s. The group's shared interests included science, technology, mass culture, aesthetics, and science fiction—the latter of which, as Nigel Whiteley points out, "members

believed [could] provide the sort of images that *shaped* attitudes."[10] An example of this belief, which took on iconic proportions, was the appearance of Robby the Robot in *This Is Tomorrow*. Section two of the exhibition, curated by Richard Hamilton, John McHale, and John Voelcker, created a multisensory environment meant to challenge perception by juxtaposing association-laden images in combinations that inspired subjective meanings unique to each viewer.[11] The curators included references to films, recorded music and ambient sounds, a scented carpet, optical illusions, and both found and collaged examples of popular art and culture. A large cardboard cutout of Robby featured prominently in this section of the exhibition (fig. 2), and Hamilton borrowed a model of the robot from MGM for an opening-night appearance (fig. 3).

Robby was not part of Alloway's section of the exhibition, but given Alloway's previous investigations of science fiction at the ICA (including a lecture given two years prior that Arthur C. Clarke was slated to chair), his early involvement in organizing *This Is Tomorrow*, and his contribution of an essay to the exhibition catalog, it seems likely that he had a role in planning the robot's inclusion.[12] Alloway did comment on Robby's appropriateness as a symbol for the show in a press release: "It is suitable that MGM's full-size model of a robot of the 22nd century should open an exhibition in which many of the younger artists and architects are collaborating to show what Tomorrow may be like."[13] Furthermore, he wrote the speech that the robot's operator read aloud on opening night.[14]

The exhibition was a success, due in large part, as Graham Whitman points out, to Alloway's efforts, for he "acted as information officer and publicized the exhibition through the press, radio, television, and cinema newsreel."[15] In September of that year, about midway through the two-month run of *This Is Tomorrow*, Alloway published an article titled "The Robot and the Arts" in *Art News and Review*. While it can be seen as part of Alloway's publicity efforts for the exhibition, the article also theorizes Robby's role as "a gimmick, of course, but a gimmick with resonance, and implications."[16] Alloway argues that Robby's opening-night appearance highlighted a central tension within the exhibition, which could be summed up as relevance. "Who makes the machine age art, the fine artists or the popular artists, the constructivists or the mass illustrators and designers?" By invoking, through comparison, the constructivist-inspired subsection within *This Is Tomorrow*, in which an aura of tradition tempers its potential newness, Alloway answers his own question resoundingly in favor of the mass arts. "Robby…symbolizes the machine age in its vivid, superstitious, and current forms. It is to the popular arts that one looks for symbols of this machine age…at a time when many artists are looking for iconographies with which to express 'the times' with a high degree of accessibility the popular arts

Fig. 2.
Cardboard cutout of Robby the
Robot in the *This Is Tomorrow*
exhibition, Whitechapel Art
Gallery, London, 1956.

Fig. 3.
Opening night at the *This Is
Tomorrow* exhibition, featuring
"live" appearance by Robby the
Robot, Whitechapel Art Gallery,
London, 9 August 1956.

Fig. 4.
**Cover of *Astounding Science
Fiction*, October 1955.**
© 2014 Penny Publications
LLC/Dell Magazines.

have it"; they are, Alloway concludes, "a tool of amazing flexibility and strength." Much more than an opening act, in Alloway's estimation, Robby can be theorized as visual shorthand for the value, relevance, and accessibility of the popular arts, as well as the ability of science-fiction imagery, in particular, to reflect the concerns of the present moment back toward viewers through the prism of entertainment. In the summer of 1956, the movie review, the exhibition, and the article allowed Alloway to work through science fiction's usefulness as a form of visual communication, one that uses a symbolic language and the comfort of temporal distance, by way of an imaginary future, to help viewers adjust to their own increasingly technological lives and to prepare them for changes to come. At the same time, juxtaposing art with popular culture highlighted the importance of contrast in Alloway's thinking, as the relevance of the popular takes on greater significance when it is contrasted with more traditional alternatives.

Robots, however, are more than just symbols of a vibrant iconography in Alloway's estimation; they also reflect their creators' deeply ambivalent attitudes regarding artificial intelligence. In "The Robot and the Arts," Alloway points out that the movie's poster depicts Robby absconding with an unconscious girl in his arms—a fantasy that is entirely external to the film's true narrative, in which Robby is an obedient servant. The poster's departure from the film is important, Alloway argues, as it "makes the point that robots in the popular arts can be presented as either an integral part of the house of tomorrow or as an abductor of girls in torn dresses. The robot can symbolize bland acceptance of machines or fears of a violent sexual nature."[17] In making this observation, Alloway points to a larger cultural interest in robots and identifies two preoccupations of science-fiction writers in the 1950s that are later articulated by Roger Luckhurst: anxiety around the potential merging of human and machine, which could lead to an inability to distinguish one from the other, and "nostalgia for the decade as the last moment of economic security, affluence, social cohesion and the benign technical transformation of everyday life."[18]

The tension generated by the ambivalent potential of artificial intelligence is also visible in the cover illustration from a 1955 issue of *Astounding Science Fiction* (fig. 4)—one of Alloway's favorite magazines and a frequent reference, which he variously described as "classy" and as one of "the snob magazines" that was intended for "scientifically and technically oriented readers."[19] A robot, presumably built by human hands, gazes down at half-buried human skeletal remains, expressionless and fixed in place as red sands begin to cover its own metal body. A first-aid kit partially buried between the two bodies poignantly raises the question of whether the robot could have intervened into this hapless individual's fate. Did the robot arrive too late, or did it deliberately withhold its help? Meanwhile, an antenna on the side of the robot's head suggests that it is

October 1955 · 35 Cents

Astounding
SCIENCE FICTION

"Follow Me..."

in communication with someone or something, but it is unclear whether the interlocutors are humans or machines. The evocative phrase "Follow Me…" underscores the irony in the scene, suggesting that humanity's pioneering spirit may outpace its endurance and that the species' demise may be witnessed and survived by its creations.

In Alloway's view, *Astounding Science Fiction* shared his interest in symbolic imagery, and the affinity was one that he took seriously. In 1958, Alloway visited the United States for the first time after receiving a U.S. State Department Foreign Leaders grant.[20] His itinerary for the trip included a meeting with John Campbell, the editor of *Astounding Science Fiction.* Alloway later observed that "this may have been the only time that an American State Department–sponsored visitor wanted to meet the editor of 'Astounding Science Fiction.'"[21] In a letter written a few days after the meeting, he noted, "Yesterday…I had lunch w/John Campbell, ed. of 'Astounding Science Fiction' which I enjoyed very much. He talks like his editorials. Full of info and ideas (some of them a bit nutty). Out of his office window is a wonderful view of the UN building."[22] The meeting with Campbell was not Alloway's only departure from an otherwise artistically and academically oriented series of meetings, as he also, for example, met with the art director and, in a later meeting, the editor of *Mad* magazine.[23] These encounters reveal Alloway's interest in continuing to juxtapose the fine arts with popular culture—he valued time spent with representatives of both and officially worked them into his busy schedule. They also underscore the role of science fiction as a through line in Alloway's intellectual pursuits; it was a sustained interest, rather than a project-based one, and can be considered in contrast with, in his words, the "many art critics [who] do this" but "don't let it show…when writing 'seriously.'"[24]

We can see Alloway pulling together a couple of these threads in his deployment of Robby the Robot. On the one hand, he is participating in creative and critical ways in current thought experiments about the robot's role in human adaptation and the ambivalent discourse around the potentially utopian/dystopian result of artificial intelligence. As Stephen Moonie points out, connections can be drawn directly from Alloway's interest in science fiction to his development of an information theory, since both draw heavily from cybernetics, the array of technologies stemming from artificial intelligence, and the increasingly permeable boundary between human and machine.[25] On the other hand, and at the same time, Alloway was working through ideas that grew out of, or contributed to, his model of a cultural continuum, in part by urging viewers to consider art and popular culture alongside each other. As Nigel Whiteley notes, Alloway was working on the idea of a continuum prior to *This Is Tomorrow,* and he continued to develop it throughout the late 1950s, ultimately arriving

at a "horizontal" model in which "art is but one channel within a more socially constructed visual communications that views art less aesthetically…and more socio-culturally"—a "radical outlook" at the time.[26] And, indeed, when Alloway notes that charting the unique functions of different forms of communication "is part of an effort to see art in terms of human use rather than in terms of philosophical problems"[27] in a personal statement that begins with a fierce declamation of his consumption of popular culture (along with a critique of other art critics who read science fiction but don't take it seriously), we see the extent to which his commitment to the genre and his theoretical practice are intertwined.

Visuality and Methodology

As the examples above illustrate, Alloway was interested in the provocative, productive power of juxtaposing symbols of science fiction—in this case, the robot—with the expressive modes and venues normally reserved for art: the exhibition and the gallery space. Juxtaposition, however, implies separation (two distinct objects compared side by side), and Alloway was also concerned with establishing a more thorough integration of science fiction with art history and art criticism.

In the summer 1956 issue of *ARK,* the journal of the Royal College of Art in London, Alloway published one of his better-known reflections on science fiction: "Technology and Sex in Science Fiction: A Note on Cover Art." He begins the essay with a provocative assertion, "the iconography of the twentieth century is not in the hands of fine artists alone," and then goes on to argue that a full understanding of how artists visualize the commingling of humans and machines must move far beyond the production of the futurists and the Dadaists to include popular arts such as advertisements, movies, and science fiction.[28] Focusing on the latter, Alloway identifies two poles within the genre: images that strive to articulate serious ideas about machines and humanity and images that are more sensational—even erotic; or, in his words, "emblems of sophisticated concepts," versus "riotous fantasy."[29] This was a scaled-down reiteration of an analysis Alloway had applied to science fiction more generally in his unpublished article, arguing that "on one side are the serious writers who develop thoroughly limited problems. On the other hand, are the writers who flamboyantly improvise space opera."[30]

In "Technology and Sex in Science Fiction," Alloway uses reproductions of some of the sensationalist covers (fig. 5) to point up their visual clichés, such as scantily clad women juxtaposed with large machines and tentacled monsters, as well as the chronically loose, or even nonexistent, relationship between the cover art and the content of the stories. But he ultimately finds value in

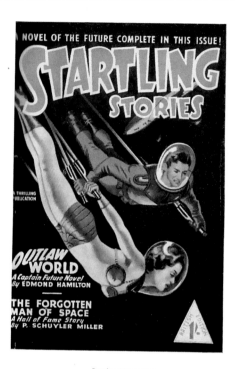

Sex in outer space.

Beauty and the Beast.

21

Fig. 5.
Covers of *Startling Stories*
and *Future Science Fiction.*
From Lawrence Alloway,
"Technology and Sex in
Science Fiction: A Note on
Cover Art," *ARK,* summer
1956, 21.

Fig. 6.
Assorted illustrations from
Astounding Science Fiction,
Galaxy Science Fiction,
and *Newsweek.*
From Lawrence Alloway,
"Technology and Sex in
Science Fiction: A Note on
Cover Art," *ARK,* summer
1956, 22.
Astounding Science Fiction
covers: © 2014 Penny
Publications LLC/Dell
Magazines.

the illustrations, noting that they are "one of the channels open to erotic art in our half-censored urban culture."[31] In the example from *Startling Stories,* a pair of astronauts flies through darkness, leaving behind what appears to be their spacecraft. The man is covered from head to toe in a space suit, protective gloves, and a helmet. The woman also wears a helmet but is otherwise mostly nude; her collared bikini top, shorts, high-heeled boots, and wrist cuffs would do little to shield her from extreme temperatures. Alloway's caption "Sex in outer space" redirects attention away from the actual activity depicted on the cover and toward a projected fantasy image for readers to imagine. On the cover from *Future Science Fiction,* another woman—her nudity barely shielded by what appears to be a loosely draped sheet—gazes forward apprehensively while a tentacled, reptilian yet still humanoid creature climbs into the spacecraft-like room. Alloway's caption "Beauty and the Beast" adds the fairy tale's narrative trajectory to the foreboding image: in spite of her protests, the woman will be won over, the intimacy that results will lead to true love, and the alien will physically transform into something more recognizably desirable. In both cases, Alloway uses captions to add additional layers of meaning to the illustrations— he turns viewers into characters and embeds stories within stories. He does not

Right: Orientation in the new world of science is not confined to the pulps (*Newsweek* cover).

Melodrama and Rhine's tests. (*Galaxy Science Fiction*)

Left: Contrasting technologies.

Right: Cybernetics and the image of man.

22

devote much time to articulating the covers' aesthetic value, but he does reference their "social function," which is to "entertain our erotic appetites."[32] More importantly, however, they create an effective foil for another kind of science-fiction illustration.

In contrast with the erotic covers are the more sophisticated or, as Alloway puts it, "classy" counterparts (fig. 6), which use symbolic imagery to highlight cultural or technological differences and to introduce readers to new concepts—keyboards and computers, for example—years before they become realities. As a result, Alloway argues, these images serve an important social function in that they help to orient readers to the real-world challenges of rapid technological and cultural change.[33] Alloway includes more images of the classy covers in his essay than he does of the erotic covers, and he spends considerably more time articulating his points about the former than the latter. The image on the far left demonstrates what Alloway refers to as "contrasting technologies" by pairing a "spaceman and [a] feathered tribesman" in order to illustrate the necessary coexistence of extremes and the tension that arises between different societies with different technologies.[34] (Alloway does not acknowledge the erotic potential expressed by two men, one of whom is partially nude, standing closely

together.) The image in the center refers to Joseph Banks (J. B.) Rhine, a scientist whose parapsychology lab, then based at Duke University, conducted tests using cards and dice like those depicted in the illustration. In the image at bottom right, a disembodied face propped up by hands and forearms gazes intently at the viewer, while complex circuitry and punched cards extend well beyond the space that a body would normally inhabit—a reference to cybernetics' potential to fuse humans with machines. The final illustration, at top right, is Alloway's strongest visual argument in favor of science fiction's relevance beyond the genre. Taken from the popular American news magazine *Newsweek,* the image shows a human head composed of circuit-like grids. "Orientation in the new world of science is not confined to the pulps," Alloway observes in the caption, and, indeed, this sentiment could stand as the caption for any of the other images gathered on this page. The caption corresponds with the only image not taken from a science-fiction magazine—and one of the images that viewers are likely to consider last. Alloway may be strategically encouraging readers to see the other illustrations initially as pure fiction and then only on second glance—and at his prompting—as sophisticated symbols of real phenomena.

In contrast, Alloway's 1968 article "Science Fiction and Artifacts: Science Fiction Is Global Thinking's Pop Culture" does not apply art historical techniques to popular culture but, rather, claims to discern science-fiction techniques—though not labeled as such—already at work within the larger art world. The article begins as a review of Pontus Hultén's 1968 exhibition *The Machine as Seen at the End of the Mechanical Age,* organized by the Museum of Modern Art, New York, an exhibition that was concerned with human relationships and depictions of science and technology but not, ostensibly, with science fiction as a genre or as a unifying theme. Instead, it aimed to tell "the story of how artists of this century have looked upon and interpreted machines in attitudes ranging from devotion and even idolatry to deepest pessimism and despair."[35] Alloway, however, saw something else at work. He proposes that the exhibition catalog itself is a form of science fiction, and he gives an example in which a photograph of an abandoned train car in a jungle and a sonnet about a dead or dying soldier lying in a valley are juxtaposed; as a result, the sonnet is "science fictionalized," a process he later connects to science fiction's commitment to presenting "challenging objects" and recounting stories about humanity's "attempts to solve a problem posed by the hostile, or merely enigmatic, artifact."[36] Later in the piece, he notes that Hultén's successful selection of objects encourages "a context of heightened participation," which in fact "confers a kind of Science Fiction status on them."[37] As the article goes on, Alloway's focus shifts from the exhibition to the social relevance of science fiction as a genre, but he reunites the two topics toward the end when he praises Hultén for drawing on multiple media for his

representations of machines, a tactic that Alloway himself practiced. Alloway's "discovery" of science-fictional curatorial techniques—not just objects—within the *Machine* exhibition allowed him to express another way in which the genre is interpretively useful within an art context, while at the same time enabling him to argue for the expansion of science fiction far beyond its generic limits and make it into something nearly universal. It is "one of the forms of the self-study of industrialized culture" according to Alloway's definition of the genre; or, as he even more succinctly puts it in the article's title, it is "global thinking's pop culture."[38] In fact, though he does not use the term, Alloway seems to be gesturing toward a science-fictional *methodology*—one that may be native to the literary genre but can be used productively in many other circumstances. One, perhaps, that is so ingrained within the cultural imagination that it is used without recognition.

Alloway's article on science-fiction cover art applies art historical terms and methods to popular cultural objects, while his article on *The Machine* theorizes the exhibition through science fiction. In other words, the first approach makes the genre into a valid object of art historical inquiry, while the second discerns science fiction already at work within an art historical practice.[39] If the cultural continuum model evolved throughout the late 1950s as Alloway "tried various ways to hold the experiences of fine and popular art together,"[40] then I would add that his theorization of the cultural continuum ran parallel and led to some practical experiments in its application.

Global Implications

The longevity of Alloway's commitment to science fiction, and the importance that the genre held for him—especially in the 1950s—can be seen in the retrospective statement he contributed to the exhibition catalog for *The Independent Group: Postwar Britain and the Aesthetics of Plenty*. Published in 1990, the year that Alloway died, the catalog accompanied an exhibition by the same name that focused on the IG's formation and continuing impact.[41] The catalog includes several other statements that dwell on the writers' memories of the IG, but Alloway's piece focuses almost exclusively on his attraction to science fiction and its influence on his work.

> My liking for SF...was, I think, compounded of several elements. First, it was American-based so far as inventive authors, tough editors, and a knowledgeable readership went. Second, it was written by men (rarely by women) who were free of classical culture and—though this is not the same thing—of English University influence. (The British mystery

story, on the other hand, offended me because of its pro-university aura.) Third, it was a popular art form with set, non-psychologized figures of hero, heroine and villain shown in situations wittily extrapolated from modern society."[42]

Toward the end of the essay, he claims the genre as a sign of his national affiliation, making reference to his "more developed pro-Americanism, of which SF was one sign." This pro-Americanism, he suggests, was ultimately linked to his dismissal from the ICA in the late 1950s. It is telling of Alloway's multivalent uses of the genre that science fiction serves alternately as a muse and a critical tool, and even as shorthand for the problems between himself and his institution that ultimately proved too divisive to overcome—the genre is both internal and external, something that is part of his character and something that he chooses to study. Alloway's strong preference for American science fiction is important beyond his career changes at the ICA. In fact, science fiction had a strong history in Britain, and it is worth asking why Alloway focused exclusively on its American counterpart.[43]

Alloway notes that he began reading science fiction as an adolescent, a time that coincided with the rise of pulp fiction publishing and an influx of American science-fictional influences, when, as Alloway puts it, "American pulp magazines reached England in fairly large numbers, as cheap bulk cargo or ballast or something."[44] As Roger Luckhurst points out, "American SF in the era between 1945 and 1960 was complex and multiform . . . it was in this period that the dominant lines of the genre emerge. . . . The English scene was no less complex, but it was also undoubtedly *reactive* to American developments on many levels."[45] So, to some extent, Alloway's predilection for American science fiction may have been circumstantial—a result of larger trends.

However, a further clue to his cultural preferences can be found in Brian Stableford's observation, which reintroduces John Campbell, the editor of *Astounding Science Fiction* and an important figure in Alloway's science-fiction circle:

Under the influence of evangelically minded editors like John W. Campbell Jr the American pulp sf writers had improved the quality of their product very markedly during the 1940s. Many of the writers working in the genre . . . were intelligent men with a good deal of scientific knowledge at their fingertips, who were perfectly prepared to be serious in trying to anticipate likely technological developments and their effects on society. Alongside them, however, were working writers who specialized in the production of gaudy costume dramas populated by gruesome monsters

and fabulous machines. It was the latter group of writers who were mostly imitated by the British paperback writers. . . . Thus, the science fiction which emerged to take its place in the British fiction marketplace was quite unlike the science fiction which, in America, was just emerging from its pulp ghetto into the new respectability of hardcover anthologies and middle brow digest magazines like *Galaxy* and *The Magazine of Fantasy and Science Fiction.*[46]

Returning to Alloway's notes and unpublished manuscript on science fiction, we see that some of the elements of American science fiction as defined by Stableford resonate with Alloway's own valuation of the genre. He writes, "SF is characterized among pop arts by its comprehensive topicality. This content is sociology as of now. It is about current problems."[47] And later, he describes the genre's big-picture sociological contribution:

SF, the branch of popular art most concerned with science, communications, and war has accurately mirrored this condition [the reduction of the world's size through the development of communication, weapon, and economic systems at a global scale]. We have, it can be said—in a rather high-level abstraction, reached the threshold of global culture. SF, by posing its problems and its adventures in terms of worlds and whole societies, seems to recognize this fact and, within the terms of entertainment, offers global play and hence global lessons.[48]

Alloway positions science fiction as a global, or globalizing, phenomenon, an imaginative exercise that, in addition to promoting scientific literacy, enables adjustment to scientific and technological change through "the orientation and the exercise of the imagination."[49] This enterprise can be seen as early as his first lecture on science fiction, given as part of his work with the IG in 1954. Separating himself from critics who "attribute evils to . . . the mass media," and "interpreters who see it as a mess of symptoms," Alloway takes up one aspect of mass media—science-fictional monsters—to argue that they are "much more nearly ourselves in an imagery of what can, or might, happen to human beings in extreme situations." "Our shudders," he argues, "come from our involvement."[50] In Alloway's view, science fiction should be recognized as a pedagogical tool that engages the mind through entertainment in order to do important, socially instructive work that is psychological as well as sociological.

Alloway was not, of course, the only person drawing connections between art and science fiction at this time. As Joy Sleeman recounts in her essay in this volume, Robert Smithson, an important figure in Alloway's later writing,

drew heavily from science fiction in order to conceive of and explain his art-work.[51] Alloway, the Englishman, was drawn to American science fiction; however, Smithson, an American, gravitated toward the British iteration of the genre. Additionally, in 1968, Harald Szeemann, a prolific Swiss curator who created influential shows on a variety of postwar art topics, organized an exhibition titled *Science Fiction* that focused exclusively on the subject (fig. 7).[52] An attempt to combat the popular conception that science fiction's visual manifestations were "second class or even vulgar art," the exhibition was, according to notes from Szeemann's research files, not about "a literary style or an art style. SF is a state of mind, a literary, creative, sociological, yes popular phenomenon that can manifest itself anywhere and in any possible form. The exhibition was therefore less directed at a presentation of selected items but intended to possibly create a climate of SF."[53] While Szeemann did not contribute an essay to the catalog, his thoughts are echoed by one of its authors, who similarly draws attention to the genre's capacity to offer social instruction:

Fig. 7.
Cover of Harald Szeemann's exhibition catalog *Science Fiction*, published by the Musée des Arts Décoratifs, Paris, 1967.
Los Angeles, Getty Research Institute.

> Science Fiction has a precious quality for the man of the twentieth century. It encourages him to keep his imagination aroused...to maintain a receptivity to the idea of change...science fiction is not only the literature of a blind confidence in science: it is also a literature that sounds warnings and interrogates. It examines—so as to arrive at one of the best definitions put forward—the possible developments of science and the effects, good or bad, of these developments on humans....If it does not necessarily offer infallible solutions, science fiction at least tries to make us realize the existence of problems. And that's why it deserves our attention, the attention of all those who understand life in an age that is marked by science and its impact.[54]

Alloway was not alone in bringing science fiction into a context normally reserved for objects more familiar to art historical discourse, nor was he the only critic and curator concerned with arguing that its relevance extended far beyond the boundaries of its genre. As Szeemann's exhibition and catalog point out, there was more general interest in the potential for science fiction to provide multiple kinds of instruction to its consumers, including psychological and sociological reflection, as well as technical literacy. Alloway's interest in science fiction was not limited to its utility in juxtaposing fine art and mass media within a cultural continuum, nor to its productive potential within the field of art history. Indeed, science fiction, for Alloway—and others—had much broader, even global, implications.

Conclusion

Science fiction threaded through Alloway's creative and critical engagements for much of his career, occupying a sustained, complex, and evaluative place in his thinking. It served as a useful symbol of popular culture and allowed him to juxtapose objects taken from high and mass arts, illustrating his evolving model of the cultural continuum. It also provided a point of departure for methodological experiments in which art and genre fiction could be shown to act on, and through, each other. Finally, it offered a widely applicable pedagogical tool, one in which entertainment-oriented products offered important lessons on human potential and the impact of social development. Ultimately, Alloway's lifelong connection to science fiction demonstrates a kind of critical or academic continuum in which enthusiastic consumption can coexist on the same plane as critical analysis and theorization over the course of many years. Alloway's sustained commitment to the genre merits similarly sustained consideration in terms of its impact on his thinking. At stake is a fuller understanding of the extent to which Alloway's critical work and creative passions were productively intertwined, and mutually generative.[55]

Notes

I would like to thank my coeditors, Lucy Bradnock and Courtney J. Martin, the participants in our research project, the contributors to this volume, and the organizers and hosts of the "Lawrence Alloway Reconsidered" conference at Tate, London, in 2011.

1. James Reinish, "An Interview with Lawrence Alloway," *Studio International* 186, no. 958 (September 1973): 62.

2. Eugenie Tsai, "The Sci-Fi Connection: The IG, J. G. Ballard, and Robert Smithson," in Lawrence Alloway et al., *Modern Dreams: The Rise and Fall and Rise of Pop* (New York: Institute for Contemporary Art; Cambridge, Mass.: MIT Press, 1988), 71.

3. Lawrence Alloway, "The Arts and the Mass Media," *Architectural Design* 28, no. 2 (February 1958), and "The Long Front of Culture," *Cambridge Opinion* 17 (1959), reprinted in idem, *Imagining the Present: Context, Content, and the Role of the Critic,* ed. Richard Kalina (London: Routledge, 2006), 57–58 and 64, respectively.

4. A letter to his wife, Sylvia Sleigh, recounting the events of the week, includes the enthusiastic observation, "For relaxation I have read some science-fiction!," while another letter to Sleigh includes a science-fiction-themed poem: "I have written a poem called *Lessons* which I enclose. On the basis of a few science-fiction clichés I have tried to define, in the thinnest, remote, and colloquial terms Spengler's idea of Faustian Man: you remember, forces rather than bodies, function instead of being"; see Lawrence Alloway to Sylvia Sleigh, 22 June 1953, Lawrence Alloway Papers, Getty Research Institute, Los Angeles, acc. no. 2003.M.46, box 6, folder 6;

and Lawrence Alloway to Sylvia Sleigh, 19 July 1953, Alloway Papers, box 6, folder 7.

5. See the essay by Lobel, this volume.

6. Lawrence Alloway, untitled, undated, and unpublished manuscript, Alloway Papers, box 26, folder 27, 22. Alloway's reference to 1953 as "a few years ago" dates this essay to approximately 1956, while some of the notes that accompany it date to 1961. At twenty-four pages long, the essay is a rich source of material on Alloway's thinking and a valuable example of a long-form—perhaps the longest form—essay by Alloway on science fiction. It is accompanied by thirteen pages of notes. Some portions of the essay resurface in the 1969 article "Science Fiction and Artifacts: Science Fiction Is Global Thinking's Pop Culture," which is discussed below.

7. Lawrence Alloway, review of *Forbidden Planet,* transcript of *Third Programme* radio broadcast, Alloway Papers, box 14, folder 7.

8. Alloway, review of *Forbidden Planet.*

9. Alloway, review of *Forbidden Planet.*

10. Nigel Whiteley, "Banham and 'Otherness': Reyner Banham (1922–1988) and His Quest for an *Architecture Autre,"* *Architectural History* 33 (1990): 213.

11. Anne Massey, *The Independent Group: Modernism and Mass Culture in Britain, 1945–59* (Manchester: Manchester University Press, 1995), 101–2.

12. For more on Alloway's plans for the science-fiction lecture, see Alloway Papers, box 6, folder 10, and box 7, folder 1. For Alloway's early involvement in *This Is Tomorrow,* see Massey, *The Independent Group,* 98. In an essay published in 1990, Alloway notes that he gave two lectures on science fiction at the ICA—one in 1954, which is documented in his letters, and another in 1958, which Eugenie Tsai explains focused on "the uses of monsters in the mass media, including the 'ergonomic approach' found in technically slanted science fiction"; see Tsai, "The Sci-Fi Connection," 71. Alloway's 1954 science-fiction lecture was preceded by Eduardo Paolozzi's 1952 IG presentation of images taken from mass media and popular culture, including science-fiction book covers; see Tsai, "The Sci-Fi Connection," 71.

13. Press release for *This Is Tomorrow,* quoted in Graham Whitman, "Exhibitions," in David Robbins, ed., *The Independent Group: Postwar Britain and the Aesthetics of Plenty,* exh. cat. (Cambridge, Mass.: MIT Press, 1990), 135.

14. Whitman, "Exhibitions," 135.

15. Whitman, "Exhibitions," 135.

16. Lawrence Alloway, "The Robot and the Arts," *Art News and Review* 8, no. 16 (1 September 1956): 1.

17. Alloway, "The Robot and the Arts," 1.

18. Roger Luckhurst, *Science Fiction* (Cambridge, Mass.: Polity Press, 2005), 109.

19. Cover art article; unpublished essay and footnote in Alloway, "The Arts and the Mass Media."

20. For further discussion of Alloway's U.S. State Department trip, see the essay by Lobel, this volume.

21. Lawrence Alloway, "Retrospective Statement," in David Robbins, ed., *The Independent Group: Postwar Britain and the Aesthetics of Plenty,* exh. cat.

(Cambridge, Mass.: MIT Press, 1990), 187. The visits with Campbell and the art director and editor for *Mad* magazine were not the only departures from an otherwise art-centric itinerary. See note 23, below. Alloway also met with a sociologist from the University of Chicago and a rhetorician at the University of California at Berkeley. For more on the significance of these last two meetings, see Courtney J. Martin, "Art World, Network and Other Alloway Keywords," *Tate Papers,* no. 16 (1 October 2011), http://www.tate.org.uk/research/publications /tate-papers/art-world-network-and-other-alloway-keywords.

22. Lawrence Alloway to Sylvia Sleigh, 5 May [1958], Alloway Papers, box 7, folder 8.

23. Lawrence Alloway to Sylvia Sleigh, 30 April 1958, Alloway Papers, box 7, folder 8. Alloway also wrote an unpublished three-page essay on the valuable cultural work done by *Mad* magazine; see Lawrence Alloway, "On *MAD* Magazine," Alloway Papers, box 26, folder 45.

24. Lawrence Alloway, "Personal Statement," *ARK* 19 (1957), 28.

25. Stephen Moonie, "Mapping the Field: Lawrence Alloway's Art Criticism-as-Information," *Tate Papers,* no. 16 (1 October 2011), http://www.tate.org.uk /research/publications/tate-papers/mapping-field-lawrence-alloways-art -criticism-information.

26. Nigel Whiteley, *Art and Pluralism: Lawrence Alloway's Cultural Criticism* (Liverpool: Liverpool University Press, 2012), 63, 64.

27. Alloway, "Personal Statement," 28.

28. Lawrence Alloway, "Technology and Sex in Science Fiction: A Note on Cover Art," *ARK* 17 (Summer 1956): 19.

29. Alloway, "Technology and Sex in Science Fiction," 19.

30. Alloway, untitled, undated, and unpublished manuscript, Alloway Papers, box 26, folder 27, 3.

31. Alloway, "Technology and Sex in Science Fiction," 20.

32. Alloway, "Technology and Sex in Science Fiction," 23.

33. Alloway, "Technology and Sex in Science Fiction," 20.

34. Alloway, "Technology and Sex in Science Fiction," 20.

35. Press release, no. 123, 27 November 1968, Museum of Modern Art, New York, https://www.moma.org/momaorg/shared/pdfs/docs/press_archives/4149 /releases/MOMA_1968_July-December_0081.pdf?2010.

36. Lawrence Alloway, "Science Fiction and Artifacts: Science Fiction Is Global Thinking's Pop Culture," *Arts Magazine* 43, no. 3 (1968): 39.

37. Alloway, "Science Fiction and Artifacts," 39.

38. Alloway, "Science Fiction and Artifacts," 40.

39. Jennifer Mundy, in this volume, discusses Alloway's pedagogical practice—teaching students how to write art criticism—and Lucy Bradnock, also in this volume, points out that his film criticism often strove to instruct film writers on the correct way to watch and write about film. These points resonate with Alloway's attempt, in this article, to point out when others are creating science fiction without realizing it; see Alloway, "Science Fiction and Artifacts."

40. Alloway, "Personal Statement," 28.

41. The exhibition was organized by the Hood Museum of Art, Dartmouth College; the Institute of Contemporary Arts, London; the Museum of Contemporary Art

(MOCA), Los Angeles; and the University Art Museum, University of California at Berkeley. It opened at the ICA, then traveled to the Instituto Valenciano de Arte Moderno, Centro Julio Gonzalez, Valencia, Spain; then to MOCA; then to Berkeley; then to Dartmouth.

42. Alloway, "Retrospective Statement," 187.

43. This question is raised by Lucy Bradnock in a discussion of Alloway's strong preference for American film; see the essay by Bradnock, this volume.

44. Alloway, "Retrospective Statement," 187.

45. Luckhurst, *Science Fiction*, 119.

46. Brian M. Stableford, *Scientific Romance in Britain, 1890–1950* (New York: St. Martin's Press, 1985), 324–25.

47. Lawrence Alloway, "Image of Tomorrow on a Planet with You," unpaginated notes, Alloway Papers, box 26, folder 47.

48. Alloway, untitled, undated, and unpublished manuscript, Alloway Papers, box 26, folder 27, 9.

49. Alloway, untitled, undated, and unpublished manuscript, Alloway Papers, box 26, folder 27, 9.

50. Lawrence Alloway, "Monster Engineering," unpaginated notes, Alloway Papers, box 26, folder 47. The attribution of these notes to Alloway's 1954 IG lecture is based on their shared title. See also Lawrence Alloway, "Monster Films," in *Encounter* 14, no. 1 (1960): 70–72.

51. For more on Robert Smithson's connection to science fiction, see the essay by Sleeman, this volume; Robert Sobieszek, "Robert Smithson: Photo Works," in *Robert Smithson: Photo Works,* exh. cat. (Los Angeles: Los Angeles County Museum of Art; Albuquerque: University of New Mexico Press, 1993); and Tsai, "The Sci-Fi Connection."

52. The show was organized for the Musée des Arts Décoratifs, Paris, and traveled to Kunsthalle Bern, Switzerland.

53. Press release found in Harald Szeemann's project files, box 284, folder 3, dated 1967; handwritten notes from Szeemann's project files, "Science Fiction in the Museum," unpaginated, undated, box 284, folder 6; see Harald Szeemann Papers, Getty Research Institute, Los Angeles, acc. no. 2011.M.30.

54. Demetre Ioakimidis, "La littérature de l'âge de la science," in Harald Szeeman, *Science Fiction,* exh. cat. (Paris: Musée des Arts Décoratifs, 1967), 12–14.

55. The 1990s, the decade after Alloway's death, saw the emergence of a new academic field focused on the study of fans—enthusiastic followers and consumers of popular cultural production. The overlap between Alloway's concerns and those of fan studies is not extensive; however, the emerging field acknowledged—and in many cases was driven by—the work of the scholar-fan, or the "academic who also claims a fan identity," an apt description for the critical stance taken by Alloway decades earlier. Future work on Alloway's commitment to popular culture, and science fiction in particular, as an object of both entertainment and theoretical inquiry might find it productive to consider this evolving discourse. See Matt Hills, *Fan Cultures* (London: Routledge, 2002), 2.

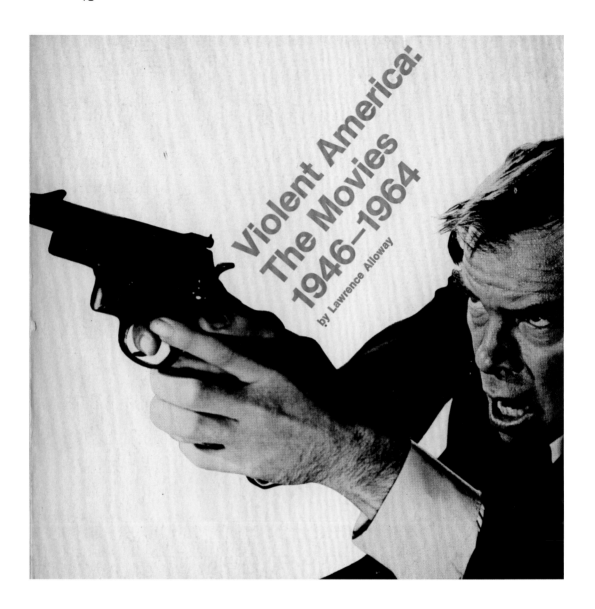

Fig. 1.
Cover of Lawrence Alloway's
book *Violent America:
The Movies, 1946–1964*,
published by the Museum of
Modern Art, New York, 1971.

LUCY BRADNOCK

CRITICISM AT THE FRONTIER
Lawrence Alloway at the Movies

A film viewed in a cinema is perceived as light in darkness and sound in silence in a place entered solely for that purpose. The film is overwhelming and suddenly it is gone.

—Lawrence Alloway, *Violent America: The Movies, 1946–1964,* 1971

In his 1971 book surveying American action movies, *Violent America: The Movies, 1946–1964,* Lawrence Alloway situated his iconography of heroes, villains, and gangsters, break-ins, shoot-outs, and last stands within the context of the quintessentially modern experience of moviegoing and the difficulty of grasping an inherently transitory art form (fig. 1). The question of how to account for the medium of film had long preoccupied him; more than a decade earlier, in 1960, he had indicated the stakes of this endeavor on *Third Programme,* a radio broadcast for the British Broadcasting Corporation (BBC), declaring that "films are unstoppable in their flow; they are hard to remember accurately, and you can't just turn back to a disputed passage."[1] Cinema, more than any other art form, demanded a new mode of critical engagement, one that could express its experiential peculiarities as well as its place in the social and cultural landscape.

Violent America grew out of a film series that Alloway organized at the Museum of Modern Art (MoMA), New York, from April to June 1969, under the title *The American Action Movie: 1946–1964.*[2] This program and the book represent the apogee of Alloway's work on film, but this was by no means his first foray into the subject. As early as 1954, he had organized screenings and discussions at the Institute of Contemporary Arts (ICA) in London, and he also published a handful of texts on film during that decade. Although little recognized in the scholarship on his critical and curatorial work, Alloway's writing on film was as crucial a part of his enterprise in the 1950s as it was at the beginning of the 1970s.[3] In post–World War II London, films represented Alloway's first exposure to American popular culture and contributed to shaping his view of the United States before he visited that country in 1958. As a topic for conversation and study, movies appear in a number of early sources,

including the correspondence Alloway exchanged with the artist Sylvia Sleigh, whom he would later marry; his 1951 notes for an unpublished book on film; articles, short texts, and opinion pieces, the earliest of which was published in 1950, though many more were never published; and radio broadcasts that he made for the BBC between 1955 and 1962. Even as Alloway forged a career as an art history lecturer and art critic, film was very much on his mind.

Films were the paradigmatic expression of the cultural vernacular that Alloway referred to as "pop art." Indeed, Alloway's insistence on using the term *movie* rather than *cinema*—attributing value to the mainstream commercial form over and above avant-garde filmmaking, and American over European production—is among the most strident early expressions of his pluralistic approach. Alloway's interest in film was not merely the result of a more general belief in the relevance and value of mass culture, however; rather, it was integral to his critical and intellectual formation. Significant similarities emerged between his writing on film and his studies of exhibitions and art world structures due to what he perceived as their common concern with audience experience and the dynamics of cultural production and dissemination. Thus, working through the methodological complexities of writing on the movies allowed Alloway to open up new possibilities for writing on art, just as the practices of art criticism and art history shaped his reading of film.

The Makings of a Film Critic

"The proper point of departure for a film critic who is going to write about the movies," Alloway emphasized in *Violent America*'s first chapter, "is membership in the large audience for whom they are intended."[4] Alloway's correspondence with Sleigh in the period between 1948 and 1954 reveals him to have been just such a member of that audience. Film appears as a central topic in his letters, ranging from passing mentions of those he had seen to full synopses and critical analyses. The letters reveal voracious viewing habits, with a particular predilection for westerns, science-fiction movies, Ealing comedies, and the films of Buster Keaton.[5] His preferred subject was mainstream movies, rather than alternative, experimental, or art cinema, and he upbraided other critics for fetishizing bohemianism. Despite his association with the Independent Group (IG), a collective of artists, architects, critics, and writers who were characterized by their interest in quotidian cultural phenomena, Alloway showed no enthusiasm for British experimental film groups such as Free Cinema, whose interest in documenting the everyday connected them to the IG. Although this might have aligned them with Alloway's beliefs also, their lack of commercial ambition and emphasis on the creative inspiration of the singular director did not.[6]

On several occasions during the first years of the 1950s, Alloway outlined numerous plans for writing and lecturing projects on the topic of film, and he began amassing a collection of film stills.[7] Among his papers are several short, typewritten texts that he had included in letters to Sleigh. While many of the texts focus on an individual film, they reflect an impulse to link particular examples with larger thematic concerns. For example, he writes to Sleigh that the three-page text on René Clément's *Jeux interdits* (1952; Forbidden games) that he included with one of his letters "could be part of an article on—say—Death in the Movies."[8] Other subjects mooted include war films, westerns, clothes and sex in the cinema, episodic films, portmanteau films, silent comedies of the 1920s, and Hollywood actresses.[9] Alloway published a handful of articles on film in different periodicals, including *World Review* (1950), *Living Cinema* (1957), *Encounter* (1960), *The Listener* (1961), *Movie* (1963), *Arts Magazine* (1966), *Art Voices* (1966), *West Side News* (1967), and *Vogue* (1968), but he would never write film criticism consistently for a single publication nor would his output in this field approach the quantity of his art criticism.

Nonetheless, it is clear that film criticism played a central role in Alloway's intellectual formation at this time. Indeed, in the early part of 1951, he embarked on writing a book on the subject of movies. In a letter written on 1 August that year, Alloway outlined a projected chapter structure for the book and reported that about a third of it was complete (though the manuscript does not survive among his papers).[10] The first two chapters concern crime films: "Key to the City" is a survey of the genre, while "D.O.A." analyzes the 1950 film noir of that name. Chapters three and four take westerns as their subject and utilize the same structure: a survey chapter, "The Iron Age," is followed by a case study on *Winchester '73* (1950). The outline indicates further chapters: "War Films" (again, a survey), *Orphée* (1950; Orpheus), and *Champagne for Caesar* (1950), as well as unfinished articles titled "Shadow on Sunset Boulevard" (on Hollywood actresses) and "The Tragic Bluff" (a study of Hollywood's "erasure of serious problems," as he had explained in an earlier letter, without further explication).[11] The outline indicates a tension, even at this early stage, between detailed analysis of individual films and the impulse to understand films thematically in groups. While the former might be considered the territory of the critic, the latter arguably indicates the job of the historian; characteristically, Alloway vacillated between the two.

Alloway's unpublished book on film, like the short critical pieces that he was sending to Sleigh, combined an iconography and iconology of the movies with a consideration of genres. On the one hand, Alloway self-consciously aligned his approach with Erwin Panofsky's study of iconography and iconology in Renaissance art, according to which analysis enables "insight into the

manner in which, under the varying historical conditions, specific *themes* or *concepts* were expressed by *objects* and *events*."[12] On the other hand, he was concerned with analyzing films across groups or cycles, identifying filmic typologies, devices, and structures in order to perceive patterns of change or development. Thus he wrote in 1951 that his interest in war films focused on "soldiers as 'things,' the theme of the quest," rather than the narrative or visual tendencies of any particular film or director.[13] His letters are peppered with classificatory terminology, including terms that define character types (such as "persecuted heroines"), describe cinematographic devices (such as the "psychic close-up"), and divide groups of films into types.[14] This strategy is developed in the 1958 essay "The Arts and the Mass Media," in which Alloway reiterates tropes that he had identified during the research for his earlier book project: "There have been cycles of psychological Westerns (complicated characters, both the heroes and the villains), anthropological Westerns (attentive to Indian rights and rites), weapon Westerns (Colt revolvers and repeating Winchesters as analogues of the present armament race)."[15] From the start, Alloway sought to develop a vocabulary that would allow him to describe film in structural terms and link its patterns to social and historical situations. In this vein, in a letter to Sleigh dated 29 August 1952, Alloway outlined his ideas on episodic films, in which a number of short, loosely connected storylines are presented in one picture. He divided this type into three categories: "the horizontal structure (*Dead of Night*), the vertical form (*Weekend at the Waldorf, Bank Holiday*) and the centripetal (*Quartet*)."[16] Although he offers little in the way of explanation regarding his reasons for defining each type, this early instinct to divide and classify would form the basis for his approach to film criticism throughout his career.

In the article "From Mickey to Magoo," published in *Living Cinema* in March 1957, Alloway set out the conditions for his method of film criticism, which celebrated the typical instead of the unique, and "collective folkloric elements" instead of "works of individualised artistry."[17] Citing Panofsky's description of films as "a product of genuine folk art," Alloway located in movies "primitive patterns of entertainment (legends, tall stories, joke routines)" that survived though they had disappeared in other art forms and revealed information about the broad scope of popular culture as it developed. "Movies are a popular art," he explained in the article "Critics in the Dark," "but not in the way that Mexican sugar skulls and paper dolls are pop art. The skulls and dolls, though expendable, have an unchanging ritual significance. The movies, on the contrary, are the index of a Baudelairean art of modern life."[18] Alloway's difficulty in pinning down the experience of viewing movies was, by his own account, analogous to Baudelaire's attempts to describe modern life,

characterized as "that which is ephemeral, fugitive, contingent upon the occasion."[19] The study of filmic trends could thus reveal important sociocultural conditions.

Alloway argued for the formulaic nature of most films, emphasizing that the designation was not meant in a derogatory sense. The role of the critic, one overlooked by most, he claimed in his seminar paper "The Styles and Problems of Film Criticism," delivered at Columbia University in 1964, was to discern and analyze "the formula and its modifications."[20] Changes in movie iconography reflected social shifts connected to specific historical events. Alloway used the example of prison movies, which he suggested were associated in the 1930s with the figure of the gangster but in the decades following World War II had been reevaluated in light of men's experiences in prisoner-of-war camps. According to this model, which favors the long view over the short and the collection over the singular work, movies "become not works of art, but records. They become historical documents."[21]

The Vernacular Gesamtkunstwerk

In seeking to chart "the formula and its modifications," Alloway chose the route of genre study over connoisseurship.[22] He treated film as a product of a complex network of factors, both structural and social, rather than the singular creative vision of its director or a self-contained aesthetic object. He emphasized the distribution of cultural responsibility across a number of roles and subject positions. Typical of Alloway's approach is his brief assessment of *The Bicycle Thieves* (1948; released in the United States as *The Bicycle Thief*) in a letter of 1951 that highlighted not only the film's structure ("imperfect") but also its sound track (likewise), camerawork ("sometimes good"), and editing (room for improvement).[23] He frequently named those besides the director who worked on a film, including writers, producers, special-effects engineers, set and costume designers, and sound engineers, even though these names would not have been familiar to his nonspecialist audience. Alloway saw a film as a collaboration involving a number of agents. "Every movie," according to Alloway in a 1960 broadcast, "even a shabby, small-screen, black-and-white old B movie is Wagnerian, an aggregate art form, like opera."[24] For Alloway, film was a "vernacular gesamtkunstwerk" (or total artwork).[25] This set him in deliberate opposition to the dominant branch of film criticism, which privileged auteurism, the creative endeavor of a single author ("some gifted man expressing himself personally," as Alloway dismissively put it).[26]

Alloway adopted a self-conscious position with respect to other film critics, reflecting on their stance as well as his own. Indeed, his writing often

approaches the status of meta-criticism, since it is as often concerned with the processes, pitfalls, and pretensions of film criticism as it is with film. He railed against the "barren and banal field" of contemporary criticism, reserving particular ire for *Sight & Sound* magazine and *Monthly Film Bulletin,* both published by the British Film Institute.[27] In his Columbia seminar paper, he again disparaged those "serious" film critics "infatuated with the notion of personal authorship."[28] His disapproval of these critics rested on a number of accusations: they were bound by a set of critical tools inherited from fine art but unsuitable for the new technologies of film; they exercised an "irrational expertise" that belied the popular nature of movies; they displayed an unreasonable bias against commercially successful films; and finally, perhaps worst of all in Alloway's opinion, some of them were tempted to become directors themselves.[29]

However, given his own invocation of Baudelaire, Panofsky, and Wagner, it seems that Alloway did not object to recourse to the language of high art per se. Rather, it was the uses to which other critics put this language that offended him. He criticized what he termed the "semantically mysterious criteria—Truth, Beauty, Reality, and the Moving—acquired from the aesthetics of literature and art."[30] He complained, furthermore, that such language is dispatched in the service of the canon, according to which critics seek to establish "a hierarchy of Master Works."[31] He emphasized the point in "Critics in the Dark," asserting that "the connection between movies and art (or literature) is rarely taken beyond a search for creative individuals and their masterpieces. Serious comparative studies of movies and other arts are so rare that one can only suppose that film critics want merely the prestige that belongs to painting and literature."[32] Seriousness is mobilized as both a failing and a virtue: the former when it obscures the popular experience of moviegoing with elitist terminology, the latter when it identifies the informed lay viewer as a member of an engaged collective audience.

Alloway's stance drew criticism from the likes of leading film critics Andrew Sarris and Pauline Kael. Sarris accused Alloway (simplistically, as Peter Stanfield has noted) of fetishizing "badness and banality" at the expense of formal excellence.[33] Kael's antagonistic response to Alloway's position in the introduction to her 1965 anthology *I Lost It at the Movies* makes explicit mention of his article "Critics in the Dark"; she accuses Alloway of both condescension toward cinema in his identification of movies as pop art and a lack of enthusiasm in his refusal to be moved by singular works of cinematic art.[34] Despite drawing such criticism, Alloway's methodology appears strikingly prescient in its rejection of the creative intent of the auteur in favor of the complex matrices of films' production and distribution.

Fig. 2.
Composite photograph
advertising Universal
International's *Wings of
the Hawk*, 1953.

Discussions of developing film technologies—including Smell-O-Vision
and 3-D, as well as the CinemaScope, Cinerama, Dynamation, Todd-AO, and
VistaVision wide-screen formats—in Alloway's early writing on film served to
divert attention further from singular authorship, establishing instead a field of
cultural production driven by industrial production.[35] A spectacular composite
photograph advertising Universal International's 3-D film *Wings of the Hawk*
(1953) illustrates the personal statement that Alloway published in the Royal
College of Art magazine *ARK* in 1957 (fig. 2); the caption indicates the potential
of technological innovation in the movies to effect the "breakdown of the con-
ventional limits between the consumer and the symbol."[36] Alloway's attention
is focused on technology's ability to alter audience experience by immersing the
viewer in a stream of visual symbols through the physical and psychic merging
of the realms of the audience and the film.

At the same time, Alloway approached exhibition display in similar terms,
investigating, along with his IG peers, the capacity of the installation to physi-
cally immerse and actively engage the viewer. The experimental installation
of the exhibition *This Is Tomorrow*, organized at the Whitechapel Art Gallery
in 1956, is a prime example, with its creation of sensory overload via an over-
abundance of signification. Overlapping images jostled for attention with film,
music, found sound, and olfactory effects. Alloway described the installation
as "a lesson in spectatorship," in which "the visitor is exposed to space, effects,
play with signs, [and] a wide range of materials and structures" that combined
to present "a many-channelled activity."[37] In the exhibition pamphlet for *an*

Fig. 3.
an Exhibit, Hatton Gallery,
Newcastle upon Tyne, 1957.
Photo: Richard Hamilton.

Exhibit, organized in collaboration with Richard Hamilton and Victor Pasmore at the Hatton Gallery, Newcastle, and the ICA, London, in 1957, Alloway wrote that the exhibition's radical modular installation of suspended panels aimed "to make a drama of space that involves the spectator" (fig. 3).[38] In art, as in film, Alloway envisioned the viewer as an active participant mobilized by modern design technology.

If *This Is Tomorrow* was inspired by Alloway's love of science fiction in particular, then *an Exhibit* arguably reflected his interest in the kinds of visual, technological, and experiential innovations that he identified in the movies more generally.[39] His writings on film and art insist on both the collaborative creative endeavor and an active viewer, whose experience is shaped by technological and spatial frameworks. There are clear parallels between the film industry advertisement reproduced in *ARK* and the experimental spatial configurations of *an Exhibit:* both involve the radical penetration of the viewer's space by technological means. Indeed, it is in his concern with the conceptual implications of display and the organizational structures of exhibition making that the similarities between Alloway's writing on art and his film criticism are especially apparent.

Alloway's critical attitude was further manifested in explicit references to movie advertising and the functions and politics of the film industry's star and awards systems.[40] His interest in the Hollywood star system, "which fans and sociologists, but not film critics, write about," is another such case (and one

that places him, ostensibly, in the fan and sociologist categories rather than in only the latter one).[41] A chapter of his unpublished 1951 film book had been devoted to the iconography of actresses, and he wrote a number of articles (some unpublished) that also address this subject, along with the cult of celebrity. He merged a more straightforwardly art historical iconography of actors and actresses with other forms of source material specific to the film industry and vernacular culture more widely. An unpublished 1950 text on the subject of the "beefcake" focuses on an article in an erotic magazine in which "Hollywood lovelies" are asked to assess a bodily phenomenon constructed by and for publicity.[42] Alloway writes about a magazine printing an article about film stars who muse on the typologies of the celebrity culture in which they participate by means of magazines. For a supposedly lighthearted piece written at an early moment in Alloway's career, it is remarkably self-conscious. In it, Alloway appears to stage the mise en abyme of not only celebrity culture but also criticism itself, by virtue of its complicity in the cycle of communication.

A 1960 broadcast extended his concern with the power structures that operate within the film industry by means of a somewhat skeptical discussion of the annual awards of the Society of Film and Television Arts, "the prizes which senior film-makers give to one another."[43] Alloway is interested, however, not in the winners but in the purpose of the awards system in furthering professionalization and conferring status on the industry as a whole, ultimately functioning as "a form of prestige advertising for a rich but insecure profession."[44] As evidence of this, he offers the example of the award for "the Best Film illustrating one or more of the principles of the United Nations Charter," an association that offers the British Academy "another source of prestige, another proof of seriousness, another badge of dignity."[45] Visual culture, politics, and society are equally implicated in this model of industry superstructure, which reveals much more than the quality of a particular film, but only in the hands of the perceptive (serious) critic.

Just as Alloway's writing on film culminated with *Violent America,* so too did his writing on exhibitions culminate with his 1968 book *The Venice Biennale 1895–1968: From Salon to Goldfish Bowl,* in which he considered the biennial's role in the network of cultural distribution that embedded artworks in a communication system.[46] Explicit in his approach is the criticism that works of art have tended to be treated as separate from "the competitive area of fairs and shows" and as "symbols of permanence rather than as complex structures subject to numerous interpretations."[47] In a maneuver that echoes his earlier reference to Baudelairean modernity, Alloway argues for the artwork as dependent upon the contemporary conditions of its display and dissemination, just as he had argued for the movie as only momentarily relevant.

Alloway's writing on film, like his writing on art, was informed by the assumption that works (whether movies or works of art) both reflect and are shaped by the superstructure of the industry itself, from which they cannot be separated. His account of the film industry anticipated the increasingly political attention that he would pay to the network of roles that constituted the art world in the 1970s, according to which he conceived of the artist as an agent, the work of art as a product, and the gallery in terms of distribution.[48] This strategy necessitated, to a certain extent, an informed understanding of the industry's inner workings, and Alloway read assiduously to keep abreast of contemporary theoretical and critical writing on film. Inevitably, his attempt to reconcile this "insider" knowledge with the lay status of a regular moviegoer raised the potential for ambivalence, a condition that he articulated explicitly in *Violent America:*

> The films treated in this book are largely the movies I saw as a consumer, paying for my seat, and any aesthetic that emerges should, in my opinion, hold onto its critical source in the original act of moviegoing. The critical notions to be discussed are not those I had as a regular, not to say compulsive, moviegoer, but I do not want to lose that early feeling, the capacity for identification, that made me see *I Walk Alone* several times when it was first released.[49]

Alloway's solution to the quandary of complicity was to attempt to occupy both positions simultaneously, using each to expand the potential of the other. His task was akin to that of the cultural whistle-blower, learning the tricks of the trade in order to reveal the hidden structures of a largely secretive industry, while never being part of that industry (as arguably he was in the art industry through his occupation as a curator).

Alloway was attuned to the potential ethical quandary faced by the film critic, who runs the risk of perpetuating the aesthetic and economic hierarchies of the film industry. In a 1956 broadcast, he contrasted the critical reception of low-budget "quickie" movies, which are rarely given press screenings, with those "expensive, efficient feature films" from Paramount, Universal, Metro-Goldwyn-Mayer, and other large studios that often presented a preview screening for film critics.[50] The topic of press previews had arisen in Alloway's letters to Sleigh on a number of occasions, revealing an element of anxiety concerning their ethical and intellectual implications. In a letter dated 21 December 1952, Alloway, ever conscious of his own position, included a drawing of his avatar "Dandy Lion" in the role of film critic (fig. 4). This curious quadripartite sketch depicts Alloway/Dandy Lion in turn pensive, skeptical, transfixed, and absent.

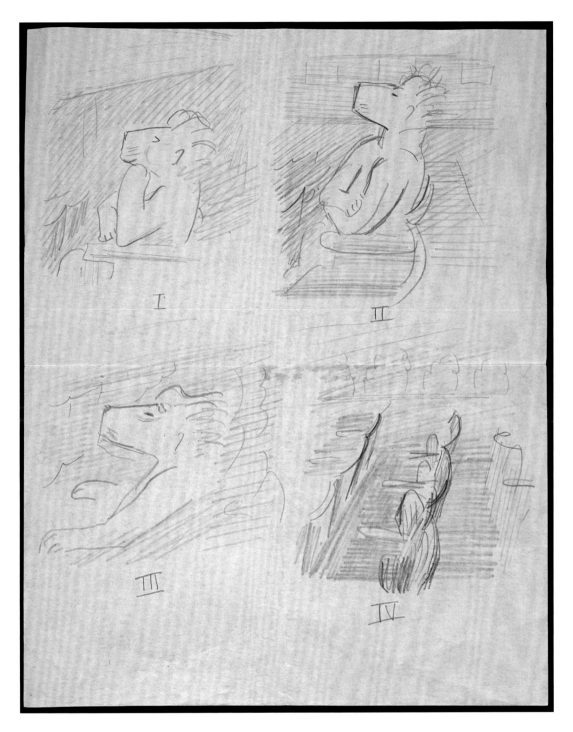

Fig. 4.
Dandy as a Film Critic, sketch,
from a letter by Lawrence
Alloway to Sylvia Sleigh,
21 December 1952.
Los Angeles, Getty Research
Institute.

The critic is portrayed as a lone viewer, divorced from the crowd, a position emphasized by the row of empty seats in the final panel. Since film is an index of the fleeting experience of modern life, then solitariness might prevent an effective recording of it. Alloway experienced both viewing scenarios—in the crowd and apart from it—in quick succession: a letter dated 24 December 1952 includes the lines: "The short happy life of a film critic. I shall be seeing my films in the evenings again with the masses, not in the mornings. Just call me John Q. Public. *Playbill* is stopping publication, after all."[51] He would later suggest, albeit somewhat facetiously, though surely with his own limited experience as a professional critic in mind, the abolition of press previews so that critics would "have to go to movies with real people."[52]

The Sociology of the Foyer

The opening lines of Alloway's 1971 essay "Anthropology and Art Criticism" invoke the art critic Roger Fry's indignant reaction to the stylistic mishmash of decor in an English railroad café. The room's mass-produced elements, Fry complained in 1912, "merely reflect the average citizen's soul."[53] The defense of that environment mounted by Alloway almost six decades later was motivated by his interest in mass-produced and reproducible cultural forms, as well as his ambition to collapse the distinction between high and low culture. More than this, however, it hinged on the status of such spaces as the railroad café as the embodiment of "the acceptable, expendable, and continuous public environment," in which cultural and artistic production is inevitably implicated.[54] The hypersymbolic ambience of Fry's gaudy railroad café appealed to Alloway by virtue of its similarity to other iconographically rich, quotidian sites, including "an airport check-in counter or a movie theatre foyer."[55]

If Fry encountered his aesthetic bête noire in the railroad café, then Alloway's aesthetic stance might be linked to an equally vernacular setting several decades before the publication of his "Anthropology" essay: that "masterpiece of pleasure architecture," the Granada cinema, in Tooting, south London, in which an Italianate exterior and an ornate neo-Gothic interior represent a striking coexistence of styles (figs. 5, 6).[56] Alloway's description of the Granada in a BBC broadcast would have made Fry shudder: "Under a curved, foliated ceiling, behind a golden screen of Gothic arches, stretches a spectacular vista of mirrors. Canned music plays at all times. The Granada was built in the 30s when leisurely access to vaulted auditoria through palatial foyers was apt to the confident industry."[57] Whether through such celebration of the exotic architectural pastiche of the Granada or via his accounts of its more streamlined modernist competitors, Alloway's broadcast painted a vivid picture of British

Fig. 5.
Granada cinema, Tooting,
London, exterior, ca. 1931.

Fig. 6.
Granada cinema, Tooting,
London, auditorium interior,
1971.

suburbia. He acknowledged the fraught status of much vernacular design but found cultural value in it nonetheless, once again treading that fine line between historian and fan. His gleeful assessment that the Lewisham Gaumont was "hideous, but it has a tiny accent of poignancy and pure history already," suggests that his enthusiasm for these buildings was based not on aesthetic preferences but on their value as historical documents.[58] Like films, the buildings that housed them operated for Alloway as important sociocultural markers.

The cinema foyer represented more than a populist merging of architectural styles, however; it was also significant as a cultural and social sphere, especially in the austere climate of post–World War II Britain, when, as Martin Cohen has noted, the cinema offered both the practical comforts of a heated auditorium and the psychological escape provided by tales of faraway places.[59] In line with the IG's fascination with mass-produced popular culture, the movie theater represented for Alloway a crucial site of human and aesthetic discovery. In the house styles of Granadas, Odeons, and Gaumonts, Alloway discerned the modern vernacular that shored up suburban development and shaped everyday life. The incorporation of other businesses into buildings that housed movie theaters—"hairdressers, jewellers, or stationers are slotted into the main body, like shops in an ocean liner"—embedded moviegoing into the continuous stream of quotidian pursuits.[60] Alloway's epic simile undercuts the banality of his description of the Morden Odeon, which occupies the same architectural complex as the underground station, the pub, and that bastion of the British suburban town center, Woolworths.[61] Such sites made manifest the spatial, temporal, and ethical inseparability of culture and everyday life, even as cinema audiences in Britain were declining.[62]

At a lecture delivered at Massachusetts Institute of Technology in 1972, Alloway theorized his approach by connecting the study of movies to the "sociology of everyday life." He also cited Ferdinand de Saussure's science of semiology, which aimed to study "the life of signs in the context of social life."[63] Thus, the community of users dictated the meaning of movies at least as much as, if not more than, the individual vision of the director. "Like pubs, amusement arcades, and theatres," Alloway had declared on the BBC in 1961, "cinemas require the acts of their occupants to complete them. Empty theatres, pubs, and cinemas are disconsolate and pointless, whereas palaces and cathedrals often look as good empty as they do inhabited."[64] For Alloway, exhibitions were similarly pregnant sites, filled with signs and symbols but waiting to be populated by active viewers, "a ceremony completed by the participation of all visitors," as he had written in the catalog of an Exhibit.[65]

While Alloway aligned his methodology with semiology, his work on film was also informed by sociology and anthropology.[66] During his research for

the MoMA film program, he consulted a number of sources from the social and natural sciences on topics that included territoriality and communication systems, aggression and its regulation, and social violence in the technological age.[67] His approach to the movies as complex, socially defined systems of signification was informed in particular by the writings of the Columbia University sociologist Herbert J. Gans, whose work was devoted to a sociological study of the role of popular culture in American society. Alloway read a number of Gans's essays and encountered several mutual concerns, including an interest in patterns discernible across cycles of mainstream films, the use of individual films to support observations of trends and shifts, and a conception of the film's "creator" as multifaceted.[68]

Gans also turned his attention toward audience expectation and experience, proposing a model of the mass culture audience as active agent whose response not only indicated movies' reception but also, through its anticipated desires and preferences, shaped movies' production. Crucially for Alloway, Gans understood the audience not as an undifferentiated entity, but rather as heterogeneous and diversified, comprising overlapping groups with individual concerns, a position that Alloway had expressed in his 1959 essay "The Long Front of Culture" and would reiterate, citing Gans, in *Violent America*.[69] Recognizing the audience as diverse and specialized allowed for the social function of movies to be equally varied. Subscribing to Gans's model of the audience as active meant acknowledging its potential to effect transformation not only at the level of anticipated feedback (per Gans) or individual consumer choice ("The Long Front") but also, as Alloway would increasingly come to recognize, through politicized action, bringing about cultural and social change.[70]

Studying Movies

Speaking at the annual meeting of the College Art Association in 1973, Alloway hailed the recent inclusion of film among the conference's topics as signaling a disciplinary shift that extended the boundaries of art history in order to accommodate an art form newly acknowledged as relevant.[71] Alloway's film writing had from the outset reflected his interest in the relationship between film criticism, art criticism, and art history; notes among his papers titled "Film and the Art Critic" and "Film and Art History" attest to his concern with disciplinary overlap. Alloway described film in the specialist terminology of art history and demonstrated a working knowledge of theoretical writing on film, while at the same time asserting his credentials as a film enthusiast first and foremost. Indeed, he distinguished his endeavor from that of intellectual film critics and popular fan magazines alike, on the grounds that they fetishized directors and

stars, respectively. Most of all, he demonstrated an ongoing concern with the public sphere of the movies, returning often to the subject of the crowd versus the elite critic, especially questions about the nature of the audience, the role of the film critic, and his own ambivalent position as both, or perhaps neither.

Alloway's film criticism is as much about criticism as it is about film, and it had a mutually informative relationship with his art criticism. His adamant use of the term *movies* instead of *cinema* reflected more than the admiration of a young Englishman for American popular culture; it reveals his methodology as well as his subject matter. *Cinema* was susceptible to being rendered as a series of masterpieces by serious critics blind to their historical obsolescence; *movies* signified a broad field that extended beyond the singular work to encompass the structures of production and distribution, as well as the encounter between the work and its audience that occurs in the public sphere. Movies existed in a heterogeneous space that epitomized Alloway's model of the cultural continuum; their status as indices of the transitory modern world demanded a negotiation of the boundaries between history and contemporaneity that would increasingly inform Alloway's art criticism. The challenges that Alloway tackled in writing on film would be those that he embraced in his investigation of other cultural fields—as he said, to capture in words that which was overwhelming and suddenly gone.

Notes

I should like to thank the Getty Research Institute for supporting this research; my coeditors, Courtney J. Martin and Rebecca Peabody; the other researchers who worked on the project *Lawrence Alloway: Critic and Curator;* Peter Stanfield; and the organizers of and participants in the workshop "Criticism and Curating: The Productive Lawrence Alloway" at Tate Britain, London, in 2013.

 Epigraph: Lawrence Alloway, *Violent America: The Movies, 1946–1964* (New York: Museum of Modern Art, 1971), 29.

1. Lawrence Alloway, "On the 'Oxford Opinion,'" transcript of *Third Programme,* BBC radio broadcast, 15 December 1960, Lawrence Alloway Papers, Getty Research Institute, Los Angeles, acc. no. 2003.M.46, box 14, folder 7, 2.

2. Although the film program began as a collaboration with Toby Mussman and Robert Smithson, both Mussman and Smithson dropped out of the project before it reached its conclusion; see the essay by Sleeman, this volume.

3. See Christine Gledhill, "Genre," in Pam Cook, ed., *The Cinema Book* (London: British Film Institute, 1985), 58–63; Steve Neale, *Genre and Hollywood* (London: Routledge, 1999), 9–12; and Peter Stanfield, "Maximum Movies: Lawrence Alloway's Pop Art Film Criticism," *Screen* 49, no. 2 (Summer 2008): 179–93. There are two notable exceptions: Nigel Whiteley, who includes film in his account of the range of Alloway's interests in the early 1950s, see Whiteley, *Art and Pluralism: Lawrence Alloway's Cultural Criticism* (Liverpool: Liverpool University Press, 2012), 23; and Anne Massey, who devotes a chapter to the importance of film for

the IG, including Alloway; see Massey, *Out of the Ivory Tower: The Independent Group and Popular Culture* (Manchester: Manchester University Press, 2013), 92–109.

4. Alloway, *Violent America,* 19.

5. Ealing comedies were films produced by the Ealing Studios, London, between 1947 and 1957.

6. See Erik Hedling, "Lindsay Anderson: *Sequence* and the Rise of Auteurism in 1950s Britain," in Ian MacKillop and Neil Sinyard, eds., *British Cinema of the 1950s: A Celebration* (Manchester: Manchester University Press, 2003), 23–31; Claude Lichtenstein and Thomas Schregenberger, eds., *As Found: The Discovery of the Ordinary* (Zurich: Lars Müller, 2001); and Massey, *Out of the Ivory Tower,* 92, 101.

7. Lawrence Alloway to Sylvia Sleigh, early November 1953 and 26 November 1953, Alloway Papers, box 6, folder 11.

8. Lawrence Alloway to Sylvia Sleigh, 1 February 1953, Alloway Papers, box 6, folder 4.

9. Lawrence Alloway to Sylvia Sleigh, 15 July 1951, Alloway Papers, box 4, folder 7; Lawrence Alloway to Sylvia Sleigh, 2 March 1952, Alloway Papers, box 5, folder 3; Lawrence Alloway to Sylvia Sleigh, 14 July 1952, Alloway Papers, box 5, folder 7; Lawrence Alloway to Sylvia Sleigh, 23 June 1952, Alloway Papers, box 5, folder 6; Lawrence Alloway to Sylvia Sleigh, 29 August 1952, Alloway Papers, box 5, folder 8, 2; Lawrence Alloway to Sylvia Sleigh, 6 April 1953, Alloway Papers, box 6, folder 4; and Lawrence Alloway to Sylvia Sleigh, 22 June 1953, Alloway Papers, box 6, folder 6.

10. Lawrence Alloway to Sylvia Sleigh, 1 August 1951, Alloway Papers, box 4, folder 8.

11. Lawrence Alloway to Sylvia Sleigh, 1 August 1951, Alloway Papers, box 4, folder 8; and Lawrence Alloway to Sylvia Sleigh, 26 June 1951, Alloway Papers, box 4, folder 6.

12. Erwin Panofsky, "Iconography and Iconology: An Introduction to the Study of Renaissance Art," in idem, *Meaning in the Visual Arts: Papers in and on Art History* (Garden City, N.Y.: Doubleday, 1955), 38, quoted in Lawrence Alloway, "On the Iconography of the Movies," *Movie* 7 (February 1963): 16.

13. Lawrence Alloway to Sylvia Sleigh, 28 September 1951, Alloway Papers, box 4, folder 9.

14. Lawrence Alloway to Sylvia Sleigh, 19 June 1953, Alloway Papers, box 6, folder 6; and Lawrence Alloway to Sylvia Sleigh, 21 October 1952, Alloway Papers, box 5, folder 10.

15. Lawrence Alloway, "The Arts and the Mass Media," *Architectural Design* 28, no. 2 (February 1958): 84–85, reprinted in idem, *Imagining the Present: Context, Content, and the Role of the Critic,* ed. Richard Kalina (London: Routledge, 2006), 55–59, 56.

16. Lawrence Alloway to Sylvia Sleigh, 29 August 1952, Alloway Papers, box 5, folder 8, 2.

17. Lawrence Alloway, "From Mickey to Magoo," *Living Cinema* 1, no. 3 (March 1957): 146.

18. Lawrence Alloway, "Critics in the Dark," *Encounter* 22, no. 2 (1964): 51.

19. Charles Baudelaire, "The Painter of Modern Life" (1859), quoted in Alloway, "Critics in the Dark," 51.

20. Lawrence Alloway, "The Styles and Problems of Film Criticism," unpublished transcript of a talk delivered as part of the Seminar on Public Communications, Columbia University, 8 May 1964, Alloway Papers, box 14, folder 8, 5.

21. Alloway, "The Styles and Problems of Film Criticism," 4.

22. Alloway, "The Styles and Problems of Film Criticism," 5.

23. Lawrence Alloway to Sylvia Sleigh, 25 April 1951, Alloway Papers, box 4, folder 4.

24. Alloway, "On the 'Oxford Opinion,'" 2.

25. Alloway, "Film and Art History," unpublished manuscript, Alloway Papers, box 27, folder 22.

26. Alloway, "The Styles and Problems of Film Criticism," 5.

27. Alloway, "On the 'Oxford Opinion.'"

28. Alloway, "The Styles and Problems of Film Criticism," 1.

29. Alloway, "The Styles and Problems of Film Criticism."

30. Alloway, "From Mickey to Magoo," 146.

31. Alloway, "From Mickey to Magoo," 146.

32. Alloway, "Critics in the Dark," 52–53.

33. Stanfield, "Maximum Movies," 183. See also Peter Stanfield, "Regular Novelties: Lawrence Alloway's Film Criticism," *Tate Papers* 16 (1 October 2011), http://www.tate.org.uk/research/publications/tate-papers /regular-novelties-lawrence-alloways-film-criticism.

34. Pauline Kael, *I Lost It at the Movies* (Boston: Little Brown, 1965), 26–27.

35. Lawrence Alloway, "The House of Bamboo," transcript of *Third Programme,* BBC radio broadcast, 20 October 1955, Alloway Papers, box 14, folder 7; Lawrence Alloway to Sylvia Sleigh, May 1958, Alloway Papers, box 7, folder 8; and Lawrence Alloway, "On the New Technical Process Dynamation in the Film 'The Seventh Voyage of Sinbad,'" transcript of *Third Programme,* BBC radio broadcast, 20 October 1955, Alloway Papers, box 14, folder 7.

36. Lawrence Alloway, "Personal Statement," *ARK* 19 (1957): 28.

37. Lawrence Alloway, introduction to *This Is Tomorrow,* exh. cat. (London: Whitechapel Art Gallery, 1956).

38. Lawrence Alloway, *an Exhibit,* exh. pamphlet (London: Institute of Contemporary Arts, 1957), n.p.

39. See the essay by Peabody, this volume.

40. In a 1967 article in the *West Side News,* Alloway claimed that "as a rule, the best guide to a movie is the advertisements for it. By their appearance, wording, frequency, size, placing, shall you know the film better than by reading critics or believing your friends"; see Lawrence Alloway, "Pretense and 'Privilege,'" in *West Side News,* 31 August 1967, 5–6, 5.

41. Alloway, "On the Iconography of the Movies," 16–18, 16.

42. Lawrence Alloway, untitled text on the "beefcake," 1950, Alloway Papers, box 5, folder 12.

43. Lawrence Alloway, "On the British Film Academy Awards of the Society of Film and Television Arts," unpublished script for *Third Programme,* BBC radio broadcast, 24 March 1960, Alloway Papers, box 14, folder 7, 1. Alloway's title conflates

the British Film Academy (est. 1947) and its later nomenclature, the Society of Film and Television Arts, so designated following its merger in 1958 with the Guild of Television Producers and Directors. In 1976, it was renamed the British Academy of Film and Television Arts (BAFTA).

44. Alloway, "On the British Film Academy Awards," 2.

45. Alloway, "On the British Film Academy Awards," 4.

46. Lawrence Alloway, *The Venice Biennale 1895–1968: From Salon to Goldfish Bowl* (Greenwich, Conn.: New York Graphic Society; London: Faber & Faber, 1968).

47. Alloway, *The Venice Biennale,* 13.

48. Lawrence Alloway, "Notes on Art Criticism," unpublished manuscript, 1979, Alloway Papers, box 27, folder 9. See also Lawrence Alloway, "Art and the Communication Network," in *Canadian Art,* June 1966, 35–37; and Lawrence Alloway, "Network: The Art World Described as a System," *Artforum* 11, no. 1 (September 1972): 28–32.

49. Alloway, *Violent America,* 12.

50. Lawrence Alloway, "Forbidden Planet," transcript of *Third Programme,* BBC radio broadcast, 12 July 1956, Alloway Papers, box 14, folder 7, 1.

51. Lawrence Alloway to Sylvia Sleigh, 24 December 1952, Alloway Papers, box 5, folder 12.

52. Alloway, "The Styles and Problems of Film Criticism," 7.

53. Lawrence Alloway, "Anthropology and Art Criticism," *Arts Magazine,* 45, no. 4 (February 1971): 22–23, reprinted in idem, *Imagining the Present: Context, Content, and the Role of the Critic,* ed. Richard Kalina (London: Routledge, 2006), 171–76.

54. Alloway, "Anthropology and Art Criticism," 171.

55. Alloway, "Anthropology and Art Criticism," 171.

56. Alloway, "On Cinema Architecture," transcript of *Third Programme,* BBC radio broadcast, 14 June 1961, Alloway Papers, box 14, folder 7, 1. See also Lawrence Alloway, "Architecture and the Modern Cinema," *The Listener,* 22 June 1961, 1085–86. The Granada Tooting was built in 1931 to a design by the architect Cecil Audrey Masey. Its interior was designed by the Russian theatrical set designer Theodore Komisarjevsky, with ornate plasterwork by Clark & Fenn. It ceased operating as a cinema in 1973. See Allen Eyles, *The Granada Theatres* (London: British Film Institute, 1999). In 2000, the building was granted Grade 1 listed status by English Heritage.

57. Alloway, "On Cinema Architecture," 1.

58. Lawrence Alloway to Sylvia Sleigh, 30 October 1953, Alloway Papers, box 6, folder 10.

59. Martin Cohen, *The Eclipse of "Elegant Economy": The Impact of the Second World War on Attitudes to Personal Finance in Britain* (Farnham, Surrey: Ashgate, 2012), 134. See also Christine Geraghty, *British Cinema in the Fifties: Gender, Genre, and the "New Look"* (London: Routledge, 2002), 4–11.

60. Alloway, "On Cinema Architecture," 2.

61. Alloway, "On Cinema Architecture," 2.

62. Geraghty, *British Cinema in the Fifties,* 6.

63. Lawrence Alloway, unpublished notes for a talk delivered at MIT, 1972, Alloway Papers, box 14, folder 15.

64. Alloway, "On Cinema Architecture," 4.

65. Alloway, *an Exhibit.*

66. On the Independent Group's anthropological affinity, see Catherine Spencer, "The Independent Group's 'Anthropology of Ourselves,'" *Art History* 35, no. 2 (April 2012): 314–35.

67. Alloway's archive contains copies of Edward T. Hall, "Territorial Needs and Limits," *Natural History* 74 (December 1965): 12–19, reprinted in Marston Bates, *Field Studies in Natural History* (Cincinnati: Van Nostrand Reinhold, 1970), 141–52; and Marshall F. Gilula and David N. Daniels, "Violence and Man's Struggle to Adapt," *Science* 164, no. 3878 (25 April 1969): 396–405.

68. Articles and papers by Gans among Alloway's papers include "The Creator-Audience Relationship in the Mass Media: An Analysis of Movie Making," in Bernard Rosenberg and David M. White, eds., *Mass Culture: The Popular Arts in America* (New York: Free Press of Glencoe, 1957), 315–24; "The Relationship between the Movies and the Public and Some Implications for Movie Criticism and Movie-Making," paper delivered at the Annenberg School of Communications course The Mass Media Today, University of Pennsylvania, 18 February 1960; "Pluralist Aesthetics and Subcultural Programming: A Proposal for Cultural Democracy in the Mass Media," *Studies in Public Communication* 3 (1961): 27–35; "Popular Culture in America: Social Problem in a Mass Society; or, Social Asset in a Pluralist Society" (inscribed "sent with best wishes, Herb"); and "Changes in Hollywood Films and the American Audience," *Social Problems* 11, no. 4 (Spring 1964): 327–36. Gans delivered "Changes in Hollywood Films" at the annual meeting of the American Sociological Association, Los Angeles, 28 August 1963, and Alloway obtained a copy of that paper prior to its publication.

69. Lawrence Alloway, "The Long Front of Culture," *Cambridge Opinion* 17 (1959): 24–26, reprinted in idem, *Imagining the Present: Context, Content, and the Role of the Critic,* ed. Richard Kalina (London: Routledge, 2006), 61–64; and Alloway, *Violent America,* 19.

70. See the essay by Bryan-Wilson, this volume.

71. Lawrence Alloway, paper delivered at the College Art Association annual conference, 24 January 1973, Alloway Papers, box 27, folder 10.

MICHAEL LOBEL

"SPATIAL DISORIENTATION PATTERNS"
Lawrence Alloway, Curating, and the Global Turn

The following is the full text of a memorandum written by Lawrence Alloway to Thomas Messer, then director of the Solomon R. Guggenheim Museum, New York, in the summer of 1962:

8/8/62
TO: TMM
FROM: LA

My chair and my desk are of antagonistic heights. As presently arranged, I am sitting too low for the writing surface of the desk. Your present chair, as I checked (sneakily) in your absence, is higher and, therefore, satisfies ergonomic requirements in relation to the desk. Will the chair be coming my way soon, before I develop all kinds of distorted muscles and spatial disorientation patterns, or should I get the desk sawed down a couple of inches?[1]

This memo, filed along with others Alloway wrote during his stint as a curator at the Guggenheim (fig. 1), made me chuckle when I came across it in the museum's archives. Considering that he was just a couple of months into his new job (he had started in June, after finishing a year of teaching at Bennington College in Vermont), its sheer cheek is rather surprising, whether in the mischievous admission that he had snuck into the director's office to check the height of his chair, or in his mock threat to saw his own desk down to size. Clearly, he was not working too hard to ingratiate himself with his new boss.

Although the memo may seem nothing more than a trifle, a humorous memento of Alloway's time at the Guggenheim, I am struck by his mention of the "spatial disorientation patterns" that he warns he will suffer if the situation is not addressed soon. It may be that his office furniture was inadequate; however, one cannot help but imagine that his complaints also functioned as a broader metaphor. Alloway was adjusting to changed surroundings and not just a new workplace. He had recently moved from rural Vermont to New York City

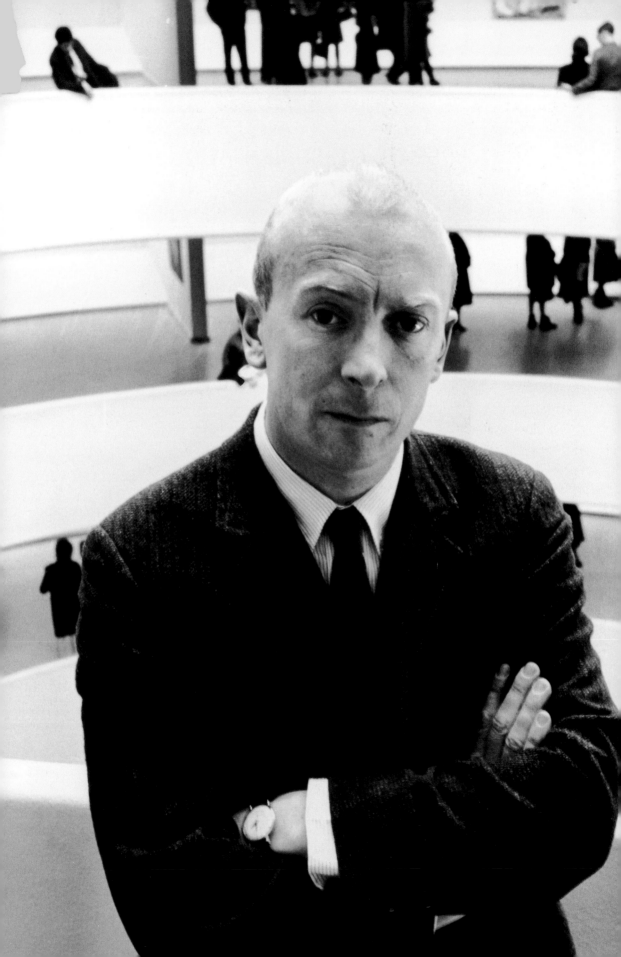

after relocating from his native England to the United States the previous year. For someone who by that point had devoted no small part of his critical project to considering art's relationship to architecture and urban space, the mention of spatial disorientation is telling.[2]

It has become an art historical commonplace that the term *pop art* originated in the postwar cultural dialogue between Britain and the United States, as experienced and theorized by members of the Independent Group (IG), Alloway included. The IG's encounter with American mass media occurred primarily through images—from comic books, magazines, films, and other popular sources. That is to say, for most of the group—aside from the artist John McHale, who visited the United States in the mid-1950s—this transnational encounter happened at a geographic remove. Alloway's experience with American culture was, in contrast, much more direct and prolonged. He traveled to the United States in 1958 under the auspices of a U.S. State Department international visitors' program, returned in 1960 to pursue some research and writing, and moved to the States in 1961, first to teach at Bennington College and then to work at the Guggenheim.

While Alloway's visits and eventual relocation were in some ways a fulfillment of the orientation toward American culture already evident in the IG's discussions, his trajectory was not defined solely by the relationship between London and New York. Rather, his activities speak to the emergent global scope of contemporary art. The art historian Hiroko Ikegami, among others, has called attention to the internationalism of the critical and curatorial efforts of figures like Pontus Hultén and Yoshiaki Tōno in the same period, as they focused on the expansion of artists' activities across national boundaries.[3] Alloway's professional endeavors can be placed within a similar framework. Although he is often identified with his theorizations of pop art and mass media, it is illuminating to consider him as one of the first curators whose work and outlook were shaped by the increasingly globalized and transnational conditions of art in the postwar period. Alloway's initial activities in the United States, particularly during his 1958 trip and his early years at the Guggenheim, highlight the possibilities and limits that attended such conditions, the experience of which could be described by the very phrase—"spatial disorientation patterns"—he had used in reference to more mundane matters.

Already by the mid-1950s, Alloway's writing and critical perspective evinced a sustained interest in American culture. As the critic Nigel Whiteley observed, this predilection reflected both the ascendance of American painting in the postwar period and a more general orientation toward American culture in Britain.[4] Hence, Alloway's 1958 trip to the United States can be seen as the fulfillment of a trajectory that he personally, and the IG more generally,

Fig. 1.
Lawrence Alloway, photographed at the Solomon R. Guggenheim Museum, New York, 1960s.

had launched years earlier. It followed the long period of study John McHale undertook at Yale University, from the fall of 1955 through the spring of 1956, a sojourn that famously supplied IG members with a large trunk filled with mass media materials.[5] Alloway's first trip to the United States lasted two months, from mid-April to mid-June 1958. He landed in Washington, D.C., where he remained for a little more than a week. Traveling by train, he made stops in Baltimore and Philadelphia, and then proceeded to New York City, the site of his longest visit, a stay of about three weeks. This was followed by a whirlwind tour of major American cities: Boston, Buffalo, Cleveland, Detroit, Chicago, Denver, and San Francisco. He continued on to Los Angeles, where he stayed for a week before flying back cross-country for a short stop in Washington and a final week in New York prior to his return to London.

Alloway's trip was organized through the U.S. State Department's Foreign Leaders Program. Inaugurated in 1949, it brought individuals and groups to the United States, with itineraries built around participants' areas of interest, affording them firsthand contact with American culture. (It continues to this day as the International Visitor Leadership Program.) The historian Giles Scott-Smith labels the program a form of Cold War era "public diplomacy," and it clearly achieved the intended effect on Alloway, at least as measured by its impact on his writing.[6] In a piece titled "Art in New York Today," which appeared in the British Broadcasting Corporation (BBC) publication *The Listener* several months after his return, he reflected on the current state of American painting, deeming it more advanced than the work being produced in London. His account, bolstered by mentions of direct encounters with American artists on their home turf, conveys his high estimation not only of the first, leading generation of American abstract expressionists (Jackson Pollock, Mark Rothko, Barnett Newman, Willem de Kooning, and the rest) but also of a younger cohort who were following in their wake. He opined: "The fact that New York has a far higher standard of painting among the younger artists than I have seen in London, or in Italy, or in Paris, seems linked to the close company they keep."[7]

Alloway made shrewd use of just that sort of "close company" to develop extensive professional contacts during his trip. One official memorandum from the Foreign Leaders Program includes a proposed list of people to meet and places to visit that was clearly derived from Alloway's discussions with program officers. In the section detailing his New York stay, the memo includes a series of names, described as individuals that "Mr. Alloway is especially interested in conferring with." The list is a veritable who's who of the 1950s New York art world: Thomas Hess and Alfred Frankfurter at *Art News*; the critics Clement Greenberg and Harold Rosenberg and the art historian Meyer Schapiro; and

the artists de Kooning, Rothko, Franz Kline, Hans Hofmann, and Clyfford Still, all leading lights of the abstract expressionist movement.[8]

The official documentation from the Foreign Leaders Program is not the only record we have of the trip; it is augmented by poignant letters that Alloway wrote to his wife, the artist Sylvia Sleigh, who remained at home in England. Those missives, filled with declarations of love and longing, offer a window onto the intimacies of their relationship, and they underscore the extent to which Alloway made good use of his time for professional networking. One letter, from May 8, shows just how packed his days were with meeting people and making contacts:

> I had lunch with Rothko *yesterday* and saw his new pictures—great dark ones for the most part. I spent all afternoon with him and learned a great deal about his art and background which was most exciting. He is charming and resourceful as a conversationalist—but without being trivial.
> … *Today* I lunched with Harold Rosenberg and questioned him about the term "Action Painting" (which he invented): most informative and useful…. *Tomorrow* I am seeing Hans Hoffman [*sic*] in the morning, Elaine de Kooning and Clyfford Still in the afternoon, and Hedda Sterne (Mrs. Saul Steinberg) for dinner. Saturday I am going to E. Hampton Long Island to see Alfonso Ossorio's collection (Pollock, Still, Dubuffet).[9]

Based on this and other letters, one gets the impression of Alloway racing breathlessly from one place (and one person) to another, as if he were trying to cram as much into the trip as possible.

The letters to Sleigh illuminate how Alloway was taking in the distinctive features of American culture, from the food he ate and the television shows he watched to his first American haircut. But it was not just the United States that Alloway was getting acclimated to, as he was also becoming attuned to the experience of travel itself. His letters are filled with references to geography and spatial orientation: he writes of the old and new houses around Boston Common; the low, flat topography of Long Island, which he found rather English; the psychological impact of Manhattan's grid plan; and the horizontal spread of Los Angeles. The very fact of travel came to constitute a primary subject of his letters through his attention to myriad details: the design of Idlewild Airport (now John F. Kennedy International Airport), the layout of a hotel room, the wonders of "one tiny ticket" that took him from "Washington to Baltimore to Philadelphia to NY—with stops along the way," or the difficulties of navigating New York City's subway system. Exemplary of this is a letter he wrote to Sleigh from the observation deck of a Vista Dome train traveling from Denver to San

Francisco. He included an elaborate description of his sleeping accommodations and several sketches of the glassed-in observation car, complete with his self-portrait as a "dandy lion," an inside joke between him and Sleigh (fig. 2). Alloway depicts himself (or at least his cartoonish, leonine stand-in) like some space-age traveler, encased in a sleek enclosure, speeding through the craggy desert landscape.

As noted, the 1958 Foreign Leaders visit was only a start. In 1960, Alloway went back to the States to work on a proposed book for the art dealer Betty Parsons; a year later, he returned for good. In late August 1962, around three weeks after his "spatial disorientation" memo, he wrote another memo to Messer, this time copying H. Harvard Arnason, who was then vice president for art administration at the Guggenheim. This note was quite a bit longer and covered more pressing matters: in it, Alloway laid out his thinking on what would become his debut exhibition at the museum, *Six Painters and the Object*. Whether or not his office seating difficulties had been resolved, he was settled enough to present a proposal for a substantive show. The memo's heading reads "Proposed Pop Artists Exhibition," and it begins with a discussion of the show's prospective theme:

> SUBJECT: Group show sampling a current trend: artists with no agreed-on name. "New Realism" is objectionable semantically (everybody from Naum Gabo to Andrew Wyeth claims to be a realist) and tactically (Pierre Restany called European all-the-way collagists "New Realists" two years ago). Working title at this stage might be "Pop Artists" which refers to the popular sources that all these artists have in common, i.e., the mass media and the man-made environment. Possible title: Signs and Objects.[10]

This short paragraph tells us a great deal about Alloway's conceptualization of and strategic intentions for the exhibit. At this early stage, he was still casting a rather wide net, indicating that the installation might include about forty-five works by up to twenty artists. He identifies nineteen artists for potential inclusion, while noting that "not every name on this list will necessarily survive to a final stage; nor is this list to be considered complete at the present time." That tally ranged far more widely than the six who were ultimately featured: it included artists with only an oblique connection to popular imagery, such as Alex Katz and Harold Stevenson; a selection of California painters, among them Billy Al Bengston, Mel Ramos, Ed Ruscha, and Wayne Thiebaud; and even the sculptor Claes Oldenburg, whose presence demonstrates that, in the initial planning, Alloway considered showing mediums other than painting. But by the time the show opened in March 1963, he had narrowed down the roster to

Fig. 2.
**Letter from Lawrence Alloway
to Sylvia Sleigh, 26 May 1958.**
Los Angeles, Getty Research
Institute.

six painters, all based in New York: Jasper Johns, Robert Rauschenberg, Jim
Dine, Roy Lichtenstein, James Rosenquist, and Andy Warhol (figs. 3, 4).

If *Six Painters and the Object* is generally identified as one of the first, if not
the first, full-scale museum exhibitions to survey the emergence of the pop art
impulse in the United States, aspects of the show and its planning nonetheless

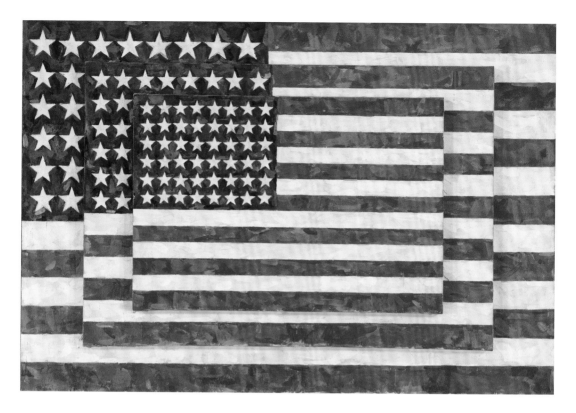

Fig. 3.
Jasper Johns
(American, b. 1930).
Three Flags, 1958,
encaustic on canvas,
78.4 × 115.6 × 12.7 cm
(30⅞ × 45½ × 5 in.).
New York, Whitney Museum
of American Art. Art
© Jasper Johns / VAGA,
New York, 2013.

speak to the international frame of Alloway's efforts.[11] While the exhibition was curated for an American museum, included work solely by American artists, and toured exclusively to American venues, Alloway was still thinking—and writing—extensively about British art during the show's planning. In fact, one of his major critical efforts in surveying pop in the U.K., an article titled "'Pop Art' since 1949," appeared in *The Listener* in late December 1962, at the same time that he was ramping up efforts on *Six Painters.*[12] The essay expanded on his earlier writings and it also represented a shift. In 1961, when he wrote "Artists as Consumers," he was still employing the term *pop art* to refer to mass media or popular forms in general; in the *Listener* article, he pivoted and began using the term to refer to the output of fine artists working with said forms, to some extent reclaiming it from critics and dealers who had already been utilizing it in this second, more limited sense.[13] Although he had been in the United States for more than a year when he wrote the *Listener* piece, he clearly had a British audience in mind in that it provides a comprehensive survey of the use of popular imagery by British artists in the postwar period, dividing the impulse up into three phases. According to Alloway, the first phase of British pop, which lasted from about 1951 to 1958, was characterized by an engagement with technology, as exemplified by the work of Richard Hamilton, Eduardo Paolozzi, and other IG members. In the second phase, which he conceives as beginning around 1957

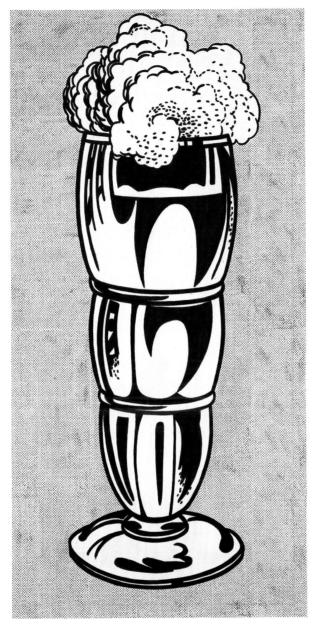

Fig. 4.
Roy Lichtenstein
(American, 1923–97).
Ice Cream Soda, 1962, oil
on canvas, 162.6 × 81.9 cm
(64 × 32¼ in.).
Private collection.

(and thus overlapping with the first), the aims of abstract painting were wedded to popular subjects, as in the work of such practitioners as Richard Smith. The third, current wave of pop, which had begun in 1961 and was exemplified by the pictures of Derek Boshier, David Hockney, and R. B. Kitaj, represented a return to figuration, in which painters drew on a wide array of iconographical sources, including popular culture.

It is in Alloway's description of, and dissatisfaction with, the third phase of British pop art that his own transnational (or intercultural) position becomes

most apparent. The problem, Alloway claimed, was that artists such as Boshier and Hockney lacked the ability to unify the diverse array of signs and imagery they employed within one coherent pictorial format, largely because they took their cues from commercial design rather than from painting. But there were alternatives to this shortcoming, which he located elsewhere:

> American painters of the same age-groups who use this kind of imagery have a stronger painting tradition to measure their performance by. They have not abandoned the high standards of the older American abstract painters, though they have moved decisively away from abstraction as such. Thus, there is a continuity between recent and current work, which confers a certain formal strength on what is new. England, not supplying any standard of comparable rigour, has, in a way, let these artists down.[14]

For all the ostensible pluralism and openness to diverse cultural forms with which Alloway has been identified, there is a streak of formalist conservatism in the views expressed here, perhaps indicative of his continuing engagement with the critical orientation of such influential figures as Clement Greenberg. One can also take issue with his claim that the formal strength of American pop lay in its continuity with abstract painting; while this may have been true of certain artists, it is clear that some of the central formal strategies of Warhol's work, for instance, were deeply shaped by the artist's long experience in the fields of advertising and design.

However we judge the specific points of the *Listener* article's argument, it is clear that the piece presages the essay that Alloway would write, several months later, for *Six Painters and the Object.* In the catalog, Alloway demonstrates how, even though painters and object-makers dealing with popular subjects had tended to be lumped together, these (American) artists' incorporation of popular imagery into painting raised medium-specific issues. The transcultural bifurcation of Alloway's critical position is echoed by a similar division in the structure of the *Six Painters and the Object* essay itself. It is separated into two parts: the first deals almost exclusively with the work of the artists in the show, while the second offers a historical overview of the incorporation of popular subjects into art, from the work of Gustave Courbet, Georges Seurat, and Vincent van Gogh to purism and surrealism. This division is further emphasized by the catalog layout, which interposes a checklist of the works in the exhibition between the two sections. This format effectively separates the historical antecedents, aligned with Europe, from the contemporary U.S.-based practices that were the exhibition's focus.

There is one further aspect of "'Pop Art' since 1949" that reveals the conditions that shaped Alloway's activities at the time. In a letter to Sleigh on stationery from the Hotel Continental in Oslo, he related, "I wrote most of my pop broadcast on Sunday. 1st half in the hotel, then when time was up I packed and did 2 or 3 hours writing at the airport of Amsterdam. So it is nearly done."[15] Dates and postmarks on accompanying letters and envelopes (contained in the same folder in the Alloway Papers) indicate that he wrote this missive in late October 1962, when he was on a European trip that included stops in Amsterdam, Copenhagen, Paris, Stockholm, and Zurich. Considering that *The Listener* was a BBC publication, the "pop broadcast" to which Alloway refers is likely none other than "'Pop Art' since 1949." Thus, in addition to providing insight into his perspective on pop, the piece also highlights Alloway's geographic mobility: he was a U.K.-born curator, working for an American museum, preparing an exhibition on contemporary artistic developments in New York, who was writing a report on the current state of British art from hotels and airports in major European cities. And there was a correlation between his situation and the cultural phenomena he was writing about. In his *Six Painters and the Object* essay, he identifies "the use of objects drawn from the communications network and the physical environment of the city" as the common thread that linked those artists. Those very conditions—increased mobility and an urban orientation—were precisely the same ones that defined his own professional experience as he traveled from city to city as a curator (even though his movements were facilitated not by media transmissions but by high-speed transportation, particularly jet travel).

While Alloway was away on his European jaunt in the fall of 1962, the art dealer Sidney Janis opened an exhibition that threatened to scoop Alloway and take the wind out of his sails. In his August memorandum, Alloway indicated his awareness of Janis's upcoming effort, mentioning a "big, sloppy survey Sidney Janis is staging this Fall of American and European artists in the style." The planning of the Janis show, dubbed *The New Realists,* itself highlights prevailing conditions of transnational exchange (and conflict); Janis had initially involved the French critic Pierre Restany—who had coined the term *nouveau réalisme*—but he later restricted Restany's contribution, choosing to focus on American over European practitioners and cutting down Restany's catalog essay.[16] Alloway must have gone to visit the Janis exhibition shortly after his return to New York in early November, since in the middle of that month he dashed off a short memo to Messer that makes his concerns quite clear: "Too many Pop shows. Not only Janis' anthology but Warhol and Indiana at Stable, Oldenberg [*sic*] and Wesselman [*sic*] at Green, [Museum of Modern Art] discussion scheduled, group shows from Philadelphia to Pasadena (Coast

to Coast)." If Janis's show, alongside these other developments, posed a problem for Alloway's planning of the Guggenheim exhibit, it at least gave him the chance to clarify the differences between his approach and Janis's, which he identified as "a mess":

> Apart from the weakness of many individual exhibits, Janis has confused assemblage (any old objects) with the *painters* of common objects and signs. This, if you remember, is what I expected would happen and so planned anyway to stress the painters (Dine, Lichtenstein, Ramos, Rosenquist, Stevenson, Thiebaud, including earlier works of theirs, not just the late). This would give, rigorously organized, a clear definition in opposition to the general confusion. Maybe it is too late, or maybe a clear statement would be welcome. I incline to the latter view.[17]

Alloway added a parenthetical aside, clearly intended to goad Messer, claiming that Peter Selz, the curator of painting and sculpture at the Museum of Modern Art (MoMA), had expressed significant interest in the show. Alloway's point was that, if they shelved plans for their proposed pop art survey and MoMA subsequently mounted a similar exhibition, it "might look bad" for the Guggenheim, considering that there had already been significant word of mouth about preparations for *Six Painters*.

Alloway's planning memos, particularly the one from November, illuminate his involvement with the term *pop art.* While today he is identified as one of the primary figures responsible for naming and defining this impulse in postwar art, the memos reveal his concern that his claim to the label, and its application to a range of contemporary artistic practices, was slipping from his grasp (if he had not already lost it), a situation that had been exacerbated by the term's transatlantic migration. While his writing of "'Pop Art' since 1949" was a way for him to assert his authority over the term in a British context (in the essay, he makes sure to note that he became involved with pop during its first phase), by the time *Six Painters and the Object* opened, the label was already in widespread use in New York. It is likely that his November memo was a response not just to the Janis show but also to Brian O'Doherty's review of it in the *New York Times,* in which the critic wrote that "this large exhibition is the first N.Y. gathering of 'Pop' art, a better name than 'New Realists.'" O'Doherty's piece was titled "'Pop' Goes the New Art."[18] Efforts to define the category were coming from near and far, whether from other museums, from dealers like Janis, from rival curators, or from locales dispersed across the country, "from Philadelphia to Pasadena," as Alloway put it in the November memo.

If the widespread interest in this new art stood to challenge Alloway's curatorial claim to the pop label and the movement's theoretical formulation, it also offered opportunities. Messer wrote letters to numerous museums gauging their interest in taking *Six Painters and the Object;* his efforts resulted in an extended nationwide tour that included an impressive seven venues in all.[19] Although the exhibition did not get to quite as many cities as Alloway had on his Foreign Leaders visit, it arguably covered more ground: from its initial installation in New York to its last stop in La Jolla, California, the show traveled from coast to coast and back again, not once but twice. The circumstances of the show's initial stop, in Los Angeles in the summer of 1963, are telling, as Alloway assembled a companion exhibition, titled *Six More,* featuring a group of artists working in California (Bengston, Joe Goode, Phillip Hefferton, Ramos, Ruscha, and Thiebaud) whose approach was similar to that of the primary coterie (fig. 5). This gesture was simultaneously expansive and provincial, highlighting the important contributions that West Coast artists were making, while at the same time emphasizing their exclusion from the original Guggenheim show. As noted, Alloway's first planning memorandum mentioned several of these

Fig. 5.
Cover of Lawrence Alloway's exhibition catalog *Six More,* designed by Deborah Sussman, published by the Los Angeles County Museum of Art, 1963.

artists, indicating that he was aware of their efforts but ultimately chose not to include them in his final cut. His catalog essay for *Six More* further underscores how his work engaged with and yet was problematized by geographic categorizations. Although he starts off the essay in a regional register, describing the specific character of West Coast object-makers (like Edward Kienholz), he then changes course and asserts that pop artists, in contrast, are treating "our only universal culture," namely, the mass media. An observer could reasonably have wondered, given the putative universality of these artists' subject matter, why they had been split up into East Coast and West Coast groups in the first place—not to mention that the Los Angeles exhibition's title suggested that it was a mere addendum to the main event. The staging of *Six More,* then, gave Alloway ample opportunity to reflect on the categorizing of art making through local, regional, and national designations as well as the impact of such frameworks on curatorial practice.

In fact, Alloway directly confronted the problem of applying geographic classifications to art making in an essay he wrote around the same time. *Six Painters and the Object* was on view at the Guggenheim through mid-June of 1963; that same month saw the publication, in the *Minneapolis Institute of Arts Bulletin,* of a piece written by Alloway to accompany the Third Minnesota Biennial, a regional exhibition. Alloway was a member of the biennial's selection and awards jury, a clear indication of the art world standing he had by then achieved (his biography in the bulletin noted his "international eminence as a critic of contemporary art"). He began the essay, titled "Whatever Happened to the Frontier?," with a series of musings on the relationship between art and place:

> Can the art of the twentieth century usefully be treated geographically? For example, is there a quality that separates art produced in Minnesota from art produced, say, on the West Coast of America? Is American art, as such, different from European art and, if so, are those differences embodied equally in the art of Minnesota and of New York? There are various possibilities of geographical ranking which can be listed in terms of diminishing area: (1) international art, global, pervasive, and encompassing; (2) continental or national art, the limits of which coincide with tariff boundaries and the rights of citizenship; and (3) local and regional styles, within countries.[20]

As the critic Cédric Vincent has observed, Alloway's piece is surprisingly contemporary and relevant in its reflection on issues of regionalism, globalization, and internationalization.[21] In "Whatever Happened to the Frontier?," Alloway

positions himself against those critical approaches that essentially tie artistic practices to national identities; more specifically, he rejects the conventional opposition between European culture, as ancient and fixed, and American culture, as defined by a mobile frontier. Instead, he emphasizes the mobility of all art in contemporary culture: in the age of advanced communications, he notes, "art circulates immediately," calling attention to how quickly abstract expressionism was received in Japan, to cite one example.[22] The defining characteristics of contemporary art, he asserts, are the presence of those communications media and the practice of art as an essentially urban activity, a claim that links the piece directly to the (basically identical) point put forth in *Six Painters and the Object*.

While cultural theorists of the time, according to Alloway, wanted to identify what he described as a national style of American art, he remained unconvinced; the American frontier, he concludes, "got eroded by the same internationalism and by the same communications revolution which exploded national boundaries in the arts of Europe."[23] If this observation provided a diagnosis of much wider cultural conditions, it also accorded with his own particular situation. His call for a theorization of art that was less tied to national characterizations and more attuned to mobile conditions was as consonant with the age as it was with his own personal and professional trajectory. Whether seated in a museum office or on the observation deck of a train making its way through the American landscape, assembling a major traveling show of recent painting or assessing the viability of regional designations for art, Alloway was uniquely positioned to reflect on the shifting borders and expanding terrain of postwar art.

Notes

1. Alloway to Thomas Messer, memorandum, 8 August 1962, Solomon R. Guggenheim Museum Archives, Lawrence Alloway Records (A0064), box 557, folder 49.

2. See, for instance, Lawrence Alloway, "City Notes," *Architectural Design* 29, no. 1 (January 1959): 34–35, in Lawrence Alloway, *Imagining the Present: Context, Content, and the Role of the Critic,* ed. Richard Kalina (London: Routledge, 2006), 65–70.

3. Hiroko Ikegami, *The Great Migrator: Robert Rauschenberg and the Global Rise of American Art* (Cambridge, Mass.: MIT Press, 2010).

4. Nigel Whiteley, *Art and Pluralism: Lawrence Alloway's Cultural Criticism* (Liverpool: Liverpool University Press, 2012), 115.

5. On McHale's visit to the United States and its relation to the 1956 *This Is Tomorrow* exhibition, see Anne Massey, *The Independent Group: Modernism and Mass Culture in Britain, 1945–59* (Manchester: Manchester University Press, 1995), 100. For a detailed account of the back-and-forth between McHale; his wife, Magda Cordell McHale; Richard Hamilton; and others during McHale's American residency, see John-Paul Stonard, "Pop in the Age of Boom: Richard

Hamilton's 'Just what is it that makes today's homes so different, so appealing?,'" *Burlington Magazine* 149, no. 1254 (September 2007): esp. 612–14.

6. Giles Scott-Smith, *Networks of Empire: The US State Department's Foreign Leader Program in the Netherlands, France, and Britain, 1950–1970* (Brussels: Peter Lang, 2008), 25.

7. Lawrence Alloway, "Art in New York Today," *The Listener* (23 October 1958): 648.

8. "Committee on Leaders and Specialists, American Council on Education, Itinerary for Lawrence Alloway, 14 April–13 June 1958, visit," Lawrence Alloway Papers, Getty Research Institute, Los Angeles, acc. no. 2003.M.46, box 36, folder 1. The document also underlines Alloway's interest in architecture and design: it names architects Frank Lloyd Wright and Victor Gruen and designers George Nelson and Harry Bertoia as people Alloway wanted to meet, notes his interest in seeing such iconic New York landmarks as the Flatiron, Woolworth, Seagram, Lever House, and United Nations buildings, and indicates his desire to travel to Connecticut to see Philip Johnson's Glass House.

9. Lawrence Alloway to Sylvia Sleigh, 8 May 1958, Alloway Papers, box 7, folder 8.

10. Lawrence Alloway to Thomas Messer, 28 August 1962, Solomon R. Guggenheim Museum Archives, Exhibition Records (A0003), box 1063, exhibition 149, folder 3.

11. For instance, Nancy Spector identifies it as "the earliest full-scale museum exhibition to investigate the phenomenon," noting that the Washington Gallery of Modern Art mounted the exhibition *The Popular Image* in April 1963, the month after *Six Painters and the Object* opened at the Guggenheim. See Nancy Spector, "Against the Grain: A History of Contemporary Art at the Guggenheim," in *Art of This Century: The Guggenheim Museum and Its Collection* (New York: Solomon R. Guggenheim Foundation, 1993), 259 and 284n5. However, her identification of *Six Painters* as the first show of its kind is open to question; Walter Hopps had curated *New Paintings of Common Objects,* which included artists such as Ed Ruscha, Andy Warhol, Roy Lichtenstein, Wayne Thiebaud, and Jim Dine, at the Pasadena Art Museum in the fall of 1962.

12. Lawrence Alloway, "'Pop Art' since 1949," *The Listener* 68, no. 1761 (1962): 1085–87.

13. Lawrence Alloway, "Artists as Consumers," *Image* 3 (1961): 14–17.

14. Alloway, "'Pop Art' since 1949," 1087.

15. Lawrence Alloway to Sylvia Sleigh, ca. 30 October 1962, Alloway Papers, box 7, folder 11.

16. On this episode, see Ikegami, *The Great Migrator,* 37–39.

17. Lawrence Alloway to Thomas Messer, memorandum, 14 November 1962, Guggenheim Alloway Records, box 557, folder 49. Alloway's mention here of "the *painters* of common objects and signs" echoes the title of Hopps's *New Paintings of Common Objects* show, which had run from 25 September to 19 October, and which was reviewed by John Coplans in the November issue of *Artforum*— an allusion, conscious or not, to yet another competing pop art show.

18. Brian O'Doherty, "'Pop' Goes the New Art," *New York Times,* 4 November 1962.

19. These were the Los Angeles County Museum of Art, the Minneapolis Institute of Arts, the University of Michigan Museum of Art, the Rose Art Museum at Brandeis University, the Carnegie Institute in Pittsburgh, the Columbus Museum of Art, and the La Jolla Museum of Art, California.

20. Lawrence Alloway, "Whatever Happened to the Frontier?," *Minneapolis Institute of Arts Bulletin* 52, no. 2 (June 1963): 54.

21. Cédric Vincent, "The 'Frontier' Revisited: Cédric Vincent Reads Lawrence Alloway," in *Sarai Reader 07: Frontiers* (Delhi: Centre for the Study of Developing Societies, 2007), 310–15. The piece includes a reprinting of Alloway's essay. An article by Shelley Rice drew my attention to Vincent's essay; see Shelley Rice, "Lawrence Alloway's Spatial Utopia: Contemporary Photography as 'Horizontal Description,'" *Tate Papers,* no. 16 (1 October 2011), http://www.tate.org.uk /research/publications/tate-papers/lawrence-alloways-spatial-utopia -contemporary-photography.

22. "Because of the efficiency of our communications, art circulates immediately: the Japanese knew of Franz Kline's painting, and were discussing its relation to calligraphy, by 1952, when it was only three years old, for instance. Cases of such prompt cultural crossovers are continual today"; see Alloway, "Whatever Happened to the Frontier?," 55.

23. Alloway, "Whatever Happened to the Frontier?," 56.

COURTNEY J. MARTIN

LAWRENCE ALLOWAY'S SYSTEMS

> If someone were to analyze current notations and fashionable catchwords, he would find "systems" high on the list. The concept has pervaded all fields of science and penetrated into popular thinking, jargon and mass media.
> —Ludwig von Bertalanffy, *General System Theory: Foundations, Development, Applications,* 1968

I.

In September of 1966, at an exhibition of contemporary art at the Solomon R. Guggenheim Museum, the term *systemic* came to the fore to define the kind of recent American painting that, while abstract, was absolutely not abstract expressionism. Instead of abstract expressionism's more free-form nonrepresentational painterliness, it was geometric in content and form and sometimes analogous to sculpture due to its large-scale shaped canvases. Conceptually, *systemic* embodied a loose layman's interpretation of systems theory, an interdisciplinary study of order developed in the hard sciences. Yet it also held sway as a shorthand definition for countercultural opposition. Throughout the 1960s, Americans were as engaged with the pseudoscientific application of systems theory as they were with revolting against the various maneuvers of "the system," be it the government, corporations, the military, or the nuclear family. The search for order amid the national chaos of the various social justice movements laid bare the very mechanisms of power that could be contested. In turn, the dissemination of science and technology into the domestic sphere lent the general public a framework, even if superficial, for finding and naming society's structures.

Lawrence Alloway was the exhibition's curator and also a member of a postwar citizenry interested in the greater aims of science and technology within a moment when the field of art held similar aspirations of progress. Systems theory was but one of Alloway's amateur science pursuits to make its way into his professional life via the exhibition *Systemic Painting* (fig. 1), on view at the

Fig. 1.
Lawrence Alloway and museum staff installing *Systemic Painting* at the Solomon R. Guggenheim Museum, New York, 1966.

Guggenheim from 21 September to 27 November 1966. Alloway invited twenty-eight New York–based painters to participate in an installation that encompassed the museum's circular ramps 1 and 2, as well as the High Gallery. Though each artist took a different approach to their works, most shared an interest in scale (large), color (often hard-edge), and innovation (acrylic paint). Nearly all of the art evidenced some aspect of the geometric. Visitors saw works that were products of their time in dialogue with recent explorations of abstract painting, though some of the paintings struggled to assert themselves within the Guggenheim's domineering architecture.

The show was Alloway's final curatorial endeavor at the Guggenheim and his last major museum exhibition in New York. The idea of "systemic" suggested that the paintings on view were holdouts of an unknown nature, creating a situation in which Alloway was comfortable recounting their New York school ancestry but less so in fitting them within their minimalist present. The exhibition's otherwise straightforward display of paintings took on additional significance due to the high drama that erupted between the institution and its curator after Alloway's resignation in June 1966 following a public dispute with the museum's director, Thomas Messer, over the curatorial plan for America's

representation at the 33rd Venice Biennale.[1] In the exhibition and, perhaps even more so, in the catalog and related writings, Alloway claimed to reveal the order, control, and power in contemporary painting through the language of contemporary society. The show lacked a conclusive or coherent explanation of the relationship between systems and painting practices. As a result, *Systemic Painting* as a concept reveals much about the state of American art in the 1960s but very little about the individual works in the exhibition. This essay seeks to situate Alloway's interest in systems as an extension of his sustained investment in art as a form of popular culture and his self-conscious strategy to identify a new strain in abstract art that would elevate him to the status of the other major figures of art criticism during a precarious period in his career.

II.

Scientists have defined a system as a "complex of interacting components together with the relationships among them that permit the identification of a boundary-maintaining entity or process."[2] Systems research developed as a method of studying order in the natural sciences, and by the post–World War II period, it had been popularized by several theorists, including the biologist Ludwig von Bertalanffy, whose General System Theory (GST) was widely adopted by scientists and laypersons alike under the shortened term *systems theory*.[3] Von Bertalanffy argued for the acceptance of the system as a "model of general nature" that functioned as "a set of elements standing in interrelation among themselves and with the environment."[4] It was a worldview that espoused the connectivity of parts into a network of the whole. Though von Bertalanffy's widely read *General System Theory: Foundations, Development, Applications* was not published until 1968, the term had been in circulation for more than three decades prior via his journal articles, lectures, and citations by colleagues.[5]

Its usage was almost solely contingent upon its applicability (either thoroughly or superficially) to a number of fields (including anthropology, biology, ecology, linguistics, mathematics, physics, psychology, and sociology to name a few) and its seemingly holistic, utopian assertion of interconnectivity. The study of human physiology by chemists and biologists and the recognition of ecosystemic relationships in the natural and built environments rely on a basic understanding of systems theory. As von Bertalanffy wrote, systems theory "suggests that the unity of science is to be found in the uniformity of conceptual constructs or models applicable to diverse disciplines and it hints at a unity of the world which these disciplines conceptualize."[6] Systems theory is unique in its common acceptance by the normally discrete disciplinary methods of hard and soft science, positing a new paradigm of interdisciplinarity across

previously closed fields. In offering a perspective, as opposed to a theorem or a fact, systems theory could be absorbed evenly, but undiluted, even when it moved into popular use. What it offered to all fields was the acknowledgment of a specific origin, the possibility that everything had a logical order (one needed only to prove it). Despite its interdisciplinary application, systems theory was, in practice, a method of differentiation, establishing through the discovery of specific order that everything—from engineering to psychology—had comprehensible purpose and meaning.

Alloway was not a scientist. However, he was just the type of person that von Bertalanffy identified—one with more than a passing interest in "jargon and mass media." Alloway's investment in popular culture was an entrenched part of his public persona. The American versions of science-fiction novels and films, horror movies, television shows, advertisements, household appliances, and other amusements appealed to his desire for escapist entertainment, but they were also the ground on which his career as a cultural worker was laid. The early part of his career as a critic segued into his work with the Independent Group (IG) at the Institute of Contemporary Arts (ICA), where these preoccupations were rigorously examined as cultural tools within an evolving understanding of culture after the war.[7] The members of the IG were fascinated by the aspect of newness in postwar American life, which emphasized scientific discovery, technology, and the promise of the future (whether in the form of next year's car model from Detroit or the alien races that populated filmic and televisual projections of futuristic America). Alloway summed up the situation succinctly in his seminal essay on the topic, "The Long Front of Culture," as "the missile and the toaster, the push-button and the repeating revolver."[8]

A kind of popular science ran in tandem with, and was inseparable from, Alloway's sense of what culture could mean. Written after his first visit to the United States in 1958, but before he emigrated there in 1961, his commentary on technology could easily be repositioned as a warning to Britain about America's postwar success in the wake of Britain's failure: "One reason for the failure of the humanists to keep their grip on public values (as they did on the nineteenth century through university and Parliament) is their failure to handle technology, which is both transforming our environment and, through its product the mass media, our ideas about the world and about ourselves."[9] His analysis was a reductive version of systems theory; it worked because it could be made to validate anything, because everything can be presumed to have order, even if obscured by disorder. Though Alloway cites neither *system* nor *systems theory,* as promoted by von Bertalanffy or any of the other systems theorists, his use of the words *system, systems,* and *systemic* to describe the New York art world and its machinations, as well as abstract painting, confirms that he was somewhat

aware of systems theory and sufficiently interested in it to adapt a lay version to suit his needs.[10]

III.

Alloway used the term *system* repeatedly in his critical writings starting in the 1950s. In "Personal Statement," a 1957 article about his "consumption of popular art," he identified the generational disconnect between himself and the older British critics Roger Fry and Herbert Read as a mismatch between different "system[s] of taste."[11] This difference led him to disagree with how they wrote about art: "As I saw the works of art that they had written about I found the works remained obstinately outside the systems to which they had been consigned."[12] In the same article, Alloway recounted the accusation that he had been "Americanized," likely due to his interest in media, abstract art, and the art criticism of Americans Clement Greenberg, Harold Rosenberg, and Meyer Schapiro. More often than not, his so-called Americanization went hand in hand with references to "systems." America was a subject for many IG members, but Alloway in particular pursued America and its art as his primary professional objective, in his criticism and in the exhibitions that he curated.

In "City Notes," an article published just two years later, after he had seen the United States firsthand, he identified the differences between American and European cities by noting that the former were "geared to the communications systems of modern technology."[13] Avidly interested in Jackson Pollock both before and after traveling to America, he saw a system at play in the drip technique: "It is important to realize that the role of chance in Pollock's work is not outside his control. Each accident is not, of course, predictable, but the system within which it occurs is regulated by the artist."[14] Though he was writing specifically about Pollock, the mention of *accident* invokes the role of chance in the shaping of modernist discourse (as in Dada, for example). Later, after living and working in the United States, he employed the concept of a system in a critique of the critical styles of Greenberg, Rosenberg, and Thomas B. Hess. The confidence with which he demanded an "alternative to such systems" of criticism reveals the subtle shifts of language that American assimilation brought about in him in the 1960s.[15] He was finally able to engage these critics on equal terms. The systems that he wanted to uncover in the 1950s were no longer relevant to him by the 1960s. They had been replaced by other, more pressing complexities that needed to be untangled. As Lane Relyea has suggested, "systems pervaded the art world of the 1960s."[16]

For Alloway, the art world was, alternately, the thing, place, or experience most in need of untangling. It preoccupied him first from afar while in London

and then in New York, once he too was embedded in its day-to-day functioning. In his article "Art and the Communications Network," his first major discussion of systems, he sought to disengage the minutiae of the business of art—including how it was sold, marketed, delivered, and shown—from the ways in which it was reproduced, consumed, ignored, and parsed as text by writers who had naturalized the system of art to such an extent that they were seemingly unaware of its constructed armature until he exposed it for them.[17] In the article, Alloway situated the art object as "an organization, a legible structure, consisting of at least two levels of information, one that can be translated into another medium for reproduction and one that is identified solely with the original channel."[18] His exposé of "the adequate system for a crowded art scene" reads very much like systems theory reworked for common consumption and applied to understanding how the creation, sale, exhibition, documentation, and critique of art is contingent upon a state of complex interdependence. Or, put simply, how making and selling art necessarily work together.[19] Given that systems theory is results oriented—the goal of studying interaction is to identify an end product—it fits easily into nearly any understanding of art that is, as a field, concerned with the art object or idea, or, in other words, the result.[20] This is essentially what Alloway determined about Barnett Newman's unified color in a series of paintings on view in *Barnett Newman: The Stations of the Cross; Lema Sabachthani*: "the series as a whole...for all its impression of austerity, constitutes a highly nuanced system."[21]

Something about the concept of systems coalesced for Alloway around 1965; for example, "Art and the Communications Network," which was published in January of 1966, was written in 1965. In the spring of 1965, in his last major lecture at the Guggenheim, "Op Art: A Response to the Responsive Eye," Alloway took on the recent Museum of Modern Art (MoMA) exhibition *The Responsive Eye* and its curator, William C. Seitz, as his main subjects. In the lecture, he reviewed key ideas currently circulating about abstract art, such as Rosenberg's theories about action painting, in order to situate the MoMA show as the execution of an affective theory—one that stressed the role of viewers' perception in the reception of the artwork. The problem with reception was that "perceptions are shaped by our prejudices," an idea that he made plain via an analogy about the film *Home of the Brave*'s (1949) summary of postwar American racism. Perception, according to Alloway, was so flawed that it could produce racism, and therefore it should not be invited into the realm of art. He also introduced a few of his own ideas, such as describing Rosenberg's theory of action painting as a "genetic theory," one that "puts the emphasis on the artist's experience in the creative act."[22] This was a continuation of his earlier rejection of action painting because it "was not the end result but a process in the discovery of aesthetic order."[23] It is not surprising that when he measured Rosenberg's genetic

"artists experience" approach against Seitz's affective "audience reception," he found that neither Seitz's approach nor the exhibition was "unique." Alloway described the exhibition as an "inventory for an optical kick" because "op art is a bit of a larger pattern," or a "device," rather than a stand-alone movement or style. He chided Seitz for the opportunism of his show, claiming that he "turned a part of the current scene in abstract art into the whole."[24] This larger pattern, Alloway went on to explain, was one that also included symmetry, large forms, and edge-to-edge painting, such as that of Ellsworth Kelly, Alexander Liberman, and Frank Stella. All were capable of a holistic canvas "animated with equal symmetry." Alloway's name for these artists' ability, and indeed for the style to which they subscribed, was "systemic form": "a characteristic of the present time, present abstract art is systemic form. A cutting down on asymmetry. A cutting down on drama. And reliance on systemic form and regular colour."[25] This lecture may be the first time that Alloway publicly outlined his forthcoming exhibition *Systemic Painting,* but, as was often the case with his ideas, he used numerous forums (criticism, public lectures, exhibitions, and exhibition catalogs) to launch and reinterpret them, mimicking a systematic approach to idea circulation. Systemic art not only controlled asymmetry and irregular color but also mastered texture, defined as "the all-over play of identical or sequential small-scaled elements" on the canvas.[26] Mastery is demonstrated by "the repetition of a constant element without interruption," a technique better known as seriality.[27] In this lecture, Alloway transitioned from *system* to the more abstract, painting-specific *systemic,* a word that suggested the active involvement of the painter.

IV.

Alloway's writing is peppered with "sciencey" words, such as *communications, field, matter,* and *network.*[28] *System* and *systemic* were additions to this subset of his vocabulary and became well-used word-concept-metaphors during his last year at the Guggenheim. Despite its ubiquity in his writing and lectures, the term *systemic* did not make its way into the exhibition's title until June 1966, just two months before it opened. In a Guggenheim interoffice memorandum, Alloway wrote, "to answer your question about the title of the American Abstract Painting Exhibition, I can only say that at the moment I am uncertain what to call it. There will be field paintings in it but the exhibition is more broadly based. I will see what I can come up with."[29] Alloway was actively working on the forthcoming exhibition while his Newman show was still on view at the museum.[30] The Newman show, if not a catalyst for *Systemic Painting,* was certainly a source for the way that Alloway framed the argument for painting

as a system. Newman's approach to painting was ordered and demonstrated quasi-illusional features that alluded to compositional depth and three dimensions. The best known of these features was the zip, the vertical line that he used to divide color and space on the canvas. The painter also worked in series, as if to suggest a closed unit or narrative to which each painting that he produced belonged. If each painting belonged to a series, then it was a part of a whole that could be revealed in full only when the series was shown together, as was the case with the works in the Guggenheim show.

Alloway began the *Systemic Painting* catalog essay with an outline of the history of American abstract painting using the terms that shaped the discourse—namely, Rosenberg's *action painting,* H. Harvard Arnason's *abstract imagist painting,* and Jules Langsner's *hard-edge painting.* The latter was the phrase that Langsner used to describe the paintings by four California artists in his exhibition *Four Abstract Classicists* at the Los Angeles County Museum of Art (LACMA) in 1959. Alloway used all three terms as foils for a longer discussion of Greenberg's shift from his first project, abstract expressionism, to a focus on a second generation of American artists whose work he termed *post-painterly abstraction.*[31]

> Abstract Classicist painting is hard-edged painting. Forms are finite, flat, rimmed by a hard clean edge. These forms are not intended to evoke in the spectator any recollections of specific shapes he may have encountered in some other connection. They are autonomous shapes, sufficient unto themselves as shapes. These clean-edged forms are presented in uniform flat colors running border to border.[32]

Alloway's reliance on Greenberg's theory in this essay was a familiar device; he had previously made productive use of Greenberg's arguments, ideas, and methods in the course of supporting his own. This instance, however, involved a more strategic use of Greenbergian methodology. *Post-Painterly Abstraction,* Greenberg's 1964 exhibition at LACMA, was a concept-driven show. Many of the artists whom Greenberg selected for *Post-Painterly Abstraction*—Thomas Downing, Paul Feeley, Al Held, Ellsworth Kelly, Nicholas Krushenick, Howard Mehring, Kenneth Noland, and Frank Stella—later appeared in *Systemic Painting.* Greenberg's exhibition proposed the existence of a new artistic movement that could specifically refer to the objects on view, as well as to a wider range of works. In their respective exhibitions, Greenberg and Langsner were both successful in simultaneously theorizing and instantiating new artistic movements. While few would remember the artists, the curatorial plans, or the specific concerns outlined in their exhibition catalogs, many artists, critics, collectors, and art historians quickly took up and redeployed their concepts. Both

of these new terms, *post-painterly abstraction* and *hard-edge,* were tied to the personas of their originators, which only seemed to make them more useful, as a kind of brand, to a wider audience. After resigning in June 1966, Alloway's relationship with the Guggenheim changed dramatically, and it affected how he viewed his final show for the museum, which opened in September. *Systemic Painting* was a grand finale, but with Langsner's and Greenberg's precedent in mind, he also wished it to serve as his calling card. At that time, Alloway determined that he needed a defined, marketable persona in order to patch together the writing, curating, teaching, and consulting positions that would provide him with a secure future.

The essay for the Newman exhibition catalog pointed to Newman as a precursor of systemic painting, noting that "although this idea [systemic painting] is not central to the paintings of Newman, it is indicative of his continuous presence on the scene in the 60s that a proposed esthetic should rest, at least partially, on his work."[33] This idea references how Alloway had previously situated Newman's practice and writing: "Newman worked, first, without pre-knowledge of group or cycle; then, as a result of developing possibilities within the work itself, he accepted a definition that partially determined the future course of the series."[34] Alloway posited this as an example of how *systemic* could be defined as a studio practice. Newman's relevance rested largely on two things: the unity of his painting ("the total field is a unit of meaning") and his cult following ("there was talk and speculation about Newman even among artists who had not seen his work").[35] The tacit suggestion throughout the catalog is that Alloway's promotion of Newman by way of the Guggenheim solo show—Newman's first in a major museum—was an act of prescient insider discovery.[36] Alloway was the only curator able to bring this reluctant artist's artist to the attention of the art world and the public.[37] His breakthrough with Newman also demonstrated his readiness to inherit the mantle of abstraction from Greenberg, and his intention to rework it to bear his mark. Alloway needed systems as both a separation from and an adherence to Greenbergian formalism at this vulnerable point in his career. The Newman exhibition was the manifestation of one of his most enduring professional relationships in America, proving that while his time at the Guggenheim had been brief, he had shown the ability to sustain involvement with artists and to curate well-planned and well-executed exhibitions, whether monographic or concept-driven. As further proof of this, he characterized *Systemic Painting* as one of a handful of recent important exhibitions of abstract art, including *Post-Painterly Abstraction,* the Jewish Museum's *Toward a New Abstraction* (1963), and MoMA's *Primary Structures: Younger American and British Sculptors* (1966) in the exhibition catalog, in his other essays, and in his lectures.

The presence of other defining shows and prominent curators weighed heavily on Alloway, almost from the moment that he was offered the Guggenheim job in 1962. He had been hired to put on the same kind of shows that his curatorial contemporaries—Michael Fried, Henry Geldzahler, Kynaston McShine, Dorothy C. Miller, Gerald Nordland, and Seitz—were putting on to great acclaim in museums around town and across the country.[38] Whether at the instigation of Messer, the Guggenheim's director, or through his own ambition, Alloway strove to curate the kinds of shows that brought equal amounts of attention to the museum and to the curator, a goal not necessarily visible to museum visitors. In the lead-up to *Systemic Painting,* Alloway actively dismissed other curators' concept shows—Seitz's *Responsive Eye* was but one—while also examining them in detail. His extant curatorial files reveal a comprehensive study of several exhibitions of abstract art; they include primary and secondary research materials, lists of artists, slides, sketches of artworks, exhibition plans, and typed notes for national and international, as well as gallery- and museum-based, shows.[39] The methodical way in which his exhaustively annotated lists were compiled shows Alloway to be astutely sizing up his competition. This is borne out by the number of artists he selected for *Systemic Painting* who had also appeared in earlier exhibitions, as well as the number of citations of ideas gleaned from either the shows or their catalog essays that made their way into Alloway's essay.

What he could not have foreseen, however, was being overshadowed by the mix of painting and sculpture represented in the Dwan Gallery's exhibition *10 × 10,* which opened in October in New York; or, more importantly, McShine's all-sculptural display of American and British art, *Primary Structures,* which had opened at the Jewish Museum in April. Organized by Virginia Dwan, *10 × 10* (also referred to as *10*) was meant to promote Carl Andre, Jo Baer, Donald Judd, Robert Smithson, and other minimalist sculptors to collectors. Its radically reduced presentation of objects, however, introduced a new style of exhibiting contemporary art. Similarly, *Primary Structures* was also innovative in its presentation of the art version of "Swinging London," which included Anthony Caro and others already well known in Britain. The exhibition was also much larger and contained more objects than the Guggenheim show. Both shows stole the thunder from *Systemic Painting*'s September opening. This fluke of timing and institutional organization also positioned *Systemic Painting* squarely between the new minimalism and the old formalism, without fully connecting it to either.

That *Systemic Painting* remained unnamed for so long seems less like the result of curatorial procrastination or haste in putting together the show and more like a product of the gestation of an idea, one that had links back to the

1950s, before the Guggenheim or any of the artists in the show were even on Alloway's aesthetic radar. Systemic, as an idea, emerged from his interest in systems, but it also had antecedents in other words that he applied to abstract painting. During his first lecture at the Guggenheim, he discussed something that he called *matter painting,* "a form halfway between painting and sculpture."[40] As objects, matter paintings were decidedly abstract and devoted to occupying literal space, rather than creating the illusion of space by means of the "space-making qualities of color or a gesture of a brush on the surface."[41] In the *Systemic Painting* catalog essay, Alloway returned to his concern with matter, describing the paintings on view as "physical and awkward, not a pure essence of art."[42] While certainly true of objects the size and scale of David Novros's pair of shaped canvases titled *2:16* (1965), this description denigrated their presence in the galleries (fig. 2). It is likely that Alloway was not out to defame the artists in his show. The statement was an attempt to reconcile his earlier concept with Donald Judd's more recent description of "specific objects" as three-dimensional works that existed somewhere between painting and sculpture.[43] While Judd approached the issue from the angle of sculpture, Alloway argued from the side of painting, a return to his previous consideration of matter. Defining an art object as nonart is a return to Alloway's first major critical contribution, pop art, which was an attempt to understand the work of culture across objects, irrespective of a hierarchy of high and low. In this case, "physical and awkward" paintings were more important precisely because they had something more substantial to offer than surface appeal.

Fig. 2.
Lawrence Alloway (far right) overseeing the installation of *Systemic Painting.* David Novros's *2:16* (1965) is visible on the wall on the left.

Alloway first proposed *Systemic Painting* in the summer of 1964, offering it as a replacement for a Robert Motherwell retrospective that the Guggenheim lost to MoMA.[44] Alloway laid out a plan for an exhibition of a "current American tendency" that would also be an affirmation of the "Museum's commitment to US art."[45] This tendency, as yet unnamed, would have four categories of objects: the shaped canvas, the multiple canvas, the one-image canvas, and objects in color, with the final designation, *objects,* confirming that this would be a show of painting and sculpture. According to Alloway, all of the proposed artists (including Feeley, Robert Irwin, Judd, Noland, Larry Poons, Ad Reinhardt, Stella, and Neil Williams) were "opposed to abstract expressionism" and invested in painting that went beyond the "traditional organisation of space," and, ultimately, perhaps most important to the project, as concerned with "*systematic* imagery" as form or color (emphasis mine).[46] The slippage from *system* to *systematic* is not noted or explained. The most striking aspect of the proposal is that the original idea included not only sculptors like Judd but also the argument that Judd's work was primarily an extension of a painting practice. Alloway stated that the show was curtailed and reoriented due to the rival sculpture show, *Primary Structures,* but it is just as likely that the exclusion of sculpture from *Systemic Painting* might have been seen as a necessary edit. Once minimalism gained ground with its assertions of the primacy of the sculptural object, it would not have been feasible to purport the claim that sculpture had its roots in painting.[47]

Another word—*field*—circulated inside the Guggenheim for more than a year and a half.[48] Alloway and the staff freely discussed the term, among themselves and with others outside the museum, as a possible name for the show. Given the inclusion of artists such as Noland and Alloway's close reading of Greenberg, it seems logical to assume that *field* was shorthand for color-field—a descriptor of Greenberg's for paintings that include large areas of uninterrupted color within a canvas. Although "mid-century Field painting"[49] is referenced in the exhibition catalog, in Alloway's full conception the painterly field in these works was not about the relationship between color and compositional space but rather spatial possession ("the seductive air of [Mark] Rothko, despite their sense of space as a field") or ownership of expertise.[50] Both possibilities are, of course, reliant upon Newman, who had been one of Greenberg's early examples of a color-field painter.[51] In the *Systemic Painting* catalog, Alloway saw Newman's canvases as whole, indivisible into "small parts," where their "total field is the unit of meaning."[52] *Field* described the interstitial relationship between the artist's knowledge and the transmission (as visibility) of that knowledge. This could happen either within the space of the canvas or not. Alloway's "total field" is relational, sharing a similar sense to the

Fig. 3.
Lawrence Alloway installing
Systemic Painting. Kenneth
Noland's *Par Transit* (1966)
is on the left, and Thomas
Downing's *Reds Escalator*
(1966) is on the right.

Fig. 4.
Lawrence Alloway installing
Systemic Painting. Neil
Williams's *Sartorial Habits of
Billy Bo* (1966) is on the left,
Frank Stella's *Wolfeboro IV*
(1966) is on the right.

Fig. 5.
Guggenheim Museum staff
installing *Systemic Painting.*
Frank Stella's *Wolfeboro IV*
(1966) is visible.

sociologist Pierre Bourdieu's later use of the term *field,* wherein a field, like art, is constituted by the set of ever-shifting conditions that determine its corpus at any one time.[53] Later, Alloway described *field* as a way to see "painting as a realm of potential meaning" that could not be reduced to its parts.[54] This idea charged a metaphorical relationship between art and "the world at large," in which both were part of "a continuum of changing relationships."[55]

V.

What, then, was systemic painting? According to critical reception, this question was not answered, either in the show itself or in the written text that accompanied it (fig. 3). As Nigel Whiteley asserts, the title/concept was "regrettable" because "it did not convey information or an idea clearly."[56] Was the investigation of systems an attempt to describe viewers' visual and physical reactions to objects that, through their size, scale, density of paint, shape of canvas, or seriality, had become something between painting and sculpture—hybrids that resisted full assimilation into a single medium?[57] The images of Alloway installing the show seem to point to the very confounded way in which he grappled with the intermedia as matter, field, or system, and with objects that required multiple hands to lift and move and greater distance to view—objects that dwarfed his physical presence in the gallery space and demanded that he, their curator, contend with them (figs. 4–6).

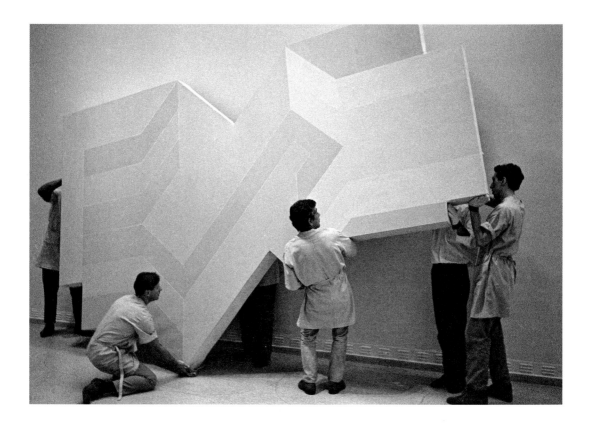

Fig. 6.
Guggenheim Museum staff installing *Systemic Painting*. Neil Williams's *Sartorial Habits of Billy Bo* (1966) is visible.

The systemic painting on view was abstract, but that was only one of its properties, and not its most central one. First and foremost, it seems that Alloway wanted viewers to understand something that they could not see—a system. Systemic painting should be planned, organized, and ordered as a composition before the painter picks up the brush and before the paint transfers from the brush onto the canvas. The resulting painting need only embody that forethought to relay it to the viewer. I would argue that the meaning of *systemic* had nothing to do with what can be seen on the canvas and everything to do with how what is there got there.

Given Alloway's interest in science fiction and his position within a generation basking equally in the potential of the space race and the civil rights movement, his invocation of systems theory, unlike formalism and Greenberg's antiprogressive, categorical separation, called for a kind of forward-leaning wholeness.[58] The utopian outlook of *Systemic Painting* wanted to be of its moment—specifically, a moment that was not institutional, academic, conventional, or embracing of establishment art—all of which fell outside of Alloway's personal mandate. Yet, the show was slightly off. It was deeply institutional at the height of countercultural activity in America. It was also

materially conservative in comparison to exhibitions such as *The Responsive Eye,* which incorporated plastics, fabric, and kinetic work. In many ways, Alloway's use of the terms *system* and *systemic* was already slightly retrograde by 1966. By then, *the system* had become a negative term for something that one fought against—the antithesis of the newly forming society. For something to be systemic it would also be endemic, like racism, sexism, or classism— ideologies that Alloway actively combated in his work and in his personal life. On the eve of his exit from the Guggenheim, Alloway certainly did not wish to endorse anything that smacked of the institutional. He was leaving the museum precisely because of its inability to be progressive. Yet, the exhibition came off as "establishment," a part of the system rather than an action set against it.

Alloway's search for a system or order within this period was an attempt to contend with what was new—what he was seeing and talking about in artists' studios. He wanted to capture the newness, to get it into the museum and out into the world within the shortest period of time possible; *systemic* provided the quick summary he sought. Seen from another vantage, *Systemic Painting*— the show, the term, the half-formed idea, the exhibition catalog essay, and the subsequent articles about it—was marked by Alloway's interest in putting his stamp on the moment. It bears the self-consciousness of someone transitioning from a secure, prestigious position to an uncertain future; someone still trying to be recognized on the level of Greenberg and in competition with curatorial peers such as Seitz and McShine.[59] And then there is a third possibility, a blending perhaps of the first two: Alloway was always looking for order, trying to make sense of things and wanting to place a stable armature on top of shifting discourses. The realization of the continuum that he so often remarked on as the motility of popular culture was one of those things that he attempted to fix and make definite for himself and for those who read his essays. This is why systemization appealed to Alloway: for him, everything was connected to something else.[60] And if he did not effectively describe this for the audience, it was not because it was not there, it was because it was such an innate, interior function of his own thinking that it was difficult for him to get it out, a situation not unlike the acknowledgment or sharing of any other personal intimacy.

A clearer picture of the systemic did emerge, eventually. After the show opened, Alloway wrote "Background to Systemic," in which he sought to nail down American art at that moment.[61] In terms of the exhibition, however, what we are left with is a show that may have failed to make its point but whose afterlife is far more important than the sum of its checklist or the outline of its floor plan.

Notes

Special thanks are owed to James H. Dickerson II, the faculty of the history of art at the University of Edinburgh, the staff of the Solomon R. Guggenheim Museum Archives, and Anthony Vidler.

Epigraph: Ludwig von Bertalanffy, *General System Theory: Foundations, Development, Applications,* rev. ed. (New York: George Braziller, 1968), 3.

1. Milton Esterow, "Curator Resigns from Guggenheim," *New York Times,* 15 June 1966, 49. See also Grace Glueck, "Not Exactly Trying to Please," *New York Times,* 19 June 1966, 108. The disagreement between Alloway and Messer caused the National Collection of Fine Arts to abandon the Guggenheim and enlist Henry Geldzahler of the Metropolitan Museum of Art to curate the biennale. In a candid letter written just before his resignation, Alloway wonders "how long I'll be a curator of the concrete corkscrew now?"; see Lawrence Alloway to Jim [surname is unknown], 20 February 1966, Lawrence Alloway Papers, Getty Research Institute, Los Angeles, acc. no. 2003.M.46, box 9, folder 3.

2. Alexander Laszlo and Stanley Krippner, "Systems Theories: Their Origins, Foundations, and Development," in J. S. Jordan, ed., *Systems Theories and A Priori Aspects of Perception* (Amsterdam: Elsevier, 1998), 47.

3. The mathematician Alfred North Whitehead and the biologist Paul A. Weiss are also credited with the early analysis of systems theory.

4. Ludwig von Bertalanffy, "The History and Development of General System Theory," in idem, *Perspectives on General System Theory* (New York: George Braziller, 1975), 159.

5. Edgar Taschdjian notes that after von Bertalanffy developed General System Theory in the 1930s in his native Austria, he began to lecture on the subject. See von Bertalanffy, "The History and Development of General System Theory," 153. In 1937, von Bertalanffy presented his research to philosophers at the University of Chicago. After World War II, influential articles such as his "An Outline for General Systems Theory," *British Journal for the Philosophy of Science* 1, no. 2 (1950) were published and circulated in English-language journals. In 1954, von Bertalanffy engaged an interdisciplinary group of biologists, economists, and mathematicians to start what would later become the International Society for the Systems Sciences. This group, which included the economist Kenneth Boulding, the physiologist Ralph Gerard, and the mathematician Anatol Rapoport, further spread the acceptance and use of systems theory in academic, governmental, and popular arenas.

6. Von Bertalanffy, "The History and Development of General System Theory," 169.

7. For a longer discussion of Alloway and the Independent Group, see Anne Massey, *The Independent Group: Modernism and Mass Culture in Britain, 1945–59* (Manchester: Manchester University Press, 1995).

8. Lawrence Alloway, "The Long Front of Culture," *Cambridge Opinion* 17 (1959): 26.

9. Alloway, "The Long Front of Culture."

10. Alloway first used systems theory as a resource in "The Support Systems and the Art Galleries," *Art Monthly* no. 53 (February 1982): 3–5. In this article, he specifically cited Kenneth Boulding, one of von Bertalanffy's collaborators.

11. Lawrence Alloway, "Personal Statement," *ARK,* no. 19 (March 1957): 28.

12. Alloway, "Personal Statement."

13. Lawrence Alloway, "City Notes," *Architectural Design* 29, no. 1 (January 1959): 34.

14. Alloway, introduction to *Jackson Pollock: Paintings, Drawings and Watercolors from the Collection of Lee Krasner Pollock,* exh. cat. (London: Marlborough Gallery, 1961): n.p. [5].

15. Lawrence Alloway, *The Critic and the Visual Arts: Papers Delivered at the 52nd Biennial Convention of the American Federation of Arts in Boston, 1965* (New York: American Federation of Arts, 1965), 15.

16. Lane Relyea, *Your Everyday Art World* (Cambridge, Mass.: MIT Press, 2013), 27.

17. Lawrence Alloway, "Art and the Communications Network," *Canadian Art* 23, no. 100 (January 1966): 35–37.

18. Alloway, "Art and the Communications Network," 37.

19. Alloway, "Art and the Communications Network."

20. Donna de Salvo made a similar connection between systems theory and art in the exhibition *Open Systems: Rethinking Art c. 1970* (Tate Modern, London, 1 June– 29 August 2005). Though she does not elaborate on systems theory, she invokes its use by "corporations and governments" in the late 1960s as an example of its currency in contemporary society; see de Salvo, "Where We Begin: Opening the System, c. 1970," in *Open Systems: Rethinking Art c. 1970* (London: Tate, 2005), 14. De Salvo's title is borrowed from von Bertalanffy's theory of open systems, a subspecialty within his systems research.

21. Lawrence Alloway, *Barnett Newman: The Stations of the Cross; Lema Sabachthani,* exh. cat. (New York: Solomon R. Guggenheim Foundation, 1966), 15–16.

22. Lawrence Alloway, "Op Art: A Response to the Responsive Eye" (lecture, Solomon R. Guggenheim Museum, 1 April 1965), Solomon R. Guggenheim Museum Archives, audio recording, reel-to-reel collection (615214T23).

23. Lawrence Alloway, "Art in New York Today," *The Listener,* 23 October 1958, 647.

24. During the lecture, much to the amusement of his audience, Alloway made several derisive remarks about Seitz's show, including the following: "hanging an abstract show based on optics is like hanging a figurative show based on vanishing-point perspective." See Alloway, "Op Art: A Response to the Responsive Eye."

25. Alloway, "Op Art: A Response to the Responsive Eye."

26. Alloway, "Op Art: A Response to the Responsive Eye."

27. Alloway, "Op Art: A Response to the Responsive Eye."

28. As Stephen Moonie has outlined, Alloway engaged in serious scientific pursuits such as cybernetics. See Moonie, "Mapping the Field: Lawrence Alloway's Art Criticism-as-Information," *Tate Papers,* no. 16 (1 October 2011), http://www.tate.org.uk/research/publications/tate-papers/mapping-field -lawrence-alloways-art-criticism-information.

29. Lawrence Alloway to Everett Ellin, 10 December 1965, Lawrence Alloway records, Solomon R. Guggenheim Museum Archives. Ironically, Ellin, then the assistant director of the Guggenheim, instigated the adoption of IBM mainframe comput- ers by museums to support the migration of museum records from manual index cards to computer databases. In 1967, he was named the first executive direc- tor of the Museum Computer Network, which spearheaded the first full-scale

introduction of technology to museums.

30. The Newman show did not close until 19 June 1966. In a letter to Kenneth Noland dated 16 June 1966, Alloway wrote, "This is to invite you formally to take part in the fall exhibition, at present untitled, at the Guggenheim Museum." Numerous other internal documents support the idea that Alloway was still actively configuring every part of the show, including its title, shortly before it opened; see 189 [*System Painting* files], Correspondence, Artists: Noland, Kenneth, Lawrence Alloway records, Solomon R. Guggenheim Museum Archives.

31. Arnason's inclusion in this list might seem odd, save for the fact that he was a trustee and vice president of art administration for the Guggenheim Foundation during Alloway's tenure at the museum. Though Alloway's relationship with Messer deteriorated in the run-up to the exhibition, his relationship with Arnason seemed to remain intact.

32. Jules Langsner, introduction to *Four Abstract Classicists,* exh. cat. (Los Angeles: Los Angeles County Museum of Art, 1959), 10. Alloway was certainly convinced of Langsner's ideas for the exhibition. After the show opened in Los Angeles, it traveled to the San Francisco Museum of Modern Art. From there, the show was rebranded as *Four Abstract Classicists: West Coast Hard-Edge* for the ICA, where it was on view from March to April 1960. Alloway worked with Langsner to install the exhibition in London and wrote a new preface for the catalog in support of Langsner and the painters.

33. Lawrence Alloway, *Systemic Painting,* exh. cat. (New York: Solomon R. Guggenheim Foundation, 1966), 12.

34. Alloway, *Barnett Newman,* 11–12. For a longer discussion of the Newman exhibition, see Courtney J. Martin, "Art World, Network and Other Alloway Keywords," *Tate Papers,* no. 16 (1 October 2011), http://www.tate.org.uk/research/publications/tate-papers/art-world-network-and-other-alloway-keywords.

35. Alloway, *Systemic Painting,* 12.

36. Martin, "Art World, Network and Other Alloway Keywords."

37. The art dealer and collector Ben Heller confirms the perception of Newman as an artist who was widely known to other artists but little known to collectors and museums well into the late 1950s. Ben Heller, interview by Avis Berman, 18 April 2001, Museum of Modern Art Oral History Program, http://www.moma.org/momaorg/shared/pdfs/docs/learn/archives/transcript_heller.pdf.

38. Although Fried is mainly known now as an art historian and critic, he was of great interest to Alloway as curator of the exhibition *Three American Painters: Kenneth Noland, Jules Olitski, Frank Stella* at the Fogg Museum, Harvard Art Museums, 21 April–30 May 1965.

39. 189 [*System Painting* files]: Research, 1964, Lawrence Alloway records, Solomon R. Guggenheim Museum Archives.

40. Lawrence Alloway, "Lawrence Alloway First Lecture" (lecture, Solomon R. Guggenheim Museum, 11 February 1962), Solomon R. Guggenheim Museum Archives, audio recording, reel-to-reel collection (615220:TO6).

41. Alloway, "Lawrence Alloway First Lecture."

42. Alloway, *Systemic Painting,* 17.

43. Donald Judd, "Specific Objects," *Arts Yearbook 8,* 1965, 74–82.

44. Robert Motherwell's first retrospective opened at the Museum of Modern Art on 28 September 1965. It was curated by Frank O'Hara.

45. Lawrence Alloway, "Exhibition Proposal, June 16, 1964," call number A0003, box 1096, folder 15, 189 [*Systemic Painting* files], Exhibition Planning, 1964–65, Lawrence Alloway records, Solomon R. Guggenheim Museum Archives.

 In April 1964, Alloway proposed a series of small-scale New York shows to Messer ("since the Museum is having a series of rather historical exhibitions, we could use the six bays at the top to demonstrate our awareness of the current scene"), one of which seems to have been the seed for *The Shaped Canvas,* which opened in December 1964 with Frank Stella, Neil Williams, Alexander Liberman, Richard Smith, and Paul Feeley. Other ideas from this memo relate to the later exhibition proposal for *Systemic Painting;* see "Proposal, *The Shaped Canvas* (#167), 1964," box 557, folder 18, Lawrence Alloway records, Solomon R. Guggenheim Museum Archives.

46. Alloway, "Exhibition Proposal, June 16, 1964."

47. Painting that pushed boundaries (abstraction, when realism was in, in the early 1950s; realism, after abstraction was the norm, in the 1970s) was one of Alloway's chief preoccupations with American art. This show prioritizes sculptural painting, which affirms what he wanted from the medium: an object that nearly abandons itself to return to its essence.

48. Numerous letters, memos, and notes circulated among Alloway, Peter Engel, Linda Konheim (the exhibition catalog editor), and Messer from the summer of 1964 until the exhibition opened in September 1996 cited *field* as a provisional, actual, or discontinued title. In one interoffice memo, Alloway referred to the upcoming show as "field painting (better known as Systemic)." See also Lawrence Alloway to Susan Tumarkin, n.d. [ca. summer 1966]; and "the field painting catalogue (which will now be called Systemic Painting catalogue...)," Linda Konheim to Peter Engel, 13 July 1966, call number A0003, box 1096, folder 4, correspondence, 189: *Systemic Painting,* Exhibition records, Lawrence Alloway records, Solomon R. Guggenheim Museum Archives.

49. Alloway, *Systemic Painting,* 13.

50. Alloway, *Systemic Painting,* 12.

51. In a review of Barnett Newman's one-man shows at the Betty Parsons Gallery, Greenberg wrote that Newman's "pictures do consist of only one or two (sometimes more) rectilinear and parallel bands of color against a flat field"; see Clement Greenberg, "Feeling Is All," *Partisan Review,* January–February 1952, reprinted in John O'Brian, ed., *Clement Greenberg: The Collected Essays and Criticism,* vol. 3, *Affirmations and Refusals, 1950–1956* (Chicago: University of Chicago Press, 1993), 103. However, the article most often cited as the source of the concept of color-field is Greenberg, "American-Type Painting," *Partisan Review* 22, no. 2 (Spring 1955): 179–96.

52. Alloway, *Systemic Painting,* 12.

53. See Pierre Bourdieu, *The Field of Cultural Production: Essays on Art and Literature* (New York: Columbia University Press, 1993).

54. Lawrence Alloway and Michael Auping, "Field Notes: An Interview," in *Abstract*

Expressionism: The Critical Developments (New York: Abrams; Buffalo, N.Y.: Albright-Knox Art Gallery, 1987), 126.

55. Alloway and Auping, "Field Notes: An Interview."

56. Nigel Whiteley, *Art and Pluralism: Lawrence Alloway's Cultural Criticism* (Liverpool: Liverpool University Press, 2012), 204.

57. Following *Systemic Painting,* Mel Bochner took up the idea of seriality to propose it as *the* mechanism of the system; see Bochner, "Serial Art Systems: Solipsism," *Arts Magazine,* no. 41 (Summer 1967): 39–43.

58. For a longer discussion of Alloway's interest in science fiction, see the essay by Peabody, this volume, as well as Nigel Whiteley, *Reyner Banham: Historian of the Immediate Future* (Cambridge, Mass.: MIT Press, 2002), 80–139.

59. Dore Ashton dismissed *Systemic Painting* as a concept (see Dore Ashton, "Marketing Techniques in the Promotion of Art," *Studio International* 172 [November 1966]: 270–71), and she was not the only critic to do so. For other unfavorable reviews, see Hilton Kramer, "Systemic Painting: An Art for Critics," *New York Times,* 18 September 1966; Rosalind Krauss's letter to the editor in response to Robert Pincus-Whitten's approval of *Systemic Painting* in *Artforum* 5, no. 4 (December 1966): 4; and Lucy R. Lippard, "After a Fashion: The Group Show," *The Hudson Review* 19, no. 4 (Winter 1966–67): 620–26.

60. Alloway's archives at the Getty Research Institute, the Archives of American Art, and the Solomon R. Guggenheim Museum attest to his desire for order. Each contains numerous lists of books, names, ideas, and so forth.

61. Lawrence Alloway, "Background to Systemic," *Art News* 65, no. 6 (October 1966): 30–33.

JOY SLEEMAN

LAWRENCE ALLOWAY, ROBERT SMITHSON, AND EARTHWORKS

He was, according to his wife, the painter Sylvia Sleigh, "an old fashioned futurist," a city dweller, whose impatience with the Arcadian extended to a dislike of plants and trees.
—Richard Kalina, "Critical Commentary: Imagining the Present," 2006

In light of his preference for urban environments, it might seem surprising that Lawrence Alloway became interested in earthworks, an art form that when first reported on by the press in the late 1960s was dubbed, among other things, "dirt art" and was characterized as an escape from the city.[1] Given Alloway's desire to be au fait with the latest cultural trends, however, it seems reasonable to assume that he would have taken an interest in earthworks when it was the talk of the town (that town being New York) in the fall of 1968 and through 1969.[2] But he did not write an extended discussion of the phenomenon (he called earthworks "a tendency") until his "Site Inspection" article of October 1976.[3]

When Alloway first referred to earthworks, in the period from 1968 to 1971, he understood it as an aspect of a larger "zone" or "cluster" of art activity, as yet unnamed (or unnameable), that included conceptual art, documentary art, and happenings, as well as land art, ecologic art, and earthworks.[4] Today, earthworks is most commonly understood as a subcategory of the larger phenomenon of land art.[5] Alloway came into early contact with many of the American and European artists currently discussed under the nomenclature of land art, including Christo, Jan Dibbets, Michael Heizer, Nancy Holt, Peter Hutchinson, Richard Long, Dennis Oppenheim, Alan Sonfist, and Michelle Stuart, all of whom are represented in his papers at the Getty Research Institute (GRI). Indeed, he wrote about the work of Christo as early as 1968. But he didn't view the work of all of these artists—including Christo—as earthworks. And it was earthworks, specifically, that became Alloway's focus.

In the first comprehensive book-length survey of earthworks, *Earthworks and Beyond,* published in 1984, John Beardsley writes that "only sculptures in earth and sod can properly be described as earthworks."[6] Even by comparison with Beardsley's definition, Alloway's conception of earthworks in his 1976

article "Site Inspection" seems narrow. In Alloway's thinking, earthworks was an American phenomenon characterized by monumentality, site-specificity, zero mobility, and long duration. For Alloway, it was largely the work of three men: Walter De Maria, Michael Heizer, and Robert Smithson.[7]

Alloway's narrow focus was not for lack of knowledge of the wider scene (as his papers at the GRI, his regular reviews in *The Nation,* and the evidence of *Artists and Photographs* makes clear).[8] This was not the reason, for example, for leaving European artists out, even in 1969 (when he published a brief definition of the movement in "The Expanding and Disappearing Work of Art"). The reason for his intentionally limited view was his relationship with Robert Smithson. In Alloway's view, earthworks was not a genre or a movement, it was a theory, given by Smithson in his article "The Monuments of Passaic";[9] and this is why their relationship is the main focus of this essay. For Alloway, earthworks and Robert Smithson were synonymous.

Alloway wrote two significant essays on Smithson: "Robert Smithson's Development," first published in *Artforum* in November 1972, and "Sites/Nonsites" in Robert Hobbs's *Robert Smithson: Sculpture* (1981), the first book-length treatment of Smithson's sculpture. Alloway also afforded Smithson a central role in his two-part essay "Artists as Writers," published in *Artforum* in March and April 1974.[10] My essay draws extensively from these published sources. It explores Smithson and Alloway's developing friendship, its impact on the writings of both, and the implications of an unrealized but significant collaborative film project. I will speculate about what Smithson and Alloway each got from their relationship. What was or was not possible for each to do or think before they met? And what did they create together?

What is the basis for such an inquiry? There are, of course, the essays Alloway wrote about Smithson, although Alloway makes clearer allusions to their friendship in his writings after Smithson's death than he did during the artist's lifetime. This reticence went both ways: Alloway receives only one reference in the index to the 1996 edition of Smithson's collected writings.[11] There is no correspondence between Smithson and Alloway in Alloway's papers at the GRI. Alloway is not named in the papers of Smithson and Nancy Holt (the American sculptor and filmmaker, and Smithson's wife) at the Archives of American Art, though in the General Correspondence folder there is a single letter and a postcard from Alloway to Smithson, both dated 1972.[12] However, two important archival sources for establishing their relationship do exist: Holt and Smithson's calendars—month-to-a-page calendars recording their activities between 1966 and 1973[13]—and the week-to-a-page diaries of Sylvia Sleigh (the Welsh artist, and Alloway's wife) that recorded her activities, and many of

Fig. 1.
**Page from Sylvia Sleigh's
engagement calendar
for 10–16 October 1966.**
Los Angeles, Getty Research
Institute.

Alloway's (fig. 1).[14] More than just traces of specific encounters, these calendars help establish the chronology of a developing relationship.

Alloway acknowledged the importance of establishing chronologies, and there is ample evidence within his papers of attempts to chart the historical arc of individual artists, including Smithson. In an interview from 1969, Alloway argues for the necessity of temporal reconstruction; although he is talking about dating paintings, the principles apply more generally:

> Now to date them right, you have got to know what order the artist painted them in. It is not just a matter of reading accounts of palaces in the old ledger books of cardinals. It is also a question of knowing that Dosso Dossi could not have painted like this until his brother had been to Rome and come back after seeing so and so. An art historian is really doing that kind of close analysis. He is reconstructing the creative thinking as well as the handiwork that went into the work of art.
>
> It is just as important to know the meaning of the chronology of works, and their sources and transformations as it is to see them painted.[15]

In order to do that art historical task with regard to Smithson and Alloway's joint activities, it will be necessary to establish some of their chronology, as I have begun to do in the introduction to this essay. But it will also become

apparent that constructing—rather than reconstructing—Smithson's creative thinking was something Alloway attempted in his writings.

Alloway and Smithson shared a point of personal affinity in that both had a stake in shaping the art history of the future. Earthworks was to Smithson what pop was to Alloway: their critical and creative heritage. For Alloway, the term *earthworks* was Smithson's coinage, and the concept was largely Smithson's creation: "It was Smithson who gave the Earthworks movement its name (the genetic moment is described in 'The Monuments of Passaic,' originally published in 1967)."[16] In a twist that appealed to Alloway, who had a lifelong appreciation for genre fiction, earthworks was named after a novel by the British science fiction writer Brian W. Aldiss.[17]

The Development of a Friendship

Alloway witnessed Smithson develop earthworks not in the deserts of the West—though that was ultimately where Alloway went to find their legacy in 1976—but a decade earlier, in New York City and in the artist's published writing. By 1966, Alloway and Smithson were moving in each other's ambit. In the chronology in *Robert Smithson: Sculpture,* Hobbs records for 1966: "Becomes friendly with Virginia Dwan; joins Dwan Gallery. Meets Ad Reinhardt, who asks him to plan '10' show at Dwan Gallery; also meets Lawrence Alloway, Jo Baer, Max Kozloff, Lucy Lippard, and Annette Michelson."[18] Many of these people were in Alloway's social circle, so it is perhaps no surprise that they ran into each other.

Smithson and Alloway met in the same year that minimal art was attracting considerable attention. And it is in this context that Alloway first encountered Smithson's work. It was a context Alloway was paying close attention to, not least because he was directly involved in promoting minimalism in exhibitions and articles. *Primary Structures: Younger American and British Sculptors,* a show curated by Kynaston McShine and often cited as the first institutional survey of minimal sculpture, included work by Smithson and opened on 26 April at the Jewish Museum in New York; Alloway's own *Systemic Painting* opened at the Solomon R. Guggenheim Museum on 22 September 1966. Alloway quoted from Smithson's *Artforum* article "Entropy and the New Monuments" (June 1966) in his essay for the *Systemic Painting* catalog. Alloway wrote the catalog essay for a twentieth-anniversary exhibition called *Pattern Art* at the Betty Parsons Gallery; Smithson's work was included in the show. *Pattern Art* opened on 4 October 1966, the same day as the exhibition *10* at the Dwan Gallery, which also featured work by Smithson. Virginia Dwan opened a New York branch of her Los Angeles–based gallery in 1965 and began representing Smithson in 1966;

she was also one of the first financial backers of the Park Place Gallery when it moved from 79 Park Place to 542 Broadway in November 1965. Alloway was close to the Park Place group—an artists' cooperative of sculptors and painters—from its beginnings in 1963.[19] Work by Park Place sculptors was featured in *Primary Structures* and work by Park Place painters appeared in *Systemic Painting*. After an initial "members only" exhibiting period, the Park Place Gallery began to show work by invitation of nonmember artists, one of whom was Smithson. Evidently, by 1966, Alloway knew something of Smithson's work and writing, and their professional circles were clearly overlapping.

There were ample opportunities for Alloway and Smithson to meet during this period, but archival evidence indicates a point when their relationship became more deliberate. The first mutual calendar entry that it is possible to cross-reference between Sleigh's calendar and that of Holt and Smithson is Thursday, 13 October 1966. Sleigh notes: "7.30 Smithoson [*sic*]" (see fig. 1). Holt and Smithson: "7:30 DINNER ALLOWAY." Lawrence Alloway's name and phone number also appear (in Smithson's handwriting) in a space at the bottom of Holt and Smithson's October calendar, perhaps suggesting this was a newly acquired number.[20]

The dinner date on 13 October 1966 coincided with interesting turning points in the careers of the two men. Both were enmeshed in the New York art world network, which Smithson made the subject of his art, and Alloway of his writing.[21] Alloway's exhibition *Systemic Painting* was still up, but he had already resigned his position as curator at the Guggenheim Museum on 13 June 1966. He had recently embarked on an academic year as writer in residence at Southern Illinois University, a period described by Nigel Whiteley as Alloway's "exile in Carbondale," and would soon return to New York to posts first at the School of Visual Arts and then at the State University of New York (SUNY) at Stony Brook. That short period of absence from New York perhaps served to sharpen his views on, and his desire to be part of, the art scene there.[22] Meanwhile, Smithson had just published his first substantial articles, "The Crystal Land" and "The X Factor in Art," in *Harper's Bazaar* in May 1966 and July 1966, respectively, and "Entropy and the New Monuments" in *Artforum* in June 1966.[23]

Alloway enjoyed the fact that earthworks, like pop art, had been picked up first by the popular magazines, rather than the art press, and that Smithson had published some of his first writings in *Harper's Bazaar*. In 1973, Alloway said in an interview: "Where do these things start? In journals like *Vogue* and *New York Magazine*. The first article on earthworks appeared in *The Saturday Evening Post*!"[24] These observations echo others he had made about pop art in 1966, when he pointed out that *Time* and *Life* provided information about pop art in advance of *Art News* and *Art International*.[25] Alloway thought that the

early attention by the popular press was a significant parallel between (his) pop art and (Smithson's) earthworks. Both Alloway and Smithson were committed to publishing in popular magazines and shared personal connections with the editorial staff of such publications: Holt and Smithson with Dale McConathy of *Harper's Bazaar,* where Holt worked part time as an assistant literary editor in 1966–67, and Alloway with *Time* magazine critic Rosalind Constable, whom he met on his first visit to the United States, in 1958. In an interview in 2007, Holt commented: "In a mass magazine we could reach a huge audience, in beauty parlors, doctors' offices, and homes around the country.... Bob and I introduced Dale to many artists and others in the art world. Initially it was Bob's suggestion to get artists to write for the magazine, and we supported their articles."[26] These observations also attest to a more active role for Holt in the development of Smithson's writings than is generally acknowledged in the literature on Smithson.

More fugitive evidence of Alloway and Smithson's burgeoning friendship can be found in various published and unpublished written sources. For example, in a 1972 interview conducted for the Archives of American Art, Smithson alludes to a meeting that must have taken place during the course of Alloway's research:

> ROBERT SMITHSON: His name [that of Smithson's great-grandfather] was Charles Smithson. Well, of course since then all the work has been torn out of the subways. I guess it was of that period that Lewis Mumford called The Bronze Decade; you know, that kind of work. There was an article written about him in an old journal from around 1900. *Lawrence Alloway is doing a very comprehensive piece on me for* Artforum *so I've given him that magazine. But it was interesting* [emphasis mine].[27]

The piece that Alloway was writing, published in *Artforum* as "Robert Smithson's Development" in November 1972 (fig. 2), did not make use of this old magazine.[28] Nor, indeed, does Alloway discuss much at all about Smithson's biography or family background, apart from an allusion to Smithson's "early experiences in New Jersey, where he was born and raised," and an anecdote of Smithson's about an uncle giving him a crystal. Instead, Alloway's article begins with Smithson in the context of minimal art and his sculpture of 1964–66, precisely the context in which Alloway first encountered Smithson and his work. But this personal connection is not disclosed here or, indeed, anywhere in the article. As it turned out, this article became the only feature-length treatment of Smithson's work to appear in print during his lifetime. In 1975, it was anthologized in Alloway's book *Topics in American Art since 1945,* a standard textbook for many university art history surveys. As a result, what Alloway

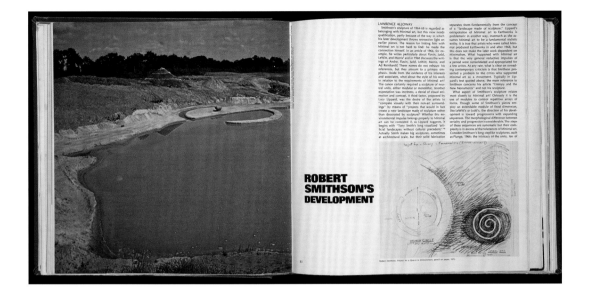

Fig. 2.
Opening spread.
From Lawrence Alloway,
"Robert Smithson's
Development," *Artforum*
11, no. 3 (November 1972):
52–53.

chose to include, and to exclude, did important work toward establishing Smithson's artistic profile. It lends credence to the piece to know that Alloway and Smithson were close and that the article was published while Smithson was alive, but there is little in the article itself to give a sense of the extent of their relationship.[29]

In "Robert Smithson's Development," intimacy is suggested but not explicitly stated. It does not say "when I first met him" or "when we visited the sites in Passaic together in 1972" (mentions that do appear in writings published after Smithson's death, most notably perhaps in the essay "Sites/Nonsites" in 1981).[30] Instead, Alloway writes of Smithson's famous Passaic text: "The 'monuments' have not survived to 1972, except for the bridge and The Sand-Box Monument (also called The Desert) in Taras Shevchenko Park." There is no footnote. Readers are not told that Alloway knows this from his trip with Smithson to Passaic sometime in 1972. Nor do they learn that Alloway's account of Smithson's *Spiral Jetty* (1970) is based on a visit to the site in Utah with Smithson in January 1972.[31] Instead, Alloway writes, "'Since I was a kid,' Smithson remembers, he had been interested in crystals after an uncle, who worked for the Hammond Map Company, gave him a quartz crystal."[32] There is no footnote, and the awkwardness of the phrasing—with Smithson appearing in the first and third person in rapid succession—is perhaps a result of Alloway struggling to record this observation without reference to a written source. Alloway goes on to explain that the landscape and its systems of ordering have been familiar to Smithson most of his life, but he does not disclose the origin of the anecdote—presumably a conversation between the two during the preparation of the article, perhaps on one of their trips.

Alloway's article on Smithson outlines a context: a childhood in New Jersey and recent visits there, connections to minimalism, Smithson's developing theory of earthworks, and the importance of books on geology, travel, and science fiction. There is evidence in the "Development" essay, especially in the footnotes, of Alloway's habitual approach to writing on artists by immersing himself in their current reading matter. Shelley Rice, a student of Alloway's at SUNY Stony Brook around the time he was writing his article on Smithson, remembered that "Lawrence spent his weeks working with artists and reading the books they were discussing at the time. He insisted that I read them too and understand their relevance to contemporary creative practice. For him, the intellectual ambiance in artists' studios was as important to the creation, exhibition, and reception of art as the finished objects that came out of them."[33]

The footnotes to "Robert Smithson's Development" reference books that were in Smithson's library and that Alloway had also read. But Alloway does not relate the immediate context of his relationship with Smithson: the one-on-one conversations in New York; the dinners with Smithson, Holt, and Sleigh; the mutual friendship with Smithson's gallerist, Dwan; or the visits to New Jersey and Utah in Smithson's company. These details are fascinating to us now as a lost dimension of Alloway's research process, though they did not seem relevant for Alloway to disclose at the time. His concept of a continuum of art and life had some boundaries, and they were ones that were conventionally accepted in the art writing of the time.

There are clues in the footnotes to "Robert Smithson's Development"—and in the article itself, particularly in parentheses in the text—to how this essay might have been less conventional and more revelatory had Alloway made more of the uniquely privileged view he had of Smithson's development through their friendship. Alloway had privileged access to Smithson and his unpublished writings (and to his varied collection of books and magazines)—"inside information" as Alloway would characterize artists' writing in part 1 of "Artists as Writers"—yet that access remained opaque. All that is revealed in the footnotes of "Robert Smithson's Development" is the following: parenthetically, in note 5, "(All books cited here are in Smithson's possession)," and, in notes 8, 12, 31, and 32, in references to dated typescripts from 1967 to 1972, the last two of which were untitled. These texts are now available to readers in the published writings of Robert Smithson. They were not available to readers of the article in 1972.

Art criticism, Alloway says, "originates its own theories and groupings."[34] The critic should present descriptive information rather than judgment, and he wants to be seen as objective, not partisan. Alloway assumes this tone in the Smithson article, perhaps believing this would better serve Smithson's career

(so tragically unrealized) and avoid accusations of nepotism.[35] He wants to get it into print that Smithson came up with the term *earthworks*—perhaps mindful of his own continual need to defend his coinage of *pop art.*

In this article, as in others, Alloway uses evidence from Smithson's writings. This seems significant, especially in light of Alloway's commitment to artists' writings. Smithson features extensively in Alloway's two-part article "Artists as Writers," written for *Artforum* in 1974.[36] For Alloway, clues to Smithson's art can be found in his writing. With regard to his use of the term *entropy,* for example, Alloway notes: "Here are some examples from his writings which, since they come from the same source as his art, may be considered to provide information about the art."[37] Smithson made the art world's support system, including magazines, galleries, dealers, collectors, and museums "part of the meaning of the work."[38] Art, writing, and the art world are coterminous. "It is I think indicative," wrote Alloway, "that his spell of maximum writing, 1966–69, coincides with the period when he was moving from an art of autonomous objects to an art penetrating the world and penetrated by sign systems."[39] Coincidentally or not, this is also the period when Smithson moved into Alloway's social circle.

Writing in *The Nation* after Smithson's death, Alloway was more candid about his relationship with the artist. But he still privileged Smithson's writings as the ultimate source for understanding his thought process:

> Smithson's subjects include a guidebook treatment of a construction site in New Jersey, proposals for sculpture for an air terminal, a celebration of a planetarium, museums, a discussion of Art Deco architecture (in 1966 he called it Ultramoderne; the period style was not then named). His first article, "Entropy and the New Monuments," made rich use of his reading of science fiction. There is a common factor: the construction site, the air terminal, the planetarium, museums, skyscrapers, science fiction, are all models of world views, theories of how the world runs, condensed as artifacts. But they are all collapsing systems, under stress both internally and externally. Smithson had a zest for the ways in which our thought is labyrinthine but incomplete. It is as if he viewed all knowledge as a form of artificial intelligence, confined by the patterns and limits of our own systems.[40]

Alloway was concerned with understanding systems; Smithson with their collapse. If Smithson got from Alloway an understanding of the art world as a system, Alloway learned from Smithson that all systems are entropic.

Alloway acknowledged the importance of writing in the development of Smithson's art, but he did not go so far as to collapse the roles of artist and

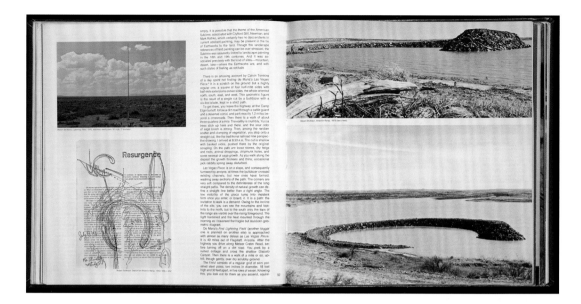

Fig. 3.
Interior spread.
From Lawrence Alloway, "Site Inspection," *Artforum* 15, no. 2 (October 1976): 52–53.

writer, neither with regard to Smithson's work generally nor in relation to his personal connection to Smithson's work in particular. Ultimately, the *Artforum* article is a critical essay on the development of Smithson's art, a conventional account that traces the work in terms of movements and styles, from minimal art to earthworks—an example, in Alloway's words, of "short-term art history." As originally published in *Artforum,* the essay's opening spread included a large-scale color photograph of Smithson's most recently completed earthwork project in Emmen, Netherlands, *Broken Circle* and *Spiral Hill* (1971) (see fig. 2). Although illustrated, this project is afforded scant discussion in the body of the article. Instead, Alloway concludes with a lengthy discussion of *Spiral Jetty,* including a detailed analysis of the construction and materials of the jetty (what Alloway terms "the equivalent of a technical description"[41]) and of the film of the same name. Thus *Spiral Jetty* becomes the culmination of Smithson's oeuvre—a view reinforced in the anthologized version of the essay by including illustrations of only three works, the last of which is *Spiral Jetty.* The misleading view that Smithson's work culminates in the achievement of *Spiral Jetty* persists to this day, not least in the extensive focus on this single work in the literature on Smithson,[42] and Alloway's essay can be seen as an early paradigmatic exegesis of this teleological narrative.

The essay is constrained by its time and by its author's concerns—the originating of terms, here *earthworks;* the idea of development in an artist's work (and beyond it, as his or her legacy), in artists' writings; and the question of film as art. Alloway's relationship with Smithson transformed his views of all of these things, but those transformed understandings did not manifest clearly in this, his first important article on Smithson's development.

The most compelling account of Smithson's development of earthworks as a theory, implemented through his work on the Dallas–Fort Worth air terminal site, and named in "The Monuments of Passaic," appears in the second part of Alloway's "Artists as Writers," published in 1974. The importance of visiting sites, including visits made in the company of Smithson, is discussed by Alloway only in retrospect, in "Site Inspection," 1976 (fig. 3), and "Sites/Nonsites," 1981. All of these essays were published after Smithson's death.

Earthworks after Smithson

By 1976, the subject of earthworks might have seemed a little dated, hardly the subject for the "young man who feels that he is behind the times if he is no more than abreast of the moment," as Alloway had been described ten years earlier.[43] Part of his rationale for a return to the subject was his ongoing interest in the work of women artists, many of whom were making earthworks/land art. The existence of a "second generation" is asserted in the concluding paragraph of "Site Inspection," though no practitioners are named. Still, it does beg the question and opens the way for an article—perhaps planned/imagined—that would discuss these women in more detail. That opportunity was not to arise in the same magazine. Apart from a reply to correspondence about "Site Inspection" (published in the January 1977 issue of *Artforum*), Alloway wrote only one more article (on Blythe Bonnen, in November 1976) for the magazine. He did, however, discuss this second generation elsewhere: for example in an interview published in 1977, in which he uses the opportunity to not only name the second generation but also continue to reinforce the importance of Smithson's legacy. Alloway notes:

> Smithson is different. Smithson, as the most brainy one among the earthworkers, continues to have a big influence. I mean there's a second generation earthworks going now—Nancy Holt, Alice Aycock, Cecile Abish, Mary Miss. He's dead, but nonetheless his ideas on site and non-site continue to be absolutely basic to the development of another generation of artists. And that's one of the ways I guess you estimate someone's continuing legitimacy—if their ideas can still be used, but come out in new forms by the people that are developing them.[44]

"Site Inspection" is not a survey of earthworks. Alloway discusses visits to works by just three artists: Walter De Maria, Michael Heizer, and Smithson (with brief mentions of Carl Andre, Robert Morris, and Dennis Oppenheim). His stated reason for visiting these sites is that "some of the works I suspected were being

embalmed in single images." The word *embalmed* creates a somewhat sepul-chral aura. The loss of Smithson, who was so central to Alloway's understand-ing of earthworks, together with the discussion of the status of *Amarillo Ramp* (the work constructed after Smithson's death at the location where he died in an airplane crash while surveying the site), adds to the article's elegiac tone. Alloway illustrated the essay with a sketch Smithson made for *Amarillo Ramp*. The sketch is drawn on a page that appears to be from some kind of evangelical Christian tract titled "Resurgence" (see fig. 3). The connection of work and title is no doubt serendipitous rather than intentional, but it is nonetheless poignant when one realizes that the inscription on the sketch, "For Stanely [*sic*] + Wendy" (Stanley Marsh, the owner of the land where Smithson was building the work), is dated 18 July 1973—just two days before Smithson's death.

The narrative of "Site Inspection" situates earthworks' formative period as 1966 to 1967 and associates the work of Andre and Morris with this moment of origin.[45] Although it is not stated in the essay, this particular constellation of artists relates to the work Smithson undertook as an "artist consultant" to Tippetts-Abbett-McCarthy-Stratton (engineers and architects) for the Dallas–Fort Worth air terminal site.[46] Alloway locates the origins of earthworks firmly back with artists in New York City, even if he had to travel to Nevada, Texas, and Utah to experience the apotheosis of those ideas in the landscape. Just as the importance of making the trip "out West," for both artist and critic, can-not be overestimated, the origination of the theory of earthworks cannot be adequately understood without acknowledgment of its early development in New York City.

Smithson had in fact argued against the idea that earthworks and land art necessitated an escape from the city when he wrote: "(Peter) Hutchinson, for instance, instead of going to the country to study nature, will go to see a movie on 42nd Street, like 'Horror at Party Beach' two or three times and contemplate it for weeks on end."[47] The reference to movies on Forty-Second Street at this moment—it was published in June 1966—is tantalizing. Watching movies was a passion shared by Alloway and Smithson and one that developed into a collabo-rative venture that was significant to both men, as well as to our understand-ing of the nature and development of their friendship, Smithson's work, and Alloway's writing.

Alloway, Smithson, and *Violent America*

Later, in 1981, when Alloway was more open about his friendship with Smithson in his writing, he contrasted their taste in science-fiction movies:

His taste for science-fiction included *The Man from Planet X,* a B movie
of 1953 directed by Edgar G. Ulmer. The movie's incomplete illusion
troubled me: my taste was for more expensive films and also for mainline
pro-technological science-fiction which had no place in Smithson's library.
What he liked about *The Man from Planet X,* and other movies of the
genre, was its artificiality, the fact that its conventions could be seen falling
apart as one watched the actor in an alien suit totter about the diminutive,
foggy set.[48]

The phrase "incomplete illusion," used by Alloway in this article from 1981 to
characterize the kind of movies Smithson preferred, is also found in an ear-
lier typescript in Smithson's papers, where it is used to describe a convention
of popular movies that is "especially well demonstrated in low budget Science
Fiction films."[49] This unpublished text is headed (in Smithson's handwriting)
"Violent America," a title that is more familiar in the context of Alloway's work
than Smithson's, and yet, the phrase has a shared history in a collaborative proj-
ect that Alloway refers to in the introduction to his book *Violent America: The
Movies, 1946–1964* (1971):

> The origin of this book was a film series shown at the Museum of Modern
> Art from April 24 to June 6, 1969, under the title *The American Action
> Movie: 1946–64.* The title originally proposed, the one given [to] this book,
> could not be used owing to the refusal of one of the film companies to lend
> prints to a series so entitled. The series began as a collaboration with Toby
> Mussman and Robert Smithson, and we conceived it as a survey of several
> genres of popular American movies, but this was too broad. Smithson,
> whose particular interest is science-fiction movies, withdrew when that
> genre was regretfully dropped from the series as the Museum scheduled a
> separate one on the subject; and Mussman moved to California.[50]

The typescript in Smithson's papers is clearly an early draft of a description of
the collaborative project when its scope still included science-fiction film. But is
the story so simple? Did Smithson's withdrawal after the project's science-fiction
section was dropped mark the end of his participation in Alloway's film project,
or the end of his influence on Alloway's film criticism? And was Smithson's own
exploration of film influenced by his collaboration with Alloway?

Alloway and Smithson shared an interest in the experience of cinema.
Directly opposed to disinterested critical viewing, they were self-proclaimed
ordinary moviegoers immersed in the act of viewing: movie fans before movie
critics.[51] In his article "Entropy and the New Monuments," Smithson contrasts

the "crummy baroque and rococo of the 42nd street theaters" with the "'padded cell' look, the 'stripped down' look, or the 'good-taste' look" of the new art houses.[52] This echoes the comparisons made by Alloway in a *Vogue* article from 1968, in which he contrasts a screening of a Frank Sinatra movie in an "elegant" Times Square theater with a showing of an Andy Warhol film in a "grim movie house violently converted from an elegant legitimate theatre."[53] But Alloway's attention to the movie house as well as the movies also goes back to his first framings of film in the early to mid-1950s, as vividly detailed in letters to Sleigh from his visit to America in 1958. His trip to see a movie with "Smell-O-Vision" is particularly striking not only for showing Alloway's openness to the full experience of cinema, rather than just a purely visual media—"It was fun in a relaxed Wagnerian (involvement of *all* senses) sort of way," he wrote—but also for the sheer diversity of cinematic experience Alloway (like Smithson) was willing to expose himself to.[54]

Comparing Alloway's and Smithson's published writings on film from a few years later, 1971–72, and knowing that they worked together on the *Violent America* project, reveals even more compelling correspondences. Smithson's essay "A Cinematic Atopia" (1971), which begins with musings on the experience of cinema as a "tangled mass" and the genre of classic westerns "taken as a lump," could easily be seen to lightheartedly echo Alloway's insistence on seeing films in terms of types or cycles. "The simple rectangle of the movie screen contains the flux, no matter how many different orders one presents," writes Smithson. "But no sooner have we fixed the order in our mind than it dissolves into limbo. Tangled jungles, blind paths, secret passages, lost cities invade our perception. The sites in films are not to be located or trusted."[55] In "Robert Smithson's Development," published the following year, Alloway cited just the last phrase of Smithson's observations, "the sites in films are not to be located or trusted," in discussing the relationship between Smithson's earthwork sculpture and his film of the same title, *Spiral Jetty* (1970). Alloway uses Smithson's observation on sites in movies in general to question whether the same observation might apply to the sites of the work as represented in his film *Spiral Jetty*. Alloway notes that Smithson "declines to use the horizontal expanse of the site. As in his still photography he likes low-profile imagery. The typical camera angle is, so to say, slightly stooped, with little sky visible, or close up."[56] In a rather literal way, Smithson's filmic representation of the site of *Spiral Jetty* contradicts the experience visitors (including Alloway himself) have of the actual site and the work's relation to its surrounding landscape. But there is another sense in which the site is not to be located or trusted if one follows Smithson's observation back to "A Cinematic Atopia," the source Alloway quotes from. As noted, the phrase occurs as Smithson is describing the ways in which the movie

screen contains flux and creates orders and groupings that proliferate outside their original structure or meaning. The dizzying concatenation of imagery in the *Spiral Jetty* film confounds its function as a straightforward record of the work's construction at a particular site. Alloway describes how the film contains reflections on time and occurs in real time. It references the history of the earth and prehistory, and, in a move "typical of Smithson's double takes," cites a quotation from "old-fashioned science fiction."[57]

In his book *Violent America,* Alloway writes that "the conditions of viewing complicate our responses to films still further. A film viewed in a cinema is perceived as light in darkness in a place entered solely for that purpose. The film is overwhelming, and suddenly it is gone."[58] Smithson proposes rather more unconventional sites for cinematic experience. He imagines showing his film *Spiral Jetty* on the Staten Island Ferry: "The ferryboat could sail out to the middle of the harbor, then sail back to the port in a spiraling voyage while the film was showing."[59] And he suggests building a cinema in a cave or an abandoned mine, where a film showing the construction of this underground cinema could be screened. Though the conditions of viewing that each describe are so very different, both Alloway and Smithson stress the importance of the sites of cinema as intrinsic to its logic.

Alloway used one of Smithson's favorite terms, *entropic,* to describe a material quality of film: "As a medium, films are subject to rapid fading; they have an entropic tendency in excess of most art forms. Apart from the complexity and elusiveness of a movie as an object of attention, the actual physical body of a film is subject to corruption."[60] Alloway credited Smithson with bringing the word *entropic* into the literature of art.[61] Here Alloway himself uses the word in the context of writing on film as a medium. It is also fascinating to note how often Alloway's observations about entropy in Smithson's work are closely aligned with references to science fiction—in "Robert Smithson's Development," entropy is discussed in proximity to H. G. Wells's [*The Shape of*] *Things to Come* (1936) and *The Blob* (1958). In the case of Wells's movie, the comparison is one Smithson made himself in his writing, and Alloway cites the source and makes a connection between "the obsolete future" in Wells's film and Smithson's notions of "ruins in reverse." In the case of *The Blob,* Alloway is discussing works such as *Asphalt Rundown* (1969) and *Partially Buried Woodshed* (1970), where structures are inundated with substances—poured asphalt, mud flows, piled dirt. "In Smithson's mind, among other things, as he set up this piece [*Partially Buried Woodshed*]," writes Alloway, "were those science-fiction movies in which amorphous beings inundate known structures, and incorporate people, such as *The Blob*."[62] Alloway cites no written source and the observation is in parentheses. How did Alloway know what was in Smithson's mind if not from their close

acquaintance? And, of course, from the many hours they spent viewing science-fiction movies in each other's company?

The collaboration echoes in the book *Violent America,* and when film serves as the denouement of Alloway's account of "Robert Smithson's Development." In Smithson's case, it seems possible that the intense focus on film afforded by the collaboration is one of the factors that led him to make films himself. One of the earliest film treatments in Smithson's (unpublished) writings is for a film, *The Monument,* that includes Alloway's and Smithson's shared milieu of New York galleries and openings, including Virginia Dwan's apartment as a location—and it was written at the time Alloway and Smithson were working on the MoMA screening.[63] In his 1981 essay "Sites/Nonsites," Alloway refers to another idea Smithson had for a movie: "Consider the film of Connecticut's Merritt Parkway that Smithson talked about making. Driving along it after his death one speculated on what it might have been. Would it have been photographed from a moving car, like the dramatically charged opening sequences of *The Spiral Jetty*?"[64] There seems to be no published record of Smithson discussing the concept for this film. If Alloway is relying on a written source, he doesn't cite it. Instead, the idea for the movie exists only in Alloway's words, a memory of a conversation with Smithson. And in Alloway's account, the experience of driving on the Merritt Parkway after Smithson's death became both an elegiac motif and a way of "making" Smithson's movie posthumously in his imagination.

In the absence of the conventional archival sources such as written correspondence or openly acknowledged coauthored texts or exhibitions, this investigation has relied on tracking Alloway and Smithson's relationship between the lines of their respective writings and through their broader social networks, particularly those shared with their wives, who (certainly in Alloway's case) more diligently recorded their lives and networks in diaries and calendars than they did themselves. Meetings and moviegoing are recorded in Sleigh's and Holt and Smithson's calendars, and it is from these sources that one can get some sense of the extent and period of time the two men devoted to their *Violent America* movie project. Meetings between Alloway, Mussman, and Smithson first appear in Sleigh's calendar in 1967, shortly after Alloway's return from his writing residency at Southern Illinois University at Carbondale. There are three meetings in quite short succession, on 22 September, 25 September, and 23 October 1967. This almost exactly covers the period when Smithson was writing "The Monuments of Passaic," the article in which Alloway identifies the "genetic moment" of the naming of earthworks, and whose narrative famously begins "On Saturday, September 20, 1967" when Smithson "went to the Port Authority building on 41st Street and 8th Avenue, bought a copy of the *New York Times* and a Signet paperback called *Earthworks* by Brian W. Aldiss" and boarded the

number 30 bus to make his tour of the monuments of Passaic. This episode thus marks both the moment earthworks got its name and the beginning of an intense period of collaborative activity that would have a significant impact on the work of both Alloway and Smithson.

Postscript

In researching illustrations for this essay, I asked Nancy Holt if she had any photographs of Alloway. I'd hoped for a candid snapshot taken by Holt or by Smithson or, better still, a photograph of Alloway and Smithson together. What I got instead was an anecdote about a remembered image of Alloway. Holt asked Alloway if he would be one of the pallbearers at Smithson's funeral. Alloway expressed uncertainty because of his leg. Holt had not noticed this physical disability before; Alloway had perhaps done a good job of disguising it. (I don't know exactly what it was—an injury or an early indication of the onset of the neurological and spinal problems that would later affect him.) But Alloway did help to carry the casket. This tale of human weakness and fragility at a moment of tragic loss, in contrast with Alloway's famed public persona "perceived as supercilious, aggressive and arrogant,"[65] conjures a poignant mental image of the two men together. It is not embalmed in a single photographic image but lives on in Holt's words.[66] I would like to thank her for sharing this picture with me.

Notes

Epigraph: Richard Kalina, "Critical Commentary: Imagining the Present," in Lawrence Alloway, *Imagining the Present: Context, Content, and the Role of the Critic,* ed. Richard Kalina (London: Routledge, 2006), 6.

1. For example, David Bourdon refers to "a new and controversial kind of sculpture known as 'earthworks' or 'dirt art'"; see "What on Earth," *Life,* April 25, 1969, 80. See also Howard Junker, "The New Sculpture: Getting Down to the Nitty Gritty," *Saturday Evening Post,* 2 November 1968.

2. The exhibition *Earth Works,* the first group show with that title, opened at the Dwan Gallery, New York, in October 1968.

3. Lawrence Alloway, "Site Inspection," *Artforum* 15, no. 2 (October 1976): 49–55. Alloway's first article on any of the individual artists associated with land art or earthworks was an article on Christo in *Art International* in 1968; see Lawrence Alloway, "Christo and the New Scale," *Art International,* September 1968. He also published a book on Christo in 1969; see Lawrence Alloway, *Christo* (New York: Abrams, 1969). But it is clear from Alloway's definitions that he did not consider Christo part of earthworks. Alloway also reviewed Seth Siegelaub's *One Month* exhibition and John Gibson's gallery/office; see Lawrence Alloway, "Projects for Commissions," *The Nation,* 7 April 1969.

4. See Lawrence Alloway, *Options: Directions 1,* exh. cat. (Milwaukee: Milwaukee Art Center, 1968); "The Expanding and Disappearing Work of Art," *Auction* 3, no. 2 (October 1969): 34–37, reprinted in Lawrence Alloway, *Topics in American Art since 1945* (New York: Norton, 1975), 207–12, 211; *Artists and Photographs,* exh. cat. (New York: Multiples Inc., 1970); and "Art," *The Nation,* 21 June 1971, 797.

5. See Philipp Kaiser and Miwon Kwon, *Ends of the Earth: Land Art to 1974* (Los Angeles: Museum of Contemporary Art; New York: Prestel, 2012), 17n1.

6. John Beardsley, *Earthworks and Beyond: Contemporary Art in the Landscape* (New York: Abbeville, 1984), 7.

7. Alloway discusses other (male) artists who were involved in earthworks early on, and then dismisses them as no longer relevant to the current (1976) definition: "Carl Andre and Robert Morris, though associated with Smithson in the formative years of 1966–67, have done only occasional works that can be considered Earthworks and neither has welcomed the label." And "[Dennis] Oppenheim, whose name was closely linked with Smithson and [Michael] Heizer at first, has worked at the scale of Earthworks, but always with temporary materials. . . . His interest in process did not lead him to move from expendable configurations to monumental works of longer duration which is, I take it, an essential requirement of Earthworks." See Alloway, "Site Inspection," 55.

8. For more on *Artists and Photographs* (1970), see the essay by von Bismarck, this volume.

9. See Lawrence Alloway, "Artists as Writers, Part Two: The Realm of Language," *Artforum* 12, no. 8 (April 1974): 30–31:

 > In 1966 Smithson published his first long article on "Entropy and the New Monuments," also in *Artforum* which in the following year published his "The Monuments of Passaic" (a construction site in New Jersey toured like the Roman Forum) and "Towards the Development of an Air Terminal Site" based on his consultative role with an architectural firm. Big sculptural projects were proposed by Smithson as well as by [Robert] Morris and Sol LeWitt whom he brought in. This implemented the theory of Earthworks, given in the Passaic article.

 See also Robert Smithson, "The Monuments of Passaic," *Artforum* 7, no. 4 (December 1967): 48–51.

10. Lawrence Alloway, "Robert Smithson's Development," *Artforum* 11, no. 3 (November 1972): 52–61, reprinted in *Topics in American Art since 1945* (New York: Norton, 1975): 221–36 and in *Robert Smithson's New Jersey,* exh. cat. (Montclair, N.J.: Montclair Art Museum, 2014), 77–89. Lawrence Alloway, "Sites/Nonsites," in Robert Hobbs, *Robert Smithson: Sculpture* (Ithaca, N.Y.: Cornell University Press, 1981), 41–45.

11. Jack Flam, ed., *Robert Smithson: The Collected Writings* (Berkeley: University of California Press, 1996), 387 [index], 35. On p. 35, Alloway's name appears in a section headed "The Anatomy of Expressionism" in a discussion on the traces of the biological metaphor or "what Lawrence Alloway called 'biomorphism,'"; see Robert Smithson, "Quasi-Infinities and the Waning of Space," *Arts Magazine,* November 1966.

12. A letter of 23 September 1972, enclosing "a copy of the concluding paragraph" and

"a copy of the 'major nonsites' lists," in which Alloway asks Smithson to check one of the entries in the list; and a postcard from Alloway, sent from Southold, Long Island, postmarked June 1972 [day unclear]. See "Correspondence General A. Miscellaneous," Robert Smithson and Nancy Holt Papers, 1905–1987, Archives of American Art, Smithsonian Institution, box 1, folder 19.

13. Smithson and Holt Papers, box 1, folders 6–11.

14. Sylvia Sleigh Papers, Getty Research Institute, Los Angeles, acc. no. 2004.M.4. There are appointment books and calendars in Sleigh's papers dating from 1952 to 2010. For this essay, I consulted her calendars for the years 1964 to 1974, boxes 48 and 49.

15. "Lawrence Alloway on Art Education, as Interviewed by Diana David," *Harvard Art Review* 3, no. 2 (Summer 1969): 49. Alloway did in fact write on Dossi, so this is a "real" example of writing on a historic artist whose work Alloway could not have witnessed in the making.

16. Alloway, "Art," *The Nation,* 15 May 1976, 603.

17. Brian W. Aldiss, *Earthworks* (London: Faber & Faber, 1965).

18. Robert Hobbs, *Robert Smithson: Sculpture* (Ithaca, N.Y.: Cornell University Press, 1981), 235.

19. Alloway Papers, box 45, folders 1–6. There is a considerable quantity of material related to the Park Place group among Alloway's papers, including press clippings, exhibition invitations, and typescripts. Alloway wrote at length on one of the sculptors in the group; see "Peter Forakis since 1960," *Artforum* 6, no. 5 (January 1968): 25–29. See also the recent publication on the group, Linda Dalrymple Henderson, *Reimagining Space: The Park Place Gallery Group in 1960s New York* (Austin: Blanton Museum of Art, 2008).

20. Each spelled the other's name incorrectly. Smithson wrote "LAREWCE ALLOWAY," which might suggest unfamiliarity, though Smithson's varied mis-spellings of Alloway's name are characteristic of his calendar entries. Alloway wrote the catalog essay for the exhibition *Pattern Art,* held at the Betty Parsons Gallery (which included work by Smithson); Smithson co-organized the *10* show at the Dwan Gallery with Robert Morris and Ad Reinhardt. Both exhibitions opened in New York City on 4 October 1966, and both are recorded in Holt and Smithson's calendar on that day. Alloway and Smithson could have met at the opening of one or the other of these shows.

21. Lawrence Alloway, "Art and the Communications Network," in idem, *Imagining the Present: Context, Content, and the Role of the Critic,* ed. Richard Kalina (London: Routledge, 2006). See also the discussion of this article and Alloway's idea of "network" in Courtney J. Martin, "Art World, Network and Other Alloway Keywords," *Tate Papers,* no. 16 (1 October 2011), http://www.tate.org.uk/research/publications/tate-papers/art-world-network-and-other-alloway-keywords.

22. Nigel Whiteley, *Art and Pluralism: Lawrence Alloway's Cultural Criticism* (Liverpool: Liverpool University Press, 2012), 223–26. Sleigh's calendar records continuing involvement in their New York circles as well as a trip to Argentina during this period, making Whiteley's notion of Alloway as an exile in Illinois seem a little exaggerated.

23. Robert Smithson, "Entropy and the New Monuments," *Artforum* 5, no. 10 (June

1966). (References to this article are from the version reprinted in Flam, *Smithson: Collected Writings.*)

24. James Reinish, "An Interview with Lawrence Alloway," *Studio International* 186, no. 958 (September 1973): 62–64.

25. Alloway, "Art and the Communications Network," 117.

26. Nancy Holt, "Interview with Nancy Holt," by James Meyer, in Alena J. Williams, *Nancy Holt: Sightlines* (Berkeley: University of California Press, 2010), 220.

27. *Oral History Interview with Robert Smithson,* 14–19 July 1972, Archives of American Art, Smithsonian Institution, http://www.aaa.si.edu/collections /interviews/oral-history-interview-robert-smithson-12013. The italicized passage in the quoted excerpt was edited out of the version of this interview published in Flam, *Smithson: Collected Writings,* 277.

28. Alloway, "Robert Smithson's Development."

29. The first publication date of "Robert Smithson's Development" is wrongly identified in Alloway's *Topics in American Art since 1945* as November 1973, a mistake that might have led some readers to assume that it was published after Smithson's death.

30. Lawrence Alloway, "Sites/Nonsites," 41–45.

31. Recorded in Holt and Smithson's engagement calendar, 25–26 January 1972, Smithson and Holt Papers, box 1, folder 10.

32. Alloway, "Robert Smithson's Development."

33. Shelley Rice, "Back to the Future: George Kubler, Lawrence Alloway, and the Complex Present," *Art Journal* 68, no. 4 (Winter 2009): 80.

34. Whiteley, *Art and Pluralism,* 238.

35. Nigel Whiteley cites Alloway's acute awareness of accusations of nepotism as a reason why he seldom wrote about the work of Sleigh; see Whiteley, *Art and Pluralism,* 38.

36. Lawrence Alloway, "Artists as Writers, Part One: Inside Information," *Artforum* 12, no. 7 (March 1974): 30–35; and Alloway, "Artists as Writers, Part Two," 30–35.

37. Alloway, "Robert Smithson's Development," 58.

38. Alloway, "Robert Smithson's Development," 58.

39. Alloway, "Robert Smithson's Development," 58.

40. Alloway, "Art," 603–4.

41. Alloway, "Robert Smithson's Development," 60.

42. See, for example, Lynne Cooke and Karen Kelly, *Robert Smithson: Spiral Jetty; True Fictions, False Realities* (Berkeley: University of California Press; New York: DIA Art Foundation, 2005), and the profusion of images of *Spiral Jetty* online.

43. John Canaday, quoted in Whiteley, *Art and Pluralism,* 221.

44. Lawrence Alloway, in Robert Arnold, "An Interview with Lawrence Alloway," *Midwest Art* 4, no. 2 (Summer 1977): 20.

45. Alloway also mentions Dennis Oppenheim as an artist "whose name was closely linked with Smithson and Heizer at first"; see Alloway, "Site Inspection," 55.

46. See Robert Smithson, "Towards the Development of an Air Terminal Site," *Artforum* 6, no. 10 (June 1967): 36–40; and Robert Smithson, "Aerial Art," *Studio International* 177, no. 910 (April 1969): 180–81. Sol LeWitt was also involved in this project.

47. Smithson, "Entropy and the New Monuments," 16.

48. Alloway, "Sites/Nonsites," 44.

49. Smithson and Holt Papers, box 3, folder 70.

50. Lawrence Alloway, introduction to *Violent America: The Movies, 1946–1964* (New York: Museum of Modern Art, 1971), 7. Mussman contributed an essay to Gregory Battcock's *Minimal Art: A Critical Anthology* (New York: Dutton, 1968) and edited a collection of essays on the nouvelle vague filmmaker Jean-Luc Godard. He moved to work in television and film production in Hollywood. His name appears in both Sleigh's and Holt and Smithson's engagement calendars and there is correspondence between Smithson and Mussman in the Smithson and Holt Papers.

51. See the essay by Bradnock, this volume.

52. Smithson, "Entropy and the New Monuments," 17.

53. Lawrence Alloway, "More Skin, More Everything in Movies," *Vogue,* February 1968. See also Peter Stanfield, "Regular Novelties: Lawrence Alloway's Film Criticism," *Tate Papers,* no. 16 (1 October 2011), http://www.tate.org.uk/research/publications/tate-papers/regular-novelties-lawrence-alloways-film-criticism.

54. Alloway Papers, box 7, folder 8.

55. Robert Smithson, "A Cinematic Atopia," *Artforum* 10, no. 1 (September 1971), reprinted in Jack Flam, ed., *Robert Smithson: The Collected Writings* (Berkeley: University of California Press, 1996), 141.

56. Alloway, "Robert Smithson's Development," 60.

57. Alloway, "Robert Smithson's Development," 60.

58. Alloway, *Violent America,* 29.

59. Robert Smithson, "...The Earth, Subject to Cataclysms, Is a Cruel Master," interview by Gregoire Müller, in Jack Flam, ed., *Robert Smithson: The Collected Writings* (Berkeley: University of California Press, 1996), 261.

60. Alloway, *Violent America,* 29.

61. Alloway, "Robert Smithson's Development," 57.

62. Alloway, "Robert Smithson's Development," 59. Later in this essay, Alloway cites Rudolf Arnheim's recently published book *Entropy and Art: An Essay on Disorder and Order* (Berkeley: University of California Press, 1971) and aligns Smithson's ideas with a formulation of Arnheim's.

63. Robert Smithson, "The Monument: Outline for a Film," 1967, in Jack Flam, ed., *Robert Smithson: The Collected Writings* (Berkeley: University of California Press, 1996), 356–57.

64. Alloway, "Sites/Nonsites," 45.

65. Whiteley, *Art and Pluralism,* 17.

66. Nancy Holt, in conversation with the author, London, 16 May 2013. Holt read the manuscript of this essay and commented, "It was a joy to read the Alloway/RS essay. You displayed elegantly your powers of investigation in clear and precise language. I saw connections between the two which I was not completely aware of at the time, even though I was a frequent witness to their friendship at dinners and at film screenings/discussions"; Nancy Holt, e-mail to the author, 29 September 2013. Nancy Holt died on 8 February 2014.

JENNIFER MUNDY

TEACHING ART CRITICISM
Lawrence Alloway at Stony Brook

> Art criticism is a genre of writing that may not yet have a methodology, but it does have a history. In addition there is increasing curiosity about the role of art criticism and the function of the art critic on the contemporary scene. The art critic is, in a sense, being called to account: his ideology and technical operations are being examined.
> —Lawrence Alloway, "The Function of the Art Critic," 1974

The state of art criticism was a subject Lawrence Alloway found himself increasingly drawn to in the late 1960s and especially the 1970s. As a critic writing for *The Nation* (1963–81) and *Artforum* (1971–76), and as a close friend of a number of artists in New York, Alloway was well placed to engage in debates about the nature and value of art criticism. He wrote several substantial articles and gave a number of talks on the topic, addressing what he saw as a growing public interest in contemporary art, its interpretation, and its evaluation (fig. 1). Never afraid of making waves, he was also more than willing to identify those areas where he felt his colleagues were failing to live up to the profession's wider responsibilities, both intellectual and political. In his texts on art criticism, however, he never set out any overarching theses or grand narratives but offered a series of insights into the changing roster of issues he saw as important for critics and readers. In doing so, he found himself obliged to reflect publicly on his own trajectory and his craft as a critic.

Alloway taught in the art department of the State University of New York at Stony Brook (now Stony Brook University) in Long Island, from 1969 to 1981, when an increasingly severe medical problem affecting his back finally obliged him to resign. This is an aspect of his career that is relatively underexplored. He rarely commented on his experiences as a professor, and Stony Brook retained few records of this period. Alloway's papers at the Getty Research Institute, however, provide evidence of the courses he taught. Paradoxically, they suggest that he achieved some of his more tangible legacies in the academy, this little-known area of his life. Examining what is known about Alloway's work as a pedagogue, this essay considers these legacies and explores the ways in

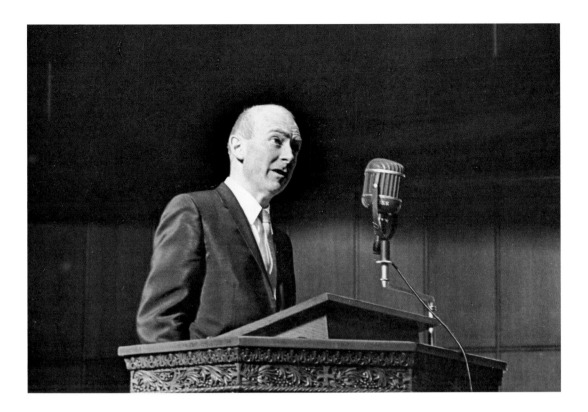

which his teaching may have contributed to his thinking about art criticism in the 1970s.

Fig. 1.
Lawrence Alloway,
Oberlin College, Oberlin,
Ohio, autumn 1965.
Los Angeles, Getty Research Institute.

Stony Brook

Before he joined Stony Brook, Alloway had some knowledge of teaching and American universities, though his experience of both was limited. In London, he had taken evening classes in the late 1940s but never acquired any formal qualifications in art history. Given the antielitist cast of his mind, however, it seems unlikely he regretted his lack of training in either the connoisseurship-led teaching associated with the Courtauld Institute of Art, founded in 1932, or the historical and iconographic approaches of the Warburg Institute, which moved to London in 1933, the only institutions in Britain where art history was then taught for a degree. To help support himself, he gave public lectures at the National Gallery and the Tate Gallery, teaching and carrying on his own studies as he went along. He developed passions for the old masters (especially the prints of William Hogarth), but from the beginning of his career, he was committed to engaging with the art and culture of his own time.

This formation as an occasional public lecturer, rather than as a trained art historian, may have played a role in determining his conspicuously concise,

stripped-back writing style. Compared with the more self-consciously literary and often elevated prose of other critics, Alloway's texts were found by many commentators to be impersonal and cold, devastatingly so on occasion. An anonymous reviewer of Alloway's first book, *Nine Abstract Artists: Their Work and Theory* (1954), for example, remarked that it was "written with a dispassionate and almost deadly velocity" ("One cannot altogether escape the feeling that these painters are not so much being written of as written off"), and likened the "extreme objectivity" of Alloway's style to that of "a field report from a Martian anthropologist."[1] Alloway might have been pleased by this reference to anthropology, but it signaled how unusual many found his "voice," as well as the risks he ran of being seen as brusque and "unclubbable."

Alloway came to the United States in September 1961 to be a lecturer at Bennington College, Vermont, then a progressive center for the visual arts. From the early 1950s, Clement Greenberg, already one of America's most prominent art critics, had organized a number of early exhibitions at Bennington for such artists as Jackson Pollock, Adolph Gottlieb, and Barnett Newman. He had also given seminars there; it seems he enjoyed the "tough give-and-take discussions" with other staff and the students.[2] In a sense, Alloway was following in Greenberg's footsteps by coming to Bennington, though it was through his contacts and growing friendship with Newman that he was offered the role. Alloway taught a course at Bennington called Art and Communication, which developed ideas first expressed in the context of discussions of the Independent Group, to which he had belonged in London.[3] He also wrote a number of reviews and exhibition catalog essays before succumbing, just one year later, to the lure of New York and a post as curator at the Solomon R. Guggenheim Museum.

In Britain, it was almost unheard of for individuals to move between these different spheres (and it was to remain so for many decades), but American institutions were open to the possibility of movement between, and combinations of, the roles of critic, curator, and academic, in the belief that, in the contemporary field at least, the skills required for each were complementary.[4] While a curator at the Guggenheim, Alloway taught courses at the School of Visual Arts and Hunter College, presenting at the latter Theory and Criticism of Art in 1964–65. This course signaled Alloway's early interest in teaching the subject of art criticism, though the course reading list indicates that he then saw the topic as firmly located within the disciplines of aesthetic theory and art history. At the bottom of the list, however, he noted, "Analysis of current art criticism and comment on current exhibitions will also be undertaken," a somewhat dry statement indicating his intention to combine study of the past with reflections on the contemporary art scene and writing.[5]

It might have been that Alloway secured his professorship at Stony Brook as much, if not more, for his rich experience of the art world and undeniably sharp intellect as for his art historical knowledge or proven teaching ability. The university had recently expanded, replacing its department of fine arts with three new departments, for theater, music, and art. The program was housed in a new multimillion-dollar complex, including a theater, a concert hall, and, from 1975, an art gallery. Dominated by the sciences and engineering (then as now), the university sought to strengthen its position in the humanities through this investment in the creative arts. Leopoldo Castedo, a scholar of Latin American art, was the head of the art department; the art historian and artist Allan Kaprow had been on the faculty at Stony Brook since 1961, and he seems to have been responsible for introducing Alloway to the university's administration.[6] The associate dean, Sidney Gelber, wrote to Alloway on 5 July 1967:

> I was delighted to have had the opportunity to meet you during your recent visit with Professors Castedo and Kaprow. It was intellectually gratifying to exchange views with one who has rightly gained the distinction as one of our most gifted art critics in the contemporary scene.
>
> As you recall we discussed the overall development and needs of the art department at Stony Brook. In that light we affirmed our commitment to build a department with the excellence of our programs and the quality of personnel as our essential goals. I was pleased to learn of Professor Castedo's and Kaprow's conviction that your personal involvement could be a major asset towards the fulfillment of these objectives.[7]

This was perhaps something of a leap of faith. Alloway not only lacked a university degree but also had a poor track record as an employee. Things had ended badly at the Institute of Contemporary Arts, London, where he had been forced to resign as deputy director in 1960. And in 1966, he had resigned his position at the Guggenheim Museum, feeling, with some justification, that he had been cheated of the opportunity to curate the American pavilion at the Venice Biennale by the Guggenheim's director, Thomas Messer.[8] His job record in the academic sector also raised questions about his attitude toward management: he abandoned his position as head of the Fine Arts Division of the School of Visual Arts in May 1968 after having been in the post for only a few months. He observed in his resignation letter that "it did not seem that the School as a Structure and I as an Individual were especially suited to one another."[9]

Alloway's years at Stony Brook, however, proved to be a period of sustained application and quiet success.[10] Working for a state school, rather than an Ivy League university, in a relatively new department, dominated by practicing

artists, seems to have been a good fit for Alloway. Hired initially on a one-year contract, his role as professor in the art department and director of the school's art gallery was soon made permanent. The gallery became known for beautifully installed shows. With almost no budget, Alloway managed to stage exhibitions of not only faculty members but also significant New York artists.[11] To do this, however, he often called in favors from artist friends, a situation he later politely pointed out to the university's president that was hardly a sustainable basis for operating the gallery.[12] Inevitably perhaps, there were tensions between the artists and the art historians in the department. A memo written by the head of the department in 1971 referred to a "matrix of personality conflicts, disagreement on policy, and a history of neglect."[13] But when discontent surfaced, Alloway, it seems, did not get involved, and in one memo, he was even held up, only half-jokingly, as something of a model worker by the department's chairman.[14]

At Stony Brook, Alloway initially taught courses that focused on art movements and were typically centered on individual artists and chronology. He made extensive notes from the key books and took pains to include recent texts in the students' reading lists. He tended to teach two courses a semester, one from the early part of the twentieth century and another that was more contemporary; in the fall of 1971, for example, he taught courses on cubism and conceptual art. Later—perhaps responding to student interests or faculty receptivity—he began to use teaching to focus on issues directly related to his own writings as a critic and the issues of the day, devising new courses on women's art (1975), realism (1976), and art and politics (1977).

Although Alloway's typed course descriptions suggest a well-structured approach, a student named Shelley Rice recalled her first course with him as exhilaratingly unpredictable:

> It was a new class, something between a lecture and a seminar, and it was called Art and Communication, though it could have been subtitled The World According to Alloway. Whatever was on his mind that week was the subject of our class, and the improvised topic could be Édouard Manet or Charles Baudelaire as easily as Barnett Newman, Norbert Wiener, or Robert Rauschenberg. The Art and Communication course was the turning point in my education and the impetus for my decision to become an art critic. Not only did I love Alloway's classes, I loved his life-style, the mixture of students and creative people, and his intense interactions with the academy, the art world, and publishing.[15]

She also recalled how he would encourage students to see as many exhibitions as possible, undertake internships in commercial galleries to gain practical

experience, and, above all, to read widely, including what artists were reading.[16]

Perhaps Alloway felt comfortable combining the roles of critic and professor because, in both fields, he valued facts or what, using the language of information theory, he called *data*. At the very beginning of his career, he had tended to see art history and criticism as distinct: the one dealing with an already established record of distant events and the other addressing a still unmapped ferment of current activity. But from the mid-1960s, he increasingly emphasized the role of historical knowledge in art criticism; he was quite proud that Newman had once joked that he had brought footnotes back into art criticism.[17] Reacting impatiently against what he perceived as vagueness, framed as personal or poetic impressions, in much writing about contemporary art, Alloway called in 1966 for a criticism that provided objective descriptions of artworks and forensic analyses of their cultural contexts:

> At the moment, maybe, what is needed is a short-term art history, one
> not concerned with the major movements of style, not distracted by
> cultural melodramas or modern sensibility, but with close-up data. Art
> history, of course, is always subject to revision, but it aims to be definitive,
> its ambition is for the comprehensive. Short-term art history should
> be less royal and provide, at least, a record of what paintings were exhib-
> ited in what order, with what differences from earlier works by the artist.[18]

Later, reflecting on his practice as a critic, he said that he tried to apply to current events "some of the sense of history which a historian dealing with a settled part of the world does," leading to a "provisional, tentative, as-I-see-it-at-the-present-moment history."[19] However, he was also critical of the way some critics applied a technique of art history (the arguments of logical development or cause and effect) to contemporary art in order to promote certain types of art. "The historical imperative that was supposed to justify the Greenbergian canon," he noted in 1973, "has not prevented [Frank] Stella and [Kenneth] Noland from collapsing miserably in the last 2 years. Without current market strength, the art historical rationale for these artists grinds away in a void."[20]

Art history itself was beginning to change, however, and Alloway was soon forced to revise his view of the discipline as overly focused on arcane matters of stylistic influences (or "puzzles in locked libraries").[21] In 1973, he welcomed growing signs of "something more sophisticated and flexible than present techniques of evidence and standards of historicity," citing the presentation of the College Art Association's Frank Jewett Mather Award for Distinguished Art Criticism—a prize Alloway himself had won in 1971[22]—to the critic Rosalind Krauss and curator Margit Rowell for their Guggenheim exhibition catalog *Miró:*

Magnetic Fields. For him, this was evidence of how the "objective references of art history" could be combined with the "freer-ranging interpretations of art criticism."[23] Alloway was quick to acknowledge that it was art historians, rather than critics, who were among the first to pioneer the reevaluation of women's art, a point he cited as evidence of the weakness not so much of the methods of contemporary criticism but of the "consciousness" of its practitioners.[24]

Criticism in Crisis

Claims that art criticism lacks the intellectual rigor, literary qualities, and public esteem that it once enjoyed are commonplace today. Such books as *The Crisis of Criticism,* edited by Maurice Berger (1998); *What Happened to Art Criticism?,* by James Elkins (2003); *Critical Mess: Art Critics on the State of Their Practice,* edited by Raphael Rubenstein (2006); and *The State of Art Criticism,* edited by James Elkins and Michael Newman (2008), point to a current uncertainty among some commentators about the function and value of criticism. Earlier echoes of such concerns can be found in documents relating to a seminar on art criticism organized by the National Endowment for the Arts (NEA) in 1983. A commissioned report mentioned almost casually, as if a given, "the generally lamentable quality of recent visual arts criticism,"[25] while an official memo sent to the seminar participants (who did not include Alloway) noted that the NEA had long been concerned with the need for more and better-quality criticism.[26]

Of course, it can be argued that criticism is in a state of near-perpetual crisis, always needing to justify its existence and redefine its position in relation to changing art practices and conditions in the art market, new readerships, and different modes of dissemination, as well as the ups and downs of the art market and trends within the academy (and, if it is judged wanting, it is nonetheless all the better for at least being held up to ambitious standards). But intermixed with the varied expressions of concern there seems to be a shared sense of decline and a nostalgia for a golden age where high-quality writing enjoyed significant intellectual status and public influence. For many in America, this seems to have been the postwar years, when such New York–based critics as Greenberg, Harold Rosenberg, and Thomas Hess commanded national and international respect through their intellectual power, visual acuity, and skill as writers.

Alloway, however, was not one to have much truck with the concept of a golden age nor one to say that the critics of his generation were any less distinguished in their intellectual firepower than their forebears. Criticism arguably enjoyed a much higher public profile than ever before as a result of growing public and academic interest in contemporary art, the proliferation of art

magazines, and the publication of various anthologies of critical writings in the 1960s. But he was acutely aware in the early 1970s that, under pressure from societal change and burdened by inherited methodologies and unexamined ideological baggage, art criticism was shown increasingly to be wanting. Demands for recognition by women artists and artists of color had profoundly called into question for many the ethics of critical judgment, the standards of evaluation, the authority and subject position of the (typically white male) critic, and what appeared to be the complicit relationship of criticism with the art market—and these demands had forced Alloway to rethink his own position. "Everything has changed about the US in the twelve years since I came here," he reflected in 1974. "Why should art criticism not shift as well?"[27]

Responding to what he saw as a new appetite for discussion of art criticism in both academic and public arenas and wanting to help frame this debate,[28] Alloway gave numerous talks, including "Criticism and the Current Scene," at Sarah Lawrence College (1972), "Elitist versus Popular Criticism," at New York University (1972), "After Art History," at the College Art Association (1973), and "An Art Critic Is Not..." in the Whitney Museum of American Art Seminar Series (1973), as well as, in the same Whitney series, "Subjects of the Critic" (1975). Developing his ideas in print and highlighting new aspects of the issues surrounding criticism, he also published several, sometimes lengthy, articles on the topic, including "Anthropology and Art Criticism" (1971), "Artists as Writers" (1974), "The Function of the Art Critic" (1974), and, expanding the latter text, "The Uses and Limits of Art Criticism" (1975).

In these last two articles, Alloway identified one moment as particularly revelatory: a conference on art criticism and art education held at the Guggenheim Museum in May 1970, a time of unexpected and intense political unrest. The U.S. invasion of Cambodia and the shooting of student protesters at Kent State University had traumatized the nation, bringing home to many the ideological nature of the war in Southeast Asia and sparking further protests and riots. These events and the subsequent art world strike organized in response by the Art Workers' Coalition provided an unusually dramatic backdrop for the conference contributions of two colleagues, Max Kozloff and Barbara Rose, leading critics who, like Alloway, wrote for *Artforum*. Reflecting on current events, both expressed serious doubts about the continued usefulness of art criticism. Kozloff compared the profession to "a form of exalted PR work for a superannuated establishment," while Rose declared the "beginning of the liquidation of art criticism" and rejected any work that supported or influenced the art market.[29] Thereafter, Rose wrote for nonart magazines, with the aim of reaching a broader audience; from 1973, Kozloff came to believe, according to Alloway, that "the art that criticism, [Kozloff's] own and other,

had supported was ideologically flawed" and was just another form of merchandise for the rich and powerful.[30] In light of his own continued engagement with academia, Alloway noted that the crisis "hit Max Kozloff especially hard because he had been teaching a course in art criticism…he declared that he would never again contribute to the production of more art critics."[31]

A third critic, Lucy Lippard, did not attend the conference, but she, too, lost confidence in art criticism. In 1971, Lippard wrote, "I have no critical system.…Criticism, like history, is a form of fiction. Moreover, so-called objective criteria always boil down to indefinable subjective prejudices."[32] Giving up the goal of interpreting art and of sharing her thoughts with a general readership, she wrote: "Freedom from interpretation provides freedom for clearer statement, aimed at those who have looked at enough art and paid enough attention to read that statement."[33] Alloway admired Lippard but criticized what he saw as her abandonment of descriptive, educational writing. "Her withdrawal from art criticism can be seen very clearly in her last book, [*Six Years:*] *The Dematerialization of [the] Art [Object],* an almost unmediated compilation of documents on conceptual art," he wrote in 1974. "Ten years ago she was an expert bibliographer, but she managed to drop her training for this book in which she puts out the documents raw. The idea is to make the book like a work of art too, but I think it is really an evasion of responsibility."[34]

As part of this circle of writers, Alloway would have been affected both personally and professionally by their rejection of the values and practices of conventional art criticism. However, it took him a number of years to respond in writing, and it could be that his identification of the Guggenheim conference as a pivotal moment was a later rationalization or even something of a rhetorical device. In "The Function of the Art Critic" (1974), he did not opine for or against the views of these three critics but instead tried to offer an explanation as to why they felt as they did and why he did not. All of them, he noted, were in their thirties and, unlike older critics who had more vivid memories of life during World War II (here he presumably included himself, as he was then in his late forties), had been shocked in 1970 "by a new experience of violence."[35] They were also university-educated and had carried over to their work as critics what Alloway defined as an academic tendency to specialize in, and thus defend, one particular type of art. "I think one of the things that worried Lippard, Rose, and Kozloff," he commented, "was the fact that they had all represented at one point in their lives a very devoted form of attention to the object as such. Theirs were highly developed sensibilities keenly aware of the preciousness of the art work. When they became disillusioned with it, the problem was what to do instead."[36]

However valid these points about the three critics were—and they were perhaps more interesting as reflections about how he perceived his own position

and personal history than as descriptions of actuality—Alloway went on to explore why neither art history as an intellectual discipline nor art criticism had proved robust or flexible enough to deal with these political challenges and provide "stabilizing factors."[37] Condemning the narrow specializations encouraged in graduate programs, Alloway judged art history—or, at least, art history as practiced by the three critics in question—to be incapable of grounding art within a broad understanding of culture and history: "As presently taught, the discipline seems to develop neither a sense of connections between art and society nor a sense of the historical diversity of art."[38] Alloway seems here to be criticizing the field that he was then responsible for teaching, but his point essentially concerned the narrowness of university training: to his mind, universities suppressed the "vivid, non-verbal culture that high school students possess before they go to college" and left them unprepared to relate their academic learning to real life. Perhaps drawing on his experience as a teacher of undergraduates as well as memories of his own intellectual formation, he suggested it would be "more logical for the university to attempt to connect with what students bring with them."[39]

If art history was not much use in the current storm, the elder statesmen of current art criticism also failed, he claimed, to provide useful models for a younger generation. The urbane and poised tone of Harold Rosenberg's *The Anxious Object* (1964) was found "too essayistic in form to satisfy the restlessness of the newly politicized,"[40] while the formalist narrowness and unquestioning attitude toward the art market displayed by Clement Greenberg ruled him out of contention, Alloway claimed, as a role model.

In fact, Alloway's position in relation to Greenberg was more complicated than this brief dismissal would imply. Like most art writers of his generation, he had engaged with the ideas and language of formalist art criticism championed by Greenberg from the 1940s; and he admired the skills the American had brought to the analysis of artworks up to the early 1960s. Unlike Greenberg, however, Alloway claimed he had never elevated the art object above the common mass of objects produced by humankind. For him, art was special in its density of meanings, and in what he called its "time-binding" function or capacity to offer meanings to succeeding generations, but it was not separate from, or superior to, other forms of cultural production. "Unique oil paintings and highly personal poems as well as mass-distributed films and group-aimed magazines can be placed within a continuum rather than frozen in layers in a pyramid," he had written in "The Long Front of Culture" in 1959.[41] In the catalog for his last major show at the Guggenheim, *Systemic Painting* (1966), Alloway tackled head-on the intellectual weaknesses of a still vigorously defended formalism within the art world: "There is a ceiling to Greenberg's esthetic which

must be faced.... What is missing from the formalist approach to painting is a serious desire to study meanings beyond the purely visual configuration."[42] Whatever the intellectual weaknesses of a formalist position, however, Alloway recognized elsewhere that Greenberg remained a potent force and a worryingly significant influence on museums and art departments in America. In an interview given in 1974, Alloway described Greenberg as "the major opposition to an open-minded kind of art criticism at the moment."[43]

If Alloway believed that Greenberg's writings did not represent a viable model for the future of art criticism, what course then did he advocate? As already noted, he favored criticism that provided "close-up data," laced, if possible, with artist-originated information. He also shied away from making judgments about art. While Greenberg had famously established his reputation through defining quality in art, and while others, such as Alloway's direct contemporary David Sylvester, could hardly stop themselves from evaluating art as part and parcel of their experience of it, Alloway thought expressions of personal opinion were frankly of little interest. "I think good and bad is mainly a lot of shit, you know," he said in an interview in 1973; "it changes from critic to critic, from generation to generation."[44] He believed that judgments of quality, furthermore, led to a premature closing down of the field to be reported on, and he regularly condemned those who, seeking the "exhilaration of dogmatic authority" in the race to identify the great art of the times,[45] tried to sift through or narrow down the field of cultural production by elevating one type of art, or even one work within an artist's career, above others. In a piece for *The Nation* in September 1973, for example, Alloway took the art history–trained critic Robert Pincus-Witten to task. "His openness to new art," Alloway wrote, was "in conflict with his desire to apprehend the great art of his time immediately.... Pincus-Witten's view, for all his astuteness, for all his expertise, does not take account of this crowded world."[46]

Critics who had adapted to the "post-elite abundance in art" were seemingly few, but Alloway praised the "wide-focus writing that does not favor one kind of art over another" of Carter Ratcliff, who discussed different artists together, "using the accidents of the exhibition schedule as a source of structure and meaning." And he singled out Jill Johnston for her early writings about happenings and John Perreault's reviews in the *Village Voice* for refusing, he wrote, to offer "false conclusions" and offering instead "the authenticity of the ongoing and current record."[47] Beyond this, in notes for a talk titled "Subjects of the Critic," he identified the lack of broadly based studies as a weakness of current criticism and called for a wide range of new types of writing ("tendency pieces," "interdisciplinary pieces," "theoretical pieces," "sociological pieces," "methodological pieces"), citing examples of his own writings in all these categories bar

the theoretical one. "All these set art into a contextual framework of related knowledge," he claimed, "rather than isolate it."[48]

Alloway's response to the crisis was to hold on to his core methods—he wanted his texts to be both "information-giving" and "adversary and corrective"[49]—and he redoubled his efforts to be open to all types of art, to give space and publicity to new artists and points of view, and to broaden the scope of his subject matter to include the politics and history of art world institutions. He acknowledged that the sheer abundance of current art production threatened to overwhelm the critic who attempted to cover the art scene, but he had no solution other than to expend more effort (he regularly condemned those who, he felt, did not do enough to see and review as wide a range of art as possible) or to focus on a few artists at a time. For him, the crisis of criticism of the early to mid-1970s required a shift in his practice, not an abandonment of his basic beliefs about either art or the value of providing information about art through criticism. "I felt pretty cool about this moment of crisis about the function of art criticism when it came," he wrote in 1974, "because I have never thought that art was something to be isolated from the rest of culture anyway."[50]

This broadening of the subjects he thought critics could and should write about derived in part from his experience of teaching at Stony Brook during the years of student unrest and political activism. In an interview in 1973, he said that teaching had not changed his ideas about art but that the students had changed his view of politics and its place in his art criticism:

L[awrence Alloway]: I think I'm a critic who teaches. The curatorial thing was nice, but I think I get more time to write by teaching than if I worked in a museum.

J[ames L. Reinish]: Does the teaching part of it compliment [*sic*] the criticism at all? Does it give you a chance to experiment or try a new approach?

L: Yes it does. I tell you, I tend to teach what I'm working on in terms of writing at any particular moment. In one way I don't get much back from the students; I don't think I've learned <u>anything</u> about art from the students, but they've changed my politics which, I think, is a lot more than I've done for them. I've been radicalized![51]

Responding to History

Emerging from this period of reevaluating the function of art criticism, Alloway decided to develop new courses on the history of criticism in the mid- to late

1970s. This may have been a response in part to growing public interest in this aspect of the art world as well as the natural reflex of someone who liked to teach what he was writing about. But the decision may also have come from Alloway's sense that the field would benefit from greater knowledge of its history and a wide range of models and examples against which to situate contemporary practice. Surprisingly for someone so associated with the latest trends in art, Alloway dwelled at some length on the eighteenth- and nineteenth-century writings of Denis Diderot and Charles Baudelaire to help illustrate and substantiate his points in articles about the state of criticism.[52] He also applied a descriptive phrase of the French poet Paul Valéry to the weekly articles of John Perreault: "'Vague branchwork' is probably the right phrase to indicate the structure of an art criticism that includes incomplete data and chance events, not falsely rounded and finished off."[53]

In his reading lists, Alloway typically brought together an eclectic mix of poets, theorists, philosophers, journalists, and professional critics. He did not attempt to set these figures within their different cultural contexts but asked his students to read the original texts and become familiar with their core ideas. For a 1976 course called Art and Art Criticism, for example, the reading list included contemporary texts by Greenberg, Kozloff, Lippard, Frank O'Hara, Rosenberg, and Leo Steinberg. Keen to explore the historical lineage of criticism, he developed three years later a course titled History of Art Criticism. This focused on "art criticism of the past 200 years, with excursions to earlier material, such as classical Greek writing on art."[54] Such courses on art criticism and its history may not have been unprecedented in the United States, but they were certainly rare; initially at least, there were hardly any books on the subject, obliging Alloway to adopt Lionello Venturi's *History of Art Criticism* (1936) as a core textbook. In the final examination for History of Art Criticism, students were tested on their knowledge of a range of writers. (For example, "Who do you regard as the first modern art critic? Give reasons." "What is meant by the Salon form of art criticism? Define it." "Discuss the importance of Charles Baudelaire's article on Constantin Guys, 'The Painter of Modern Life.'" "Roger Fry translated the poems of [Stéphane] Mallarmé and edited the discourses of Joshua Reynolds. What does this tell us about him?" "What is Linda Nochlin's contribution to the art criticism of the 70s?")[55]

Building on such courses, Alloway seems to have envisaged turning his teaching of criticism at Stony Brook into something more ambitious and significant. He petitioned the university authorities for a center for art criticism that would offer three lectures and one conference per semester. "Topics would be originated by myself in consultation with the speakers," he wrote. "They would be of interest to both art history and studio majors, but I would aim

Fig. 2.
Cover of SUNY, Stony
Brook's *Art Criticism,* vol. 1,
no. 1 (Spring 1979).
Los Angeles, Getty Research
Institute.

more widely than this. Such a program should be fundamentally interdisciplin-
ary in nature."[56] He also requested funding to support the creation of a new
journal to be called *Art Criticism,* which, jointly edited by him and Donald
Kuspit (then at the University of North Carolina at Chapel Hill but soon to
move to Stony Brook), would publish papers arising from talks given at the cen-
ter.[57] *Art Criticism* was founded in spring 1979 and continues to this day, more
or less unchanged in its sober, unillustrated format designed to echo scientific
journals (and possibly all the more acceptable to Stony Brook University, then
very much focused on the sciences and medicine, because of that) (fig. 2). (The

Fig. 3.
Notes by Alloway schematically mapping the field of art criticism from 1960 to 1979, n.d.
Los Angeles, Getty Research Institute.

choice for the cover of a knot design by the German Renaissance artist Albrecht Dürer was unexplained but suggested an intricate web of connections that at least suited Alloway's idea of the art world as a complex network.) Suffering operations on his back in 1979 and again in 1980, Alloway collaborated with Kuspit on only the first two issues, but the creation of the journal and of the center was largely his project and represents a lasting legacy of his tenure at Stony Brook.

Of course, Alloway's vision would not have been manifested at Stony Brook without the support of colleagues and the backing of the institution. In autumn 1979, the Stony Brook Foundation supported a major conference on criticism in the arts (including visual art, theater, film, and music). The conference brought together leading academics and practicing critics, and Alloway introduced the plenary session.[58] When, in the early 1980s, the university wanted the department to offer postgraduate courses, Alloway put forward plans for MA courses in art criticism. For the syllabus description of History of 20th Century Art Criticism and Theory, he wrote:

> The literature of art has expanded enormously in the 20C far beyond attempts to organize it developmentally or conceptually. An attempt will be made to define types of criticism, both in relation to the critics and their audiences. The ideas of the critics and their relation to the support system for the arts of which they are part will both be examined. Guillaume Apollinaire, Roger Fry and Clement Greenberg will be discussed in detail.[59]

To this he added in pencil, "Preparation for dealing with the ongoing intellectual issues of contemporary thought and sensibility," a comment that shows his conviction that a course about the history of criticism had a broad value. A note among his papers schematically listing the various tendencies within criticism of the 1960s and 1970s indicates that he then thought of himself, together with Kuspit and Pincus-Witten, as "post-formalists" (fig. 3).

In 1981, Alloway had to resign his post at Stony Brook owing to his deteriorating physical condition, but his plans, and those of like-minded colleagues, blossomed eventually in an MA course in art criticism launched in 1985. The course brochure testifies to the new prominence of criticism following Alloway's period at the university: "The M.A. in Art Criticism...reflects the growing belief among leading scholars that the studies of art history and art criticism are inseparable, that the unity of art history and art criticism in the history of art is indisputable and that the role of art criticism in the history of art is central."[60] Today Stony Brook runs MA and PhD programs called Art

History and Criticism that still resonate with Alloway's thinking in their inclusion of the history of criticism and their aim to develop "the critic-historian, who can combine the various fields of traditional art historical study with a critical consciousness and awareness of broad intellectual issues."[61]

Alloway had always seen art criticism as part of the broad communications network that characterized modern societies, and as such, it was complex and

resistant to easy summarizing or quotable descriptions. He did not develop sustained or theoretical arguments about the nature of criticism or its history, and consequently, his often strikingly acute insights on these subjects have tended to be overlooked. Instead, his goal was to map and comment on the always-shifting contemporary debates about criticism as both an observer of the scene and a knowledgeable participant.

In the early 1970s, he focused largely on explaining what criticism should not be: "elite-dominated," "reduced to a single tradition," and "possessing any absolute value."[62] To promote the study of the history of art criticism at Stony Brook as a subject of academic significance in the late 1970s, he highlighted the different traditions within art criticism during the last two hundred years. Although he never commented on why he felt this was important, it seems likely that it was at least in part because it pointed up the plurality of paths open to contemporary art critics and bolstered the intellectual qualities of a field that always risked seeming minor in comparison with established disciplines and subject areas. By the time he left Stony Brook, he had come to see interesting areas of overlap between art criticism and what became known in the 1980s as the new art history. In an undated review of papers given at the College Art Association in the early 1980s, he noted that art historians were now routinely viewing the past in light of contemporary sensibilities and raising topical issues in ways that diminished the separation of the two fields. This was not an expression of a postmodern eclecticism of methodology, he claimed, but a "recovery of the speculative humanistic views of earlier art writing"; and he added, "this is what art criticism should be like."[63] Alloway had already championed the use of historical research methods in art criticism, albeit in the name of information theory. It was perhaps fittingly symmetrical that he lived to see art history begin to engage self-consciously with the kinds of contemporary political, social, and cultural issues that he always felt should inform and shape the most engaging art criticism, blurring the boundaries between the two fields.

Notes

Epigraph: Lawrence Alloway, "The Function of the Art Critic," *New York University Education Quarterly* 5, no. 2 (Winter 1974): 24. I should like to express my profound gratitude to the staff of the Getty Research Institute for their patient support of my research for this essay and to the book's editorial team, especially Nola Butler.

1. Anonymous review of Alloway's *Nine Abstract Artists: Their Work and Theory,* exh. cat. (London: Alec Tiranti, 1954); see *Listener,* 3 February 1955, 209, quoted in Nigel Whiteley, *Art and Pluralism: Lawrence Alloway's Cultural Criticism* (Liverpool: Liverpool University Press, 2012), 44.

2. Whiteley, *Art and Pluralism,* 167.

3. Whiteley, *Art and Pluralism,* 167. Alloway shared, and through his writings helped articulate, the Independent Group's fascination with mass culture and view of art as embedded in, and an aspect of, contemporary culture and thought. In 1955, he co-organized with the artist John McHale what proved to be the group's final project: a series of seminars held at the Institute of Contemporary Arts that explored the relationship between popular culture and the fine arts.

4. See, for example, the careers of Eugene Goosen and Rosalind Krauss in the 1960s and 1970s.

5. Lawrence Alloway Papers, Getty Research Institute, Los Angeles, acc. no. 2003.M.46, box 37, folder 10.

6. This is indicated in an article in the Stony Brook student newspaper, which appears to have been based on an interview with Alloway:

 > He came to our campus, at the urging of Allan Capro [*sic*], the originator of the 60s art events called "Happenings." Working with Capro Alloway was to set up the graduate program in Art at Stony Brook, as well as become Gallery Director. The deal fell through when Capro left, but Alloway decided to stay on to teach undergraduates, as a Professor of Art, a decision he says he hasn't regretted. Since undergraduates are not yet concerned with careers, he finds them "more enthusiastic," and while they haven't altered his views on art, they have radicalized his views on politics. (Tara Treacy, "Alloway Seeks Art for Everyone," *Statesman,* 27 October 1976)

 My thanks to Kristen H. Nyitray, head of special collections and university archives at Stony Brook University, for finding information relating to Alloway in the student newspaper, and to Courtney J. Martin for kindly forwarding it to me.

7. Sidney Gelber to Lawrence Alloway, 5 July 1967, Alloway Papers, box 37, folder 11.

8. See Whiteley, *Art and Pluralism,* 220–22.

9. Lawrence Alloway to Silas Rhodes (director of the School of Visual Arts) resignation letter, 12 May 1968, Alloway Papers, box 37, folder 10.

10. Alloway also worked briefly as a visiting professor at Columbia University from September 1976 to January 1977.

11. See a glowing review of the gallery in the Stony Brook student newspaper: "Under Professor Alloway's direction, the Fine Arts Gallery has had a new wall installed and new lighting to compensate for the structural change. The Gallery is the most professional-looking of all the campus galleries. It is spacious and the lighting is superb. Says Betsy Boudreau of the new gallery, 'The gallery is a credit to the University and a credit to Professor Alloway.'" (Vivienne Hesten, "Fine Art Flourishes at Stony Brook," *Statesman,* 26 September 1979)

12. Lawrence Alloway to John Marburger, memorandum, 20 March 1981, Alloway Papers, box 27, folder 13.

13. Jacques Guilman to the chairman of the Committee of Personnel Policy, 13 December 1971, Alloway Papers, box 37, folder 12.

14. Jacques Guilman to the art history faculty, memorandum, 20 February 1981. Guilman wrote, "Lawrence Alloway mentioned in a recent meeting that he felt we should all work a little harder. I recommend that you take him as your role model." Alloway Papers, box 37, folder 14, 2.

15. Shelley Rice, "Back to the Future: George Kubler, Lawrence Alloway, and the Complex Present," *Art Journal* 68, no. 4 (Winter 2009): 78.

16. My thanks to Shelley Rice for sharing her recollections.

17. Unpublished comments in "Interview Transcript: James L. Reinish and Lawrence Alloway," 3 January 1973, Alloway Papers, box 44, folder 10.

18. Lawrence Alloway, "Background to Systemic," *Art News* 65, no. 6 (October 1966): 31.

19. James Reinish, "An Interview with Lawrence Alloway," *Studio International* 168, no. 958 (September 1973): 63.

20. Lawrence Alloway, "After Art History," typescript of notes for talk at College Art Association, 24 January 1973, Alloway Papers, box 27, folder 10.

21. Alloway, "After Art History."

22. The citation read: "Few art critics of our time have shown such breadth of interest, such variety of approach, and so profound a knowledge of the contemporary art scene as Lawrence Alloway. Few, also, have been so prolific. There is almost no aspect of contemporary art that has not been illuminated by his insight, enriched by his breadth of knowledge, and enlivened by his skills."

23. Alloway, "After Art History."

24. Lawrence Alloway and Donald Kuspit, "Editorial Note," *Art Criticism* 1, no. 2 (1979): 1.

25. John Beardsley, "The Art Critics Fellowship Program: Analysis and Recommendations," August 1983, Alloway Papers, box 30, folder 5.

26. Benny Andrews, director, Visual Arts Program, to Visual Arts Criticism Seminar participants, 21 December 1983, Alloway papers, box 36, folder 6.

27. Alloway, "The Function of the Art Critic," 28.

28. Tom Wolfe's satirical attack on art theory in contemporary criticism, *The Painted Word* (New York: Farrar, Straus & Giroux, 1975), can be seen as reflecting a growing concern with how art was then being discussed in art world circles.

29. Lawrence Alloway, "The Uses and Limits of Art Criticism," in *Topics in American Art since 1945* (New York: Norton, 1975), 260.

30. Alloway, "The Uses and Limits of Art Criticism," 262.

31. Alloway, "The Function of the Art Critic," 27.

32. Lucy Lippard, *Changing: Essays in Art Criticism* (New York: Dutton, 1971), 12.

33. Lippard, *Changing*, 33.

34. Alloway, "The Function of the Art Critic," 27; and Lucy Lippard, *Six Years: The Dematerialization of the Art Object from 1966 to 1972* (New York: Praeger, 1973).

35. Alloway, "The Uses and Limits of Art Criticism," 263.

36. Alloway, "The Uses and Limits of Art Criticism," 263.

37. Alloway, "The Uses and Limits of Art Criticism," 263.

38. Alloway, "The Uses and Limits of Art Criticism," 264.

39. Alloway, "The Uses and Limits of Art Criticism," 267.

40. Alloway, "The Uses and Limits of Art Criticism," 263.

41. Lawrence Alloway, "The Long Front of Culture," in idem, *Imagining the Present: Context, Content, and the Role of the Critic,* ed. Richard Kalina (London: Routledge, 2006), 61.

42. Lawrence Alloway, "Systemic Painting," in idem, *Imagining the Present: Context,*

Content, and the Role of the Critic, ed. Richard Kalina (London: Routledge, 2006), 127–28.

43. Ray Thornburn, "An Interview with Lawrence Alloway," August 1974, Alloway Papers, box 44, folder 10.

44. Reinish, "An Interview with Lawrence Alloway," 63.

45. Lawrence Alloway, "Art," *The Nation,* 3 September 1973.

46. Alloway, "Art," *The Nation,* 3 September 1973.

47. Alloway, "The Function of the Art Critic," 27.

48. Lawrence Alloway, "Subjects of the Critic, April 3, 1975 (Whitney Museum)," Alloway Papers, box 27, folder 8.

49. Alloway, "Subjects of the Critic."

50. Alloway, "The Function of the Art Critic," 28.

51. This passage was not included in full in the published interview; see "Interview Transcript: James L. Reinish and Lawrence Alloway."

52. While the country was recovering from the antiwar protests, Alloway wrote a letter seeking support for a new paperback edition of a translation of Denis Diderot's Salon reviews: "There is an exceptional degree of interest in Diderot now. For example, there are two new translations of 'Rameau's Nephew' in print. In the art world there is for the first time, a great concern with the history of art criticism"; see Lawrence Alloway to ["Dick"], 29 May 1970, Alloway Papers, box 27, folder 21.

53. Alloway, "The Function of the Art Critic," 27.

54. Lawrence Alloway, "History of Art Criticism ARH326," Fall 1979, Alloway Papers, box 27, folder 10.

55. Lawrence Alloway, "Exam. History of Art Criticism ARH326," n.d., Alloway Papers, box 27, folder 13.

56. Lawrence Alloway to Sidney Gelber, memorandum, n.d., Alloway Papers, box 37, folder 15.

57. In the first issue of *Art Criticism* (Spring 1979), Alloway and Kuspit wrote: "If *Art Criticism* meets some of its editors' hopes for it, we shall be able to claim the appearance of some art criticism, with subjects arising from the writers' or editors' decisions, rather than the art market's. Articles on individual critics and on current groups and tendencies will lead towards the adequate history of art criticism so badly needed in relation to art and in relation to the literature of other disciplines"; see *Art Criticism* 1, no. 1 (Spring 1979): 1.

58. Tom Zatorski, "Art Criticism Conference at SB," *Statesman,* 31 October 1979.

59. Lawrence Alloway, "Hist. of 20C AC and Theory," n.d., Alloway Papers, box 37, folder 13.

60. Program description for the MA in art criticism at the State University of New York at Stony Brook, Alloway papers, box 37, folder 19.

61. SUNY, Stony Brook, online course descriptions, http://www.art.sunysb.edu /maphd.html [URL no longer active, accessed 1 June 2013].

62. Alloway, "The Function of the Art Critic," 24.

63. Lawrence Alloway, "Art History and Criticism," typescript, n.d., Alloway Papers, box 26, folder 30.

148

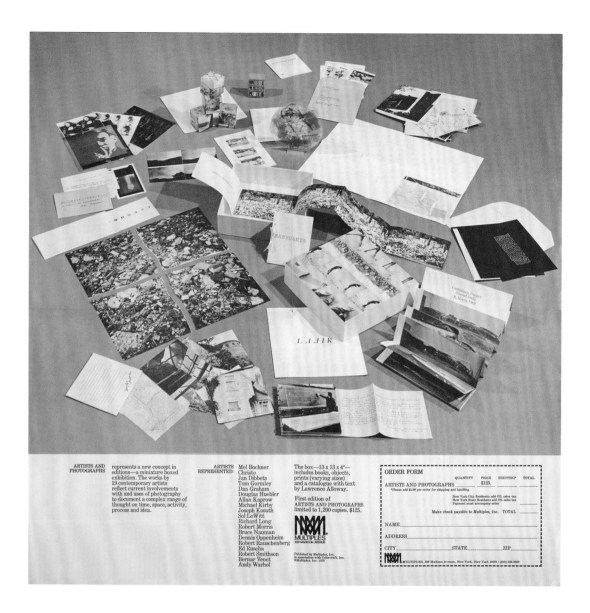

ARTISTS AND PHOTOGRAPHS represents a new concept in editions—a miniature boxed exhibition. The works by 19 contemporary artists reflect current involvements with and uses of photography to document a complex range of thought on time, space, activity, process and idea.

ARTISTS REPRESENTED: Mel Bochner
Christo
Jan Dibbets
Tom Gormley
Dan Graham
Douglas Huebler
Allan Kaprow
Michael Kirby
Joseph Kosuth
Sol LeWitt
Richard Long
Robert Morris
Bruce Nauman
Dennis Oppenheim
Robert Rauschenberg
Ed Ruscha
Robert Smithson
Bernar Venet
Andy Warhol

The box—13 x 13 x 4"—includes books, objects, prints (varying sizes) and a catalogue with text by Lawrence Alloway.

First edition of ARTISTS AND PHOTOGRAPHS limited to 1,200 copies. $125.

MULTIPLES
929 MADISON AVENUE

Published by Multiples, Inc, in association with Colorcraft, Inc. ©Multiples, Inc. 1970

ORDER FORM

	QUANTITY	PRICE	SHIPPING*	TOTAL
ARTISTS AND PHOTOGRAPHS		$125.		

*Please add $4.00 per order for shipping and handling

New York City Residents add 6% sales tax
New York State Residents add 3% sales tax
Payment must accompany order

Make check payable to Multiples, Inc. TOTAL_____

NAME_____

ADDRESS_____

CITY_____STATE_____ZIP_____

MULTIPLES, 929 Madison Avenue, New York, New York 10021 • (212) 249-3250

Fig. 1.
Advertisement and poster for *Artists and Photographs* showing the box and its contents.
Los Angeles, Getty Research Institute.

BEATRICE VON BISMARCK

THE ART WORLD AS MULTIPLE
Lawrence Alloway and *Artists and Photographs*

Lawrence Alloway counts as the instigator of *Artists and Photographs,* a cardboard box containing editions and multiples by nineteen (mostly) American artists, published in 1970 by Multiples, Inc., in association with Colorcraft, Inc. (fig. 1). Mel Bochner, Christo, Jan Dibbets, Tom Gormley, Dan Graham, Douglas Huebler, Allan Kaprow, Michael Kirby, Joseph Kosuth, Sol LeWitt, Richard Long, Robert Morris, Bruce Nauman, Dennis Oppenheim, Robert Rauschenberg, Ed Ruscha, Robert Smithson, Bernar Venet, and Andy Warhol contributed to the project. Although representing different approaches from conceptual art to land art, happenings, and pop art, each of the works shared a common denominator: an interest in photography. The portfolio was "intended to show the importance of photographs to contemporary artists."[1] But, in hindsight, it also marked, as Douglas Fogle noted in 2003, a decisive point in the history of the proliferation of photography as an artistic medium.[2] The photographic attitude covered a wide range, including documentary approaches, as in the case of Kaprow; self-contained photographic artist's books, like Ruscha's *Babycakes;* sculptural multiples using photography, such as those by Gormley (fig. 2) and Rauschenberg (fig. 3); index cards with a selection of quotations on the meaning and function of photography by Bochner (fig. 4); a foldout of photographic images by Oppenheim; and the photographic cover of the cardboard box itself, designed by Graham (fig. 5). While all the artists produced works that were shown in a gallery exhibition of the same title—also organized by Multiples, Inc., in 1970 in New York—some of them had developed a format specifically appropriate for the box.[3] Alloway participated in the project by contributing a contextualizing essay, which was included in the box in the form of a catalog/booklet.[4]

Artists and Photographs marks a historic moment in Alloway's career and in the field of art. The project's concept, content, and structure testify to Alloway's art critical and art historical value system, with regard to not only the nature and potential of the photographic medium, which he elaborated in his accompanying essay, but also his wider sociologically oriented aesthetics. In a wider frame, the box may also be understood as epitomizing the structural changes

Fig. 2.
Tom Gormley (American,
1937–2005).
Red File Cabinet, 1970,
illustrated cardboard box,
lightbulb, socket, electric
cord, box, 11 × 8 × 5 cm
(4 3/8 × 3 1/8 × 2 in.).
From *Artists and Photographs*
(New York: Multiples, Inc.,
in association with Colorcraft,
Inc., 1970).
Los Angeles, Getty Research
Institute.

Fig. 3.
Robert Rauschenberg
(American, 1925–2008).
Revolver, 1970, 5 Plexiglas
disks, acetate sheet, Plexiglas
base, instruction sheet, and
envelope; each disk:
22.9 cm (9 in.) in diameter.
From *Artists and Photographs*
(New York: Multiples, Inc.,
in association with Colorcraft,
Inc., 1970).
Los Angeles, Getty Research
Institute.

MISUNDERSTANDINGS

(A THEORY OF PHOTOGRAPHY)

MEL BOCHNER

I WANT TO REPRODUCE THE OBJECTS AS THEY ARE OR AS THEY WOULD BE EVEN IF I DID NOT EXIST.

TAINE

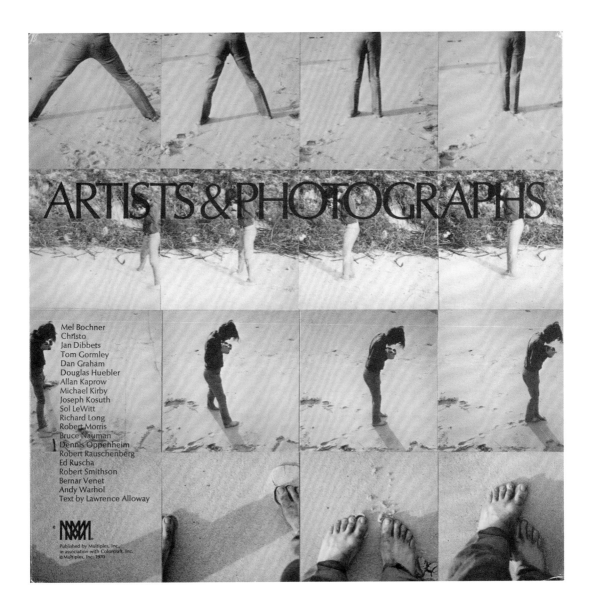

ARTISTS & PHOTOGRAPHS

Mel Bochner
Christo
Jan Dibbets
Tom Gormley
Dan Graham
Douglas Huebler
Allan Kaprow
Michael Kirby
Joseph Kosuth
Sol LeWitt
Richard Long
Robert Morris
Bruce Nauman
Dennis Oppenheim
Robert Rauschenberg
Ed Ruscha
Robert Smithson
Bernar Venet
Andy Warhol
Text by Lawrence Alloway

Published by Multiples, Inc.,
in association with Colorcraft, Inc.
© Multiples, Inc. 1970

Fig. 4.
Mel Bochner (American,
b. 1940).
*Misunderstandings (A Theory
of Photography)*, 1970,
10 index cards and envelope;
index cards: 12.7 × 20.3 cm
(5 × 8 in.), envelope:
15.2 × 22.9 cm (6 × 9 in.).
From *Artists and Photographs*
(New York: Multiples, Inc.,
in association with Colorcraft,
Inc., 1970).
Los Angeles, Getty Research
Institute.

Fig. 5.
Dan Graham (American,
b. 1942).
Cover of *Artists and
Photographs* (New York:
Multiples, Inc., in association
with Colorcraft, Inc., 1970).
Los Angeles, Getty Research
Institute.

Fig. 6.
Robert Morris (American,
b. 1931).
*Continuous Project Altered
Daily,* 1970, offset lithograph;
folded: 11.4 × 30.5 cm
(4½ × 12 in.), unfolded:
182.9 × 30.5 cm
(72 × 12 in.).
From *Artists and Photographs*
(New York: Multiples, Inc.,
in association with Colorcraft,
Inc., 1970).
Los Angeles, Getty Research
Institute.

that took place within the art field around 1970. Interwoven with each other, these two perspectives finally bestow the box with the function of visualizing Alloway's own positioning process within the field.

It is significant that Alloway took on several different tasks for *Artists and Photographs;* each of his roles and responsibilities remained somewhat indistinct. As "instigator," his functions in relation to those of the publisher, Multiples, Inc., and its cofounder, Marian Goodman, in deciding the actual concept, selecting the artists, and defining the character and format of the works, as well as the design of the cardboard box that contained them, were not clearly defined. The box itself does not give away who might have actually taken on these and other curatorial tasks, including the funding of the project and the mediation process. As the author of an essay, Alloway was also playing an unspecified role in relation to the artists who contributed textual material. The small catalog with his writing corresponds to the other small text-based works in the box, such as Graham's *Two Parallel Essays: Two Related Projects for Slide Projector. Photographs of Motion,* Oppenheim's and Morris's foldouts (fig. 6), Bochner's *Misunderstandings (A Theory of Photography),* and Ruscha's *Babycakes* (fig. 7). While all these works deal with photography, Alloway explicates the attitudes taken by the participating artists. They, in turn, integrate

Earth, water, grease, plastic, felt, wood, thread, light, photographs, sound

different parts of the box's concept into their contributions, thus—together with Alloway's text—knitting a net of cross-references among different historical and contemporary positions on photography. As interwoven utterances in various media, the status and professional roles—as artists, theoreticians, publishers, editors, curators, documenters, and/or commentators—are blurred, merge, and shift in relation to each other. Instead of a single author who can be credited and cited as such, *Artists and Photographs* has a number of participants, including the contributors, the writer, and the publisher. Boxed-in, as it were, in a shared situation and not subject to any directives as to a narrative sequence in which they should be arranged or perceived, contributors and contributions constitute an unhierarchical collective. When, on the occasion of an exhibition of multiples at René Block's gallery in 1974, Marian Goodman and her partner John Loring connected this art form with the "superpersonal," they were primarily concerned with the position of the artist: "In order to demystify the artist and his work, the individual personality must be submerged in a more socially conscious effort and a more viable relationship between art and society established."[5] In *Artists and Photographs*,[6] however, the demystifying and equalizing effect of multiples is extended also to the writer, Alloway, and the publisher, Goodman. The box created a situation in which the contributors

Fig. 7.
Ed Ruscha (American,
b. 1937).
Babycakes, 1970, artist's
book, 52 pages.
From *Artists and Photographs*
(New York: Multiples, Inc.,
in association with Colorcraft,
Inc., 1970).
Los Angeles, Getty Research
Institute.

became equal partners in a collective effort to publicize their—in this case, photography-related—concepts of art.

This blurring of professional roles within the field corresponds with the changing roles Alloway adopted throughout his career—from art critic to art historian, curator (in freelance as well as institutional positions), collector, and teacher.[7] He defined all these roles quite explicitly as partial, subjectivized positions within the discourse of contemporary art. He saw himself on equal footing with the artists he was exhibiting and writing about; they were "in it together," and he understood his own cultural practice as equivalent to those of the artists.[8] His multiple roles connect him to the major shifts that the art field and its related discourse were experiencing around 1970. The growth and accompanying professional differentiation of the field, the dissolution of the boundaries between the arts, the proclaimed "crisis of the author," and the rise

of the third sector in the economy are key parameters for a heightened awareness of the conditions under which art becomes public. Control over the assignation of meaning and value to art, symbolic or economic, was at stake. In this context, the multidirectional transgressions among professionally designated fields of practice—above all, those of artists, curators, and critics—had been occurring since the late 1960s. Artists took over curatorial tasks and responsibilities, curated shows, published books, wrote theoretical texts, and organized their own publicity; participants in *Artists and Photographs,* such as Douglas Huebler, Robert Morris, and Ed Ruscha, were among them. And, comparable to Alloway, curators and writers like Wim Beeren, Germano Celant, Lucy Lippard, Seth Siegelaub, and Harald Szeemann would move between professions and institutional affiliations with great freedom and gain status equivalent to that of artists with their personalized curatorial output.[9]

Alloway was, therefore, part of a more general development within the art field, but it is characteristic of his attitude toward his various roles that he approached them self-reflexively. He saw himself—as Courtney J. Martin has shown—as part of the art world, and he used his connections to reposition himself once he left London and settled in New York.[10] Likewise, he subjected the different professional roles within the "art world" to analyses, regardless of his own involvement. The curator and the critic both developed into prominent figures within his critique of the dependencies and hierarchies within the art field.[11] Apart from writing about the state of art education; the function of art magazines and art books; the working conditions of museums, commercial galleries, and exhibition spaces; and the place of independent artistic initiatives as manifested in alternative galleries, independent studios, and women's co-ops, he would evaluate the relations between the various participants within the field. He also reflected on his personal bias when writing about the art distribution system and acknowledged his own complicity within it.[12] His notion of the "continuum,"[13] the equality he claimed for high and low art forms, can be extrapolated to the art field and the different but equitable positions within it. The way in which he saw his contribution to the *Artists and Photographs* box—on the same footing with all the other participants—reflects his understanding of his role as an integral, embedded part of the system. With regard to his part in the project, he wrote in 1972: "In ten years I have been a curator, a teacher, and an art critic, usually two at a time. The roles available within the system, therefore, do not restrict mobility; the participants can move functionally within a cooperative system.... All of us are looped together in a new and unsettling connectivity."[14]

This understanding of embeddedness within a system had corresponding consequences for the notion of an "artwork," in terms of its character as well

as its status. In his publication *The Venice Biennale, 1895–1968: From Salon to Goldfish Bowl,* which came out two years before *Artists and Photographs,* Alloway reflected on the effect of reproductions: "Exhibitions and reproductions have in common the fact that both are channels that move the work of art, or its image, out of its original context of creation and ownership into a public situation."[15] Developing his argument against the backdrop of the ideas of the interdisciplinary art historian Edgar Wind and the art critic Harold Rosenberg, who both claimed that duplication and distribution would corrode the originals' value and presence, Alloway posited that "there is no evidence that exposure and multiplication degrade original works of art. Both exhibitions and reproductions move works of art, or their surrogates, into new relationships."[16] In his essay for *Artists and Photographs,* he pushed the concept of publicizing art through multiplication and presentation still further, now locating the channeling function also within the artwork itself. Acknowledging the range from "documentation to newly minted works," he described the different attitudes the contributing artists had taken toward photography: "Some photographs are the evidence of absent works of art, other photographs constitute themselves works of art, and still others serve as documents of documents."[17] Within this spectrum, the photographs offered Alloway the occasion to discuss the specific role of transmission. Starting out with the philosopher Max Bense's differentiation between the aesthetic process of painting versus the mechanical process of photography, along the lines of creation versus transmission, Alloway identified for each contribution the specific meaning that documentation had in relation to the artistic practice. His text laid out the complex interrelations among the different media used in the contributions, insisting that photography's scope is always wider than its channel function. Photography appeared as the "basic graphic form" of the works, as tool, initiator of ideas, and visual enabler, as well as the proper completion of a work. Ruscha's and Nauman's contributions finally represented for Alloway the blurring of the boundaries between the channel function assigned to photography and that of the "source" art Bense aligned with painting.[18]

At the core of Alloway's argument lies the contested status of photography as an art form. Another issue, however, is inseparably linked to this one: the intrinsic mediating capacities of art, including photography. Imbued with specific artistic qualities, among which there is, at least potentially, also the transmission of the temporality of an artistic activity, photography, according to Alloway's formulation, annihilates the differentiation between an object in a show and its documentary appearance in the publication. As "variants" rather than "reproductions," the photographs were of equal status to him and where they appeared, in the exhibition or in the catalog, was inconsequential: "Both

the exhibited 'object' and the catalogue 'entry' are permutations made possible by the repeatability of the photographic process."[19] In the same way, he does not distinguish between the sites of appearance of the various contributions, neither the artworks nor his own text, when talking about the "present catalogue/exhibition."[20] Without any explicit mention, this formulation intertwines not only two sites—the exhibition and the catalog—but also a third, the cardboard box. The box has the status of a catalog as well as that of an exhibition, and it maneuvers between a material frame and format for the gathering of the participants and their contributions on the one hand and an independent, self-contained work of art on the other. It is a reproducible item that, like the works it contains, can be exhibited for its own sake. Expanding the formulations Alloway had found in relation to the Venice Biennale, *Artists and Photographs,* in character and in function, oscillates between reproduction, exhibition, and artwork.

With its hybrid status, *Artists and Photographs* echoes the topical artistic and curatorial debates about the potential for printed matter and multiples to affect art's mode of becoming public. As "alternative spaces," as Kate Linker called them in retrospect in 1980, these formats attempted to reformulate the existing economic, social, and aesthetic conditions of the presentation and distribution of art.[21] Ruscha's book-like *Every Building on the Sunset Strip* (1966); Seth Siegelaub's conception of an exhibition catalog, *One Month* (1–31 March 1969), without an accompanying exhibition; and Lucy Lippard's *557,087,* which consisted of a manila envelope of artist-prepared loose index cards, are examples of the shifting of the physical venue of an exhibition to the book.[22] The ten issues of *Aspen* magazine, which were conceived by artists and critics alike, including the artist Dan Graham and the artist and critic Brian O'Doherty, developed the concept of a self-contained presentational frame in a magazine format.[23] In the second half of the 1960s, conceptual artists around Siegelaub, Huebler, LeWitt, Kosuth, and Lawrence Weiner began to merge artworks and publicity strategies into one, using the materials of publications—advertisements and invitations as much as catalogs—as media and venue at the same time.[24] Intertwined in this development, the art form of the multiple witnessed a surge in popularity in the 1960s, starting with Daniel Spoerri's first MAT (Multiplication d'Art Transformable) edition in 1959 and taking Marcel Duchamp's *Boîte-en-valise* (1935–41; Box in a suitcase) as its model.[25]

All these formats are represented within the box of *Artists and Photographs,* and together they constitute it as a whole. Like the leaflets, booklets, multiples, leporellos, collections of note cards, texts, and photographic fragments, the cardboard box, which is covered by a photographic image itself, is also reproducible and serves as a container. As a reproduction, a transportable exhibition, and an exhibition site, it multiplies its own function within itself. Consisting

of exhibitions and reproductions, it doubles the function of moving "works of art, or their surrogates, into new relationships"[26] while also becoming movable itself into new contexts. Comparable to the artists' museums exhibited at Documenta 5 in Kassel in 1972,[27] which Alloway called "subsystems in the system of Documenta with the function of exposing the arbitrary nature of acts of ordering, unmasking the ideology of classification,"[28] the box-as-exhibition points to the aesthetic, spatiotemporal, and social restrictions of institutional exhibition conditions, emphasizing instead self-determined alternative models of presentation.

For Alloway, substituting the unique art object with "multiple originals" altered the artwork's status as personal property.[29] With this perspective, he picked up on the core argument repeatedly voiced in favor of the previously mentioned art forms that are based on multiplication and reproduction. Books, magazines, and multiples were understood as means of addressing a wider, more diversified audience through mobility and low production costs, thus making them more accessible in terms of reception as well as acquisition; they were also conceived as undermining the art market by their ephemeral, immaterial nature. Graham, for instance, described the "book as object" in 1967 as an attempt to circumvent the gallery system, and the critic and art historian John L. Tancock, looking back in 1971 on the first decade of multiples, described them as the appropriate tool with which to react to the "dissatisfaction with the museum as an anachronism in contemporary society," believing, above all, that multiples could combat the "influence exerted by the commercial galleries in the creation of reputations and their stranglehold on artists."[30] Alloway's own vehement criticism of the "galleries' uncontested dominance" a year later seems to echo this line of argument.[31]

However, this critical perspective remained as idealistic as the one directed toward a wider audience.[32] The accessibility of prints and multiples still depended largely on the respective (institutionalized or, rather, more privatized) distribution system—their production costs were often higher than sales income could cover,[33] but more importantly, the gallery system changed in accordance with the newly developed art forms. Many galleries, including Marlborough Graphics (est. 1963), Waddington Graphics (est. 1966), and Richard Feigen Graphics (est. 1968), opened branches specifically geared toward prints and multiples, and the once cheaper editions soon sold for as much as luxury items.[34] The challenge that process orientation, ephemerality, and dematerialization meant for the marketability of art was directly absorbed into new marketing strategies conceived by artists, gallerists, and curators alike. The collection in *Artists and Photographs* testifies to these developments not only in the reproducible character of the box and the items published by

a print dealer within it but also by the specific economic structures through which these items were generated. To name but one example: Morris's foldout publication *Continuous Project Altered Daily* (see fig. 6) referred to an installation project that was originally made possible by Leo Castelli. For the production and presentation of the project, which was defined by its ongoing changes, Castelli had made his warehouse available. He had already conducted this semi-extra-institutional experiment once before, inviting Morris to curate a show of process-oriented works in *9 at Leo Castelli* (1968). Goodman's engagement in the multiple box of *Artists and Photographs* showed an analogous aptitude and originality in converting initially critical attitudes toward economic appropriation of the arts into new presentational formats and structures. Both gallery initiatives demonstrate the inseparable bond between presentation and marketing, which the publicity of art entails and which had become a trigger for the changes within the art field around 1970, from a "dealer-critic" system to a "dealer-curator" system.[35]

Alloway's position in this development was not restricted to merely addressing the commercial structure of presentation. His approach also, and quite uniquely, connects the economic perspective with a constellational attitude toward the publicity of art. The understanding of art as information among other kinds of information within a society not only supports his pluralist conception of it, granting equal value to all its different styles and social functions, but also sets it in context. His attack on autonomy as propagated by formalism, from the work of the artist and critic Roger Fry to the criticism of Clement Greenberg, culminated in the proposal of an aesthetically, socially, and economically contextualized relational understanding of art. Instead of focusing on single works, Alloway stressed in his last exhibition at the Guggenheim, *Systemic Painting* (1966), a syntactic relationship between the show's various works. Developing his "network" theory more explicitly after he left the museum, Alloway devoted himself to the analysis of the specifics of different art institutions—galleries, museums, art journals, art schools—and their positions within the power structures of the field. On the one hand, he was advocating for a "nonhierarchic connectivity";[36] on the other, he pointed to the dependencies and exertions of power within the field, be it between curators and artists, museums and galleries, or private and public collectors.[37] Additionally he understood the recipients as part of the presentational situation. Already by 1968, in his catalog essay for *Options,* he elaborated on the notion of viewer participation in the process of producing meaning in art. The spectator becomes part of the art's environment, which she or he can change, and thus she or he can challenge the object status of art in relation to this environment.[38] The viewer becomes a "player" within the "game" of art, which is made up of

conflicting, but rule-governed, relations. By being offered different options, the spectator as player is bound up within the activities of choosing and evaluating his choices.[39] Alloway further elaborates on this participation within an exhibition when discussing spectatorship at the Venice Biennale. Distribution and exhibition are brought together in his argument through the newly activated participatory role of the viewer, whose experience of the "stepped-up distribution" of art not only has been undiminished but, on the contrary, Alloway insists, has become more singular through the changing contexts of art. The multiplicity of possible contexts begs even more for active viewer participation to turn the encounter with art into a specific situation. "The spectator's freedom of interpretation is a function of his responsibility for his own reactions, like his own walking pattern in a large exhibition."[40] The spectator becomes a part of the "changing connections" of art.[41]

Artists and Photographs implements the participative structure of an exhibition: the contents of the box offer nonlinear access and reception according to the subjective predilections and handling modes of the recipient, thus also allowing for the possibility of multiple narratives. The process of reception opens new links between the items as well as between the artists and the issues they address. Furthermore, the main agents of what Alloway had termed art's "support-system" are represented in the box: the tasks usually assigned to critics, curators, or collectors have been shared or taken over altogether by the artists, and the institutions of the museum, the commercial gallery, and the publisher are present through the artists' appropriation of their distributing or presentational formats. Hosting all the different participants of "art as a public system" in their changing and shifting interrelations, *Artists and Photographs* embodies the perspective Alloway asserted in 1982, when he accused collectors, curators, editors, and critics of not searching out alternative points of view to counter the dominance of art galleries.[42] With its dissolution of clear hierarchies, status attributions, and economic dependencies, the collectivity of *Artists and Photographs* serves as a metaphor for the contestations within the art field around 1970, an arena where Alloway quite self-confidently saw himself as "looped" in.[43]

Notes

1. Lawrence Alloway, "Artists and Photographs," in idem, *Artists and Photographs,* exh. cat. (New York: Multiples, Inc., in association with Colorcraft, Inc., 1970), 3.
2. Douglas Fogle, "The Last Picture Show," in idem, ed., *The Last Picture Show: Artists Using Photography, 1960–1982* (Minneapolis: Walker Art Center, 2003), 13.
3. Mel Bochner, Dan Graham, and Andy Warhol altered their exhibition contributions when transferring them to the box format. Richard Long was the only contributor who did not participate in the exhibition at Multiples, Inc., gallery. The

contributions for the exhibition and the box are listed in the catalog; see Alloway, *Artists and Photographs,* 17–20. For a discussion of the relationship between the show and the contents of the box, see Steven Leiber's website, *Public Collectors,* http://www.publiccollectors.org/Steve%20Leiber%20Audio/discussed%20items /audio%20files/4(artists&photographs).mp3.

4. Alloway, *Artists and Photographs,* 3–6. The text also appeared in *Studio International* 179, no. 921 (April 1970): 162–64.

5. John Loring and Marian Goodman, "Erfinden ist göttlich; Vervielfältigen ist menschlich" (To create is divine; to multiply is human), in *Multiples: Ein Versuch die Entwicklung des Auflagenobjektes darzustellen* (An attempt to present the development of the object edition) (Berlin: Neuer Berliner Kunstverein, 1974), 25.

6. *Artists and Photographs* was not included in René Block's show, which focused on examples by individual artists instead of collective or group initiatives in the medium of the multiple.

7. For more information on Alloway's collecting and teaching activities, see Lawrence Alloway Papers, Getty Research Institute, Los Angeles, acc. no. 2003.M.46.

8. While working on Barnett Newman's monographic exhibition (1966) at the Solomon R. Guggenheim Museum, Alloway differentiated his view of the role of the curator from that of other contemporary curators who thanked the artist for his or her cooperation: "I assumed we were, so to speak, in it together"; see Lawrence Alloway, "Institution: Whitney Annual," in idem, *Network: Art and the Complex Present* (Ann Arbor: UMI Research Press, 1984), 149.

9. For a more fully elaborated argument about the transgressions between artists and curators, see Beatrice von Bismarck, "Unfounded Exhibiting: Politics of Artistic Curating," in Matthias Michalka, ed., *The Artist as . . .* (Vienna: Museum Moderner Kunst, 2007), 31–44.

10. See Courtney J. Martin, "Art World, Network and Other Alloway Keywords," *Tate Papers,* no. 16 (1 October 2011), http://www.tate.org.uk/research/publications /tate-papers/art-world-network-and-other-alloway-keywords.

11. On the relation between curator and critic in Alloway's writing, see Stephen Moonie, "Mapping the Field: Lawrence Alloway's Art Criticism-as-Information," *Tate Papers,* no. 16 (1 October 2011), http://www.tate.org.uk/research/publications /tate-papers/mapping-field-lawrence-alloways-art-criticism-information.

12. For this self-reflexive attitude, see, for example, Alloway's revision of his previous focus on certain institutions within the distribution system, Lawrence Alloway, "Art," *The Nation,* 23 October 1972, 381.

13. Lawrence Alloway, "Art and the Expanding Audience," in idem, *The Venice Biennale, 1895–1968: From Salon to Goldfish Bowl* (Greenwich, Conn.: New York Graphic Society; London: Faber & Faber, 1968), 125.

14. Lawrence Alloway, "Network: The Art World Described as a System," in idem, *Network: Art and the Complex Present* (Ann Arbor: UMI Research Press, 1984), 4. In a note for this passage, Alloway refers back to his earlier article on the concept of a network; see Lawrence Alloway, "Art and the Communications Network," in *Canadian Art* 23, no. 100 (June 1966): 35–37.

15. Alloway, "Art and the Expanding Audience," 124.

16. Alloway, "Art and the Expanding Audience," 124.

17. Alloway, *Artists and Photographs,* 3.

18. Alloway, *Artists and Photographs,* 4–5.

19. Alloway, *Artists and Photographs,* 4.

20. Alloway, *Artists and Photographs,* 3, 4.

21. Kate Linker, "The Artist's Book as Alternative Space," *Studio International* 195, no. 990 (1980): 75–79. For more on the countereconomic conception of printed matter around 1970, see Dan Graham, "Das Buch als Objekt" (The book as object), *Interfunktionen,* no. 11 (1974): 112; Lucy Lippard, "The Artist's Book Goes Public," *Art in America* 65, no. 1 (January-February 1977): 40–41; and Gwen Allen, *Artists' Magazines: An Alternative Space for Art* (Cambridge, Mass.: MIT Press, 2011).

22. See Ed Ruscha, *Every Building on the Sunset Strip* (Los Angeles, 1966). For a discussion on the exhibition-like character of Ruscha's books, see Beatrice von Bismarck, "Exhibitions, Agents, and Attention: In the Spaces of Ruscha's Books," in Yilmaz Dziewior, ed., *Reading Ed Ruscha* (Bregenz: Kunsthaus Bregenz, 2012), 66–75. See also Seth Siegelaub, *One Month* (New York, [self-published,] 1969), about which Lucy Lippard wrote: "First exhibition to exist in catalogue form alone; distributed free worldwide"; see Lucy Lippard, *Six Years: The Dematerialization of the Art Object from 1966 to 1972* (1973; repr., Berkeley: University of California Press, 1997), 79; and Lucy Lippard, *557,087: An Exhibition,* exh. cat. (Seattle: Seattle Art Museum).

23. For a more extensive discussion of *Aspen* magazine, see Gwen Allen, "The Magazine as a Medium: *Aspen,* 1965–1971," in idem, *Artists' Magazines: An Alternative Space for Art* (Cambridge, Mass.: MIT Press, 2011), 43–67.

24. For a thorough analysis of the artistic orientation in the 1960s toward issues of publicity, see Alexander Alberro, *Conceptual Art and the Politics of Publicity* (Cambridge, Mass.: MIT Press, 2003).

25. The first extensive study of the multiple as an artistic format was presented by John L. Tancock. See his *Multiples: The First Decade,* exh. cat. (Philadelphia: Falcon Press, 1971).

26. Alloway, *Venice Biennale, 1895–1968,* 124.

27. Documenta 5, curated by a team grouped around the Swiss freelance curator Harald Szeemann, chose an overarching thematic orientation, the first in the history of this international art exhibition; *Interrogation of Reality—Picture Worlds Today* had a whole section dedicated to museums by artists, showing works by BEN, Marcel Broodthaers, Herbert Distel, Marcel Duchamp, Robert Rauschenberg, and Daniel Spoerri.

28. Lawrence Alloway, "'Reality': Ideology at Documenta 5," in idem, *Network: Art and the Complex Present* (Ann Arbor: UMI Research Press, 1984), 167.

29. Alloway, *Artists and Photographs,* 4.

30. Graham, "Das Buch als Objekt," 112; and Tancock, *Multiples.*

31. Lawrence Alloway, "The Support-System and the Art Galleries," in idem, *Network: Art and the Complex Present* (Ann Arbor: UMI Research Press, 1984), 175.

32. For an analysis of the hopes connected to the artist's book as an extended, democratized, and accessible form that has the potential to undermine the

existing structures of the art market, see Graham, "Das Buch als Objekt," 112; *Art-Rite* 14 (Winter 1976/77), special issue on artists' books, which includes statements by the artists John Baldessari, Douglas Huebler, and Sol LeWitt; Lippard, "The Artist's Book Goes Public," 40; and Linker, "The Artist's Book as Alternative Space," 77. In his analysis of the relationship between conceptual art and publicity, Alexander Alberro elaborates on the mythic character of this idea; see Alberro, *Conceptual Art,* 4–5. For another view, with an emphasis on the discouraging prospect of finding a wide audience, see Brian Wallis, "The Artist's Book and Postmodernism," in Cornelia Lauf and Clive Phillpot, *Artist/Author: Contemporary Artists' Books* (New York: DAP; American Federation of Arts, 1998), 94. For a discussion of the demand for democratization in relation to the production costs of artists' books in the 1960s, see Johanna Drucker, *The Century of Artists' Books* (New York: Granary Books, 1995), 72–73.

33. Ed Ruscha kept a precise record of the people to whom he wanted to distribute *Every Building on the Sunset Strip;* see Bismarck, "Exhibitions, Agents, and Attention," 73. For more on the discrepancy between the intention to produce low-priced accessible books and the rather high actual production costs, see Steven Leiber's assumption that *Artists and Photographs* might not ever have been produced in the full edition of 1,200 copies, Steven Leiber's website, *Public Collectors,* http://www.publiccollectors.org/Steve%20Leiber%20Audio/discussed%20items/audio%20files/4(artists&photographs).mp3.

34. For a list of multiple-related events, including the openings of graphic departments by art galleries, see Stephen Bury, *Artists' Multiples, 1935–2000* (Aldershot, England: Ashgate, 2001), 169–72. For a discussion of how the prices of artists' books evolved, see Hans Dickel, *Künstlerbücher mit Photographie seit 1960* (Hamburg: Maximilian Gesellschaft, 2008), 11–12.

35. For more on the dealer-critic system, see Harrison C. White and Cynthia A. White, *Canvases and Careers: Institutional Change in the French Painting World* (1965; repr., Chicago: University of Chicago Press, 1993), 76–110. It is against this backdrop that the changes in the art world of the 1960s can be described along the axes of a dealer-curator system; see Magda Tyzlik-Carver, *Interfacing the Commons: Curatorial System as a Form of Production on the Edge,* Digital Aesthetics Research Center (DARC) site, http://darc.imv.au.dk/publicinterfaces/wp-content/uploads/2011/01/Tyzlik-Carver.pdf.

36. Alloway, "Network: The Art World Described as a System," 8.

37. For these emphases, see Alloway's articles "Institution: Whitney Annual," "The Great Curatorial Dim-Out," and "The Support-System and the Art Galleries" (1982), in idem, *Network: Art and the Complex Present* (Ann Arbor: UMI Research Press, 1984), 141–50, 151–59, 171–76.

38. Lawrence Alloway, introduction to *Options: Directions 1,* exh. cat. (Milwaukee: Milwaukee Art Center, 1968), 4–5.

39. Alloway, introduction to *Options,* 7.

40. Alloway, *Venice Biennale, 1895–1968,* 127.

41. Alloway, *Venice Biennale, 1895–1968,* 125.

42. Alloway, "The Support-System," 175.

43. Alloway, "The Support-System," 4.

JULIA BRYAN-WILSON

THE PRESENT COMPLEX
Lawrence Alloway and the Currency of Museums

Currency

In the early 1970s, the critic and curator Lawrence Alloway published a remarkable series of articles that directly confronted the political, economic, and ideological struggles faced by art institutions in the United States. With subjects such as artists' protests against the Vietnam War, the 1973 strike at the Museum of Modern Art (MoMA), the undermining of curatorial authority, and the ramifications of staff unionization, Alloway chronicled a growing sense that art museums were, on several fronts, in a state of "crisis" and that art criticism was tainted by collective feelings of "uneasiness/disgust."[1] Primarily published in *Artforum* and *The Nation,* Alloway's essays at this time were especially concerned with questions of *currency*—that is, how the museum could be current, up to date, and relevant to the still-unfolding conditions of the now.[2] Donald Kuspit has remarked that "topicality is Alloway's watchword and obsession."[3] For Alloway, the contemporary moment—which he termed the "complex present"—is complicated because of its "unsettled issues" and "topics in suspense" that might be understood only in the future, with the clarity of historical distance.[4] Emphasizing his relationship to temporality, Alloway practiced what he called "short-term art history," a provisional, contingent record that was as accurate as possible given the uncertainty of what we can know at any given time.[5]

This essay looks closely at a few years within Alloway's decades-long career and contends that this "complex present" should be revisited and inverted, arguing that what was at stake regarding the crisis of museums in the late 1960s and early 1970s could also be called a *present complex*—a complex (in other words, neurosis or anxiety) about the precise status of the present moment for art institutions.[6] I argue that Alloway's work at this time clustered around sets of interrelated problems, each of which I examine in turn: the expansion of the art world, a pluralistic approach to evaluation, the waning influence of curators and museums, the commercialization of artistic production, the politicization of artists' rights, the crisis of art criticism, and the unionization of museum

staff. These pressing issues both shadowed and structured Alloway's writing in the early 1970s.

Increasingly, Alloway took museums to task for refusing to recognize their role as not only safeguards of the past but also active shapers of contemporary culture. *Currency* has a double meaning that was significant for Alloway as he considered how museums, as well as other facets of art's support structures (like art magazines, corporate patrons, and educational institutions), are irrevocably steeped in market exchanges. These structures create charged forms of valuation that are unequally applied at every level of involvement with artistic circulation and distribution, from artists to critics to museum employees, including manual laboring art handlers and high-level curators. During these years, Alloway—who, as a curator and a critic, was implicated himself in this *system* (a term he was greatly invested in)—tackled disparate levels of compensation and unequal systems of worth head-on, just as such issues were becoming more visible and more urgent.

He pursued an alternative model of criticism that he referred to not only as "short-term art history" but also, more potently, as "anthropological" art history, in which art is not cordoned off from economics or social conditions of circulation but instead is integrated within a wide frame that includes the creation and management of culture.[7] Alloway's notion of anthropology does not reject qualitative assessment based on value judgments but integrates those judgments with hard facts, deploying quantitative data such as economic statistics in an ethnographic manner. Though Alloway attempted a wider humanistic inquiry into cultural production, he was not trained in anthropology's specific disciplinary methodologies; in fact, his method of aggregating information also resembles a sociological approach to art.[8] Yet his hybrid practice of criticism evidences some distinctive characteristics that overlap with the field of anthropology, namely participant-observer methods of immersive fieldwork, and, most significantly, taking a self-reflexive approach that acknowledges one's implication within one's object of study. Rather than assuming a detached or "neutral" observer, the reflexive scholar attempts to grapple with his or her own subjectivity and power; significantly, this reflexive turn in anthropology emerged in the late 1960s and 1970s, just as Alloway became interested in questions of critical complicity within institutional systems.[9]

Expansion

Alloway's output in the late 1960s and early 1970s tended to focus on the changing state of the art museum, which was not exceptional given his long-standing interest in broader questions of cultural formation. His forays into

these anthropological analyses of the art world were prefigured by writings in the 1950s such as "The Long Front of Culture," which argued for expanded attention to mass media and other popular forms of production.[10] Widely known for a nondogmatic, eclectic approach to criticism, Alloway championed no one style nor promoted a single theoretical lens. Instead, his work was sympathetic and inclusive; in the late 1960s and early 1970s, this inclusion took a decidedly political cast as he began to take seriously work made in the wake of both the civil rights movement and second-wave feminism.

Indeed, Alloway's concerns about the museum's function must be placed in relation to broader questions about the exclusion of white women artists and artists of color within museums, as these issues drove both artistic activism against institutions and, increasingly, Alloway's own curatorial and critical commitments. The crisis of the museum that so concerned Alloway in the late 1960s and early 1970s is inseparable from questions of race and gender. One overarching question of interest to Alloway at this time was, "What does art do for such groups as women or blacks? How do museums relate to artists, to the community as a whole?"[11] Alloway had begun to write about artists of color by the late 1960s, and he became a more visibly active promoter of black artists in 1969, when he cocurated, with Princeton Art Museum curator Sam Hunter, a show titled *5 + 1* at the State University of New York at Stony Brook (now called Stony Brook University), where Alloway taught in the art department and where he also served as the gallery director/curator (fig. 1). *5 + 1* featured six black artists (all men), including Frank Bowling and Jack Whitten.[12] The curatorial statement in the exhibition brochure is silent about the political ramifications of a show about black artists curated by two white men, but it does discuss the artists' use of abstraction and their philosophy of art for art's sake, as well as their explicit connections to African and African American issues: "The situation of black artists is ambiguous: there is considerable use of the idea of art as an instrument to advance Black identity, Black rights; there is, also, clearly and successfully, an impulse towards the making of art as art. In the artists' statements in this catalogue, both possibilities oscillate."[13] In other words, Alloway and Hunter understood that these artists' forms of abstraction—despite their ostensible lack of subject matter—should not be deracinated or universalized but instead should retain their specificity within the context of black artistic traditions, and therefore might have profound, if oblique, political possibilities.

By the mid-1970s, Alloway was also reviewing more and more art by women, and he became the first prominent male art critic to write about women's art—particularly, pointedly feminist art—in major art publications. In part this move

ART GALLERY
STATE
UNIVERSITY
OF NEW YORK
AT STONY BROOK
OCT.16 TO NOV.8 , 6 9
AND THE ART MUSEUM
PRINCETON UNIVERSITY
NOVEMBER 12 – 23 , 1969
SPONSORED BY
THE AFRO – AMERICAN
STUDIES PROGRAM

Fig. 1.
Cover of Lawrence Alloway's exhibition brochure _5+1_, published by Art Gallery, State University of New York at Stony Brook, 1969. Los Angeles, Getty Research Institute.

to a more inclusive position was influenced by his wife, the pioneering feminist artist Sylvia Sleigh, but it should also be seen as an outgrowth of his larger commitment to take seriously previously marginalized voices. As he commented in notes regarding Sleigh's impact on his career, "I see my involvement w[ith] women's art as part of the (general) politicization of art."[14] These issues are difficult if not impossible to segregate; for Alloway, recognizing white women artists (not all of whom were self-identified as feminists) and artists of color was deeply formative and existed alongside and in relation to his writings on museums, because they were both part of the present conditions—the _currency_—that museums were agonizingly slow to exhibit. He was sharply critical of the outdated overrepresentation of white male artists in biennials and annuals, which he saw as a blatant refusal to acknowledge developments as they were occurring. "The [Whitney] Annuals do not function efficiently to distribute fresh information," he wrote in a column in _The Nation,_ pointing to his explicit valuation of museum currency.[15] Along with the concept of _freshness,_ the term _information_ is pivotal here; Stephen Moonie has described Alloway's understanding of criticism as information, unpacking how _information_ signified in the moment with regard to Alloway's absorption of cybernetics theory and in terms of its use in Kynaston McShine's _Information_ exhibition at MoMA in 1970.[16]

Obsolescence

A few years later, in his article "The Great Curatorial Dim-Out," Alloway became even more specific regarding his insistence that museums maintain their contemporary relevance, fuming:

> The curators should be expected to be in touch with changing social and stylistic forces, but the history of the exhibition does not support this expectation. It was only after demonstrations that the curators increased the representation of women in the [Whitney] annuals. Why had the curators not anticipated the pressure of women artists and recognized their exhibitability before the issue became a crisis? The fact that the representation of women climbed steeply is, of course, an admission of their previous error. If women's work had not been esthetically acceptable to them, I assume that the curators would not have modified their original position. It is hard to imagine a more difficult task for a White curator than the Whitney's *Contemporary Black Artists in America.* Then why was it organized in such a way as to antagonize the Black community and embarrass the curator [Robert] Doty? It is another failure of the power to assess correctly the changing situation in the artworld.[17]

This passage indicates that Alloway was deeply concerned with questions of contemporaneity and palpably felt the failure of museums to account for their own activities in relation to "the changing situation in the artworld," in other words, the impact of political movements, such as feminism and civil rights. Because of an inability to stay topical and current, "the profession of the curator is in crisis," he bluntly hypothesized.[18] Yet the challenge of how to maintain this currency given the relatively slow pace of museum calendars and the lag in curatorial scheduling was something that Alloway, a former curator at the Solomon R. Guggenheim Museum, was keenly aware of. His insider knowledge of these constraints made him quite clear-eyed and pragmatic about how museums could better reflect shifting values, and thus all the more agitated when they were unable, or refused, to do so, as in the case of the Whitney Annual.

In contrast to the glacial tempo of the museum with all its delays and retrograde ways, Alloway sought to keep track of rapidly changing social and economic conditions. How, though, could a critic stay on top of the mountains of information about the present crisis in museums—widely discussed at this time from a spectrum of perspectives within both more conservative and more progressive venues—and be appropriately accountable to those perspectives in his or her own writing? In order to stay abreast of the swirling debates, Alloway

was an assiduous reader of newspapers and journals, as well as a collector of all manner of texts, handbooks, brochures, and protest matter related to art, politics, and art institutions. He amassed a vast array of clippings from a variety of publications, both mainstream and alternative, and he would often annotate and refer to this material in his writings.

Among the diverse materials on this topic in his personal archive (now housed at the Getty Research Institute) are articles ranging from the Houston-based *Judaism: The Jewish Digest* ("What Ails the Jewish Museum: An Institution Adrift") to polemics from the California-based newspaper for the Black Panther Party. In the former, printed in 1969, the Jewish Museum is diagnosed as "not well," failing in its efforts to balance its specialized mission with a sense of contemporary relevance; in the latter, from 1970, Black Panther minister of culture Emory Douglas rejects art museums altogether, stating that "the time has come when all artists must take a stand against the reactionary forces in racist America or bite the dust, along with all other reactionaries" and proposing an open call for progressive work that will be collected in a book of "People's revolution art."[19] This range of perspectives about the contested role of art and art institutions from across the country displays how remarkably attentive Alloway was to the full gamut of opinions about the interface of artistic production, institutionalization, and social movements in America.

Also found among Alloway's papers are items related to wider economic issues, such as articles from sociologists regarding class-based social stratification and *Wall Street Journal* columns dissecting global monetary woes related to devaluation of currency and the competitive international circulation of goods. One such clipping from a newspaper article includes the following underlined sentence among several flagged passages: "When a currency floats, its value is determined by the market and may fluctuate sharply."[20] One can only speculate about how such analyses might have affected Alloway's anthropological understanding of the interrelation between art markets and other sorts of markets, but it is clear from his writing at this moment that he was thinking through questions about the monetization of art, not least his own key, implicated position in that enterprise as a critic and freelance curator. He also gathered texts that pointed to a widespread dissatisfaction with museums, such as a 1973 article from the *New York Times* that asked a question that seemed to be on many people's minds: "Why Should Anyone Go to Museums Any More?"[21] Such articles signaled a larger discourse regarding the diminished role of the museum in public culture. For a critic and curator like Alloway—who was not only invested in museums as repositories of public culture but also distrustful of their elitist gatekeeping function, especially after he became disenchanted by the machinations of major museums during his tenure at the

Fig. 2.
Museums USA: Highlights,
brochure produced by the
National Endowment for
the Arts, 1973.
Los Angeles, Getty Research
Institute.

museums usa:
highlights

finances
programs
attendance
trustees
personnel
facilities

national endowment for the arts

Guggenheim—this recognition of the museum's diminished role was no doubt received with some ambivalence.

Museums were imperiled not only from without (because of a perceived waning interest in their programs and exhibits) but also from within, as financial upheavals threatened many institutions and forced heavy budget reductions. Traces of Alloway's research into the bleak financial situation facing many American museums in this era, including a pamphlet issued by the National Endowment for the Arts, *Museums USA: Highlights* (fig. 2), are also found among his papers. This survey of the field was begun in May 1972 and published in November 1973 (with a book-length study on the same topics issued in 1974), providing a snapshot of economic conditions of museums of natural history, science, art, and so forth. The study glumly concluded that "of all museum types, art had the highest proportion of museums in which cutbacks were necessary."[22] Alloway was diligent during these years about collecting a range of perspectives,

including governmental reports, museum-based professional association news-letters, such as that of the Association of Art Museum Directors, and acquisition transaction records for places including the Metropolitan Museum of Art, which was under scrutiny for its deaccessioning policies.[23] These are the files of not only an art critic grappling with the problems of the current moment but also an investigative reporter performing due diligence when piecing together an exposé. "Network: The Art World Described as a System," from 1972, was meant to be one such revelation; in this essay, Alloway combined systems theory with an analysis of the interlocking structures that govern artistic distribution. Published in the tenth-anniversary issue of *Artforum*, which referenced itself by putting a photo of its own offices on the cover, "Network" described how "all of us are looped together in a new and unsettling connectivity."[24] The reflexivity emphasized by this cover, in which *Artforum* acknowledged its own role as a tastemaker, was embraced and promoted by Alloway in his anthropological criticism.

Politicization

Notably, Alloway collected many of the fliers and posters created by the Art Workers' Coalition (AWC), an organization that came together in 1969 to conduct activities agitating for artists' rights, including asking for more transparency regarding museum decision making, calling for artist representation on boards of trustees, and, as the group evolved, demanding that museums exhibit more black, Latino, and white women artists.[25] Its members included Carl Andre, Hans Haacke, Lucy Lippard, Tom Lloyd, Faith Ringgold, and other artists and writers who came together under the loose and often fraught rubric of *art worker*. The formation of the AWC was sparked by a catalyzing incident regarding artists' control of their own work; in a guerrilla action, the Greek artist Takis unplugged a kinetic sculpture that he had created and carried it out of an exhibition at MoMA to assert his ownership of the work and his discontent with the conditions of its display.

Yet the AWC broadened its horizons quickly to become the primary outlet for left-leaning artistic activism in New York at that time, launching protests against MoMA's Rockefeller-studded board of trustees' involvement in the Vietnam War and advocating for a free day at MoMA, one of the group's most concrete victories. One flier, "All Museums Free—A.W.C.," heralds this victory, urging a large turnout for MoMA's first free Monday, stating "It is free because the Art Workers Coalition fought to make it free. It is free because a growing cultural revolution in this country requires that it be free and that the functions of all cultural institutions, along with the very definition of 'culture' itself, be

ALL MUSEUMS FREE – A.W.C.

ALL MUSEUMS FREE – A.W.C.

COME TO THE FIRST FREE MONDAY AT THE MODERN MUSEUM ON FEBRUARY 9TH BETWEEN 5 AND 9 P.M. BY COMING AT THIS TIME YOU WILL HELP TO SHOW THE URGENT NEED FOR CULTURE WHICH IS ACCESSIBLE AND MEANINGFUL TO THE ENTIRE POPU- LATION. THE MUSEUM IS LOCATED AT 11 WEST FIFTY-THIRD STREET IN MANHATTAN.

From February 9 onwards the Museum of "Modern" Art is free on Mondays. It is free because the Art Workers Coalition fought to make it free. It is free because a growing cultural revolution in this country requires that it be free and that the functions of all cultural institutions, along with the very definition of "cul- ture" itself, be expanded to keep pace with a changing society. What is the point of a culture that can only admit a money-paying public to see works of art that must be guarded by guards with guns?

The Art Workers Coalition (A.W.C.) is continuing its fight to reform the art world structure. Here are some of the things it is fighting for:

* To have only one 'pay day' each week, instead of only one free day, at all museums in the country.

* To decentralize all cultural institutions into the poorer and minority areas of this city and to encourage any changes this process may bring about in what we think of as "culture."

* To bring about fair representation of black and puerto rican artists in the museums of this city and to give black and puerto rican artists the encouragement which the present museum-gallery system has failed to give.

* To give artists a place in running our museums and to bring to artists the same resale and revenue privileges in their work as are available to writers and composers.

* To bring about fair treatment of women artists and of artists without galleries.

* To create free unstructured alternatives to museums, similar to England's arts labs, where cultural precon- ceptions can be suspended.

COME TO A.W.C. MEETINGS AND HELP US REACH THESE AND OTHER GOALS SOONER--EIGHT O'CLOCK EVERY MONDAY EVENING AT 729 BROADWAY, CORNER OF WAVERLY PLACE, SECOND FLOOR. FOR MORE INFORMATION PHONE 982-1500.

expanded to keep pace with a changing society" (fig. 3). Again, the sense that museums must shift with the times, on "pace with a changing society," is the central concern.

Alloway wrote about the AWC on numerous occasions, not only in "Network" but also in various short texts in *The Nation;* not all of these articles were uniformly celebratory.[26] Rather than unreservedly championing the AWC's free day success, in which "the museum yielded to [the Coalition's] pressure," he was sometimes wary of the group's presumed status as the major mouthpiece for artistic activism: "The Coalition is the main form by which current protest enters the art world, but it is not the only one."[27] In fact, he was initially skeptical of the AWC's sometimes overly simplistic claims with regard to museums. In a column from 30 June 1969, he wrote,

> A group called the Art Workers' Coalition has attempted to confront the Museum of Modern Art on the subject of "The New American Painting and Sculpture" show.... In the rhetoric of the Coalition the Modern is attacked as if it were monolithic, but this is a distortion of the new situation prevailing at the museum. The long-delayed departure of Alfred Barr and this month the retirement of senior curator Dorothy Miller have released the museum from a protracted ambivalence about American art.[28]

In other words, in Alloway's view, the AWC failed to account for present conditions, displaying an outmoded understanding of what the museum's current state was. He thought many members of the AWC were blinded by their anger and utopian ideals, with a worldview that must be "the product of a malicious or ignorant misunderstanding of the normal operations of an active museum."[29]

No doubt it was difficult for Alloway to keep up with the times, not only to track museums' rotating cast of personnel (including very brief directorial tenures at MoMA, such as the one-year run of director Bates Lowry and the less than two-year reign of John Hightower) but also to monitor and account for the rapid schedule of demonstrations and events involving the AWC and its offshoots. Struggling to map the many strands of political art activity since Takis's action on 3 January 1969, Alloway generated a number of handwritten timelines that list the AWC's activities and other related flashpoints in the contentious relationship between artists and museums, including "fruitless exchanges" between Lowry and members of the AWC, a demonstration of three hundred people in MoMA's sculpture garden, and the contested printing of a poster about the massacre of civilians and children by American soldiers in the village of My Lai (also known as Song My, which Alloway refers to as Song Mi)[30] (fig. 4). In addition, he noted when feminists advocated that more dedicated

Fig. 3.
"All Museums Free—A.W.C.,"
flier for the Art Workers'
Coalition, 1970.
Los Angeles, Getty Research
Institute.

Fig. 4.
**Notes by Lawrence Alloway
on artists' political activities
from 1969 to 1970,
ca. 1973.**
Los Angeles, Getty Research
Institute.

attention be paid to women's issues and began holding protests against museums, such as the Whitney Museum of American Art and the Brooklyn Museum, for their dismal lack of representation of women artists.[31]

A much more comprehensive timeline, the "Provisional List of Events Related to the Politicization of Artists," begins with the "student rebellion" of the free speech movement at Berkeley in 1964, lists events related to the organization of the women's movement and the AWC, and ends with the spray-painting of "Kill Lies All" on Pablo Picasso's *Guernica* in 1974, Tony Shafrazi's oblique vandalism-cum-protest. There are many more such lists by Alloway on this topic, and their very proliferation in his archive suggests that he was anxious to get a handle on the flow of artistic protests against museums and place them in their wider, albeit unruly, context.

Scattered notes reveal that Alloway was working toward a comprehensive "Index of Discontent" that would begin in 1960 but focus on post-1969 to chronicle "a crisis, a rise up, of dysfunction" that would include "museums, collectors, galleries, politicization of art criticism (anti-commodity and career-building)."[32] "What is the reason, if there is a single one, for this situation?" he mused. He posed some possible answers, including the idea that the expansion of art—its overproduction—had put pressure on galleries, museums, critics, and artists alike. "The increased number of artists puts a strain (quantity pressure) on the traditional system of distribution (but how to modify it?)." Alloway produced many pages of notes on this topic, attempting to grasp the complexity of the state of the art world and its many shifting allegiances. Alloway was investigating the root causes of this widespread dysfunction just as he was asking a question that was for him—as well as for many artists in the AWC—increasingly crucial: "How to write about black, Indian, Puerto Rican, and women artists?"[33]

In addition, he ventured that class codes of cultural capital in the United States had made viewers more cynical and more critical of art as a product for the elite: "orig. a Marxist tool against capitalism; now a product of sophistication. Hence the situation of skepticism without adequate reform targets in US." This series of thoughts, condensed by the author's shorthand, is inflected with the sociological theories of Karl Mannheim, whose writings about class and ideology Alloway knew well.[34] Mannheim's explorations into the development of belief systems based on social stratification may have given Alloway some purchase on the complex and often veiled registers of class in his nonnative United States.

Artforum's Crisis

It is vital to recognize that Alloway's articles documenting museum cultures and their discontents were largely written for *Artforum* under the editorship of John Coplans, who headed the magazine from 1971 to 1977. Coplans had a special interest in broadening the magazine's focus beyond formalism, and he created a climate in which its contributors wrote pieces about a large range of art world politics, not just reviews of gallery exhibitions. In addition, Coplans (like Alloway) was a British expat, and he promoted writing about white women artists, artists of color, and artists not based in the United States. As Coplans recalled, the shift toward a more pluralistic and political approach "greatly enhanced circulation and greatly enhanced income. We never had such a high income as the year of 1974 when the change began."[35]

Though this change turned the magazine around financially and increased its influence, it was met with hostility from some quarters. In a piece titled

"Muddled Marxism Replaces Criticism at *Artforum*," the art critic Hilton Kramer castigated the "rash of radical chic" that had infected the magazine, a tendency according to which critics denounced those within art institutions as "elitist, repressive exploitative racists and (a latecomer to the lexicon of such invective) sexist."[36] Kramer continues: "Modernist art itself would, on these holiday occasions, be discovered to have nefarious connections with the world of money, privilege and power—to be, indeed, a despised and malignant 'commodity.'"[37] Although his tone is sneering and dismissive, Kramer grasps the fundamental critique of institutions that was nascent in this moment, when artists were becoming ever more aware of the imbrication of museum and corporate interests. One anonymous (undated) letter found in the Alloway papers, written on *Artforum* letterhead, accuses museums of being "hostages to Galleries and Collectors" and decries the "secret commitments and the initiatives that have made dealer-financed shows increasing phenomena."[38]

Although the atmosphere in the early 1970s among the editorial board at *Artforum* (which included Alloway, Rosalind Krauss, Annette Michelson, and Robert Pincus-Witten) was hostile if not toxic, the magazine under Coplans did consistently provide an outlet for extended, substantial writings that directly confronted major art establishments.[39] Alloway was far from the only critic interested in these concerns, and as the conceptual branch of art known as institutional critique began to take shape, major essays by artists, such as Ian Burn's "The Art Market: Affluence and Degradation," examined questions of money, taste, and power from a far more critical stance than that of Alloway.[40] Writers such as Max Kozloff and Eva Cockroft also contributed substantial scholarly interventions into the history of modernism that linked the U.S. government's patronage of art during the Cold War with ideological notions of freedom in abstract expressionism.

Yet Alloway played a special role at *Artforum* due to his insistence that no one school of art triumphed above others. He was widely recognized as the most insistent critic in his acknowledgment of and advocacy for pluralism, that is, the idea that there was not one dominant style but rather a multiplicity of artistic modes, schools, and possibilities. In an interview in 1975, Coplans recounted that he brought Alloway into the *Artforum* fold "for one factor and one factor only. That was the notion of the coexistence of styles."[41] Alloway had always cast his critical net widely and was thus less apprehensive than other art critics when the art world began to expand and the role of the critic as definitive tastemaker began to wane.

As Alloway commented in 1974, "I felt pretty cool about this moment of crisis about the function of art criticism when it came, because I have never thought that art was something to be isolated from the rest of culture anyway."[42]

By contrast, Coplans echoed the larger feeling that "there is much more a sense of anxiety now than there was at any previous time," stemming in part from "too many galleries junking the quality of the work."[43] The AWC (which was more or less defunct by 1972) had started an early conversation regarding the "decentralization" of art, hoping to move art away from a few sanctified museums by placing it in a range of sites; by the mid-1970s, this decentralization was starting to come to fruition as self-organized groups of artists began to take advantage of still-cheap rents in downtown Manhattan and formed their own art spaces. As a result of this and other factors, the exhibition possibilities for art proliferated. Rather than participate in Coplans's anxiety about this expansion "junking the quality," Alloway, more than any other regular *Artforum* critic, enthusiastically reported on the new galleries opening in SoHo, the growth of artist cooperatives, the rise of alternative spaces, and the opening of institutions in sites such as Harlem (the Studio Museum in Harlem and El Museo del Barrio, founded in 1968 and 1969, respectively) and downtown (the downtown branch of the Whitney opened in 1973 at 55 Water Street).[44] "It seems that alternative spaces require alternative critics," he noted.[45] Fellow critic Carter Ratcliff noted that Alloway was "born again in the seventies," transformed into "Manhattan's one true populist critic."[46] As such, he was somewhat less focused on the activities of museums, leaving their hothouse debates behind as he documented practices such as street art and murals, public sculpture, earthworks, and performance. He wrote in 1970 that "the gallery system is under pressure again, as it was ten years ago, from the activity of downtown cooperatives run by artists. Now the pressure is from two sources, young artists who detect commercialism everywhere and experimental artists who work in hard-to-exhibit forms."[47] Alloway traveled to see art where it took him, to small renegade spaces as well as outdoors, where artists were making non-object-oriented conceptual or site-specific work that was less easy to contain commercially.[48]

Art in SoHo, a publication from 1976 spearheaded by Alloway's Stony Brook students (Alloway taught there from 1968 to 1981), contains charts and detailed information pinpointing the spread of galleries in the neighborhood. The cover of the booklet shows a zoning map of SoHo with the title "Art in ~~NY~~ SoHo," emphatically crossing out *NY* and replacing it with the more specific region (fig. 5). The interior includes bar graphs detailing the paucity of art magazine coverage of shows in SoHo, the culmination of quantitative analysis regarding the dismally small number of reviews published by major publications. For instance, according to the students' statistics, during the period from September 1974 to June 1975, less than a quarter of the exhibition reviews in *Artforum* were about spaces in SoHo. Here Alloway's students have produced an incisive and clearly documented study in the anthropological vein of the disproportionate

Fig. 5.
Cover of *Art in SoHo*,
publication by students at
State University of New York
at Stony Brook, 1976.
Los Angeles, Getty Research
Institute.

attention paid to blue-chip galleries, commercial dealers, and major museums, along with an exposé of the complicity of critics in these interlocking regimes of publicity. As stated in the booklet's introduction, "this publication is the result of our recognition that SoHo's emergence as an art center has not been accompanied by matching art criticism."[49] Alloway's students grasp how art magazines and their critics were trapped in an outdated model, refusing to keep current with the flood of alternative art activity rushing into freshly developed locations. Alloway himself hoped that the buzz of activity in locations like SoHo would eventually shift the focus away from a small handful of uptown museums.

At the same time, rather than looking for their own piece of the art institutional pie, some feminists were withdrawing, at least partially, from the conventional museum economy. Some early 1970s feminist art practices openly attempted to resist the dominant art market. The founding of the Feminist Art

Program and Womanhouse in California (1971–72), for instance, offered a radical challenge to pedagogy and to structures of display. Just as conceptual artists were making works critical of art magazines and museums that were meant to exist within those very spaces, many feminists were actively establishing alternative networks of distribution, such as *Feminist Art Journal,* and starting collaborative, nonprofit art spaces, including the first all-women cooperative gallery, A.I.R., founded in 1972.[50]

Unionization

Among Alloway's major contributions to criticism at this moment was not only his willingness to venture to out-of-the-way alternative galleries, SoHo cooperatives, and feminist spaces but also his sustained attention to issues of museum staff professionalization and unionization. In preparation for articles such as "Museums and Unionization," published in *Artforum*'s special issue on museums in February 1975, he drew from research he conducted around the country, interviewing staff and collecting documents that included employment contracts, union constitutions and bylaws, collective bargaining agreements, memos of negotiation, and charts of salary standards. He also attended gatherings of museum staff that were organized by the newly formed Museum Workers Association of New York and were meant to create solidarity across different institutional affiliations. One such assembly, convened in the early 1970s, "Issues Facing the Museum Worker Today," covered the following issues: salaries, policy making, job security, the role of the union, and the museum and the community (fig. 6).

Alloway was keen to track the formation of such groups, as well as staff associations at the Whitney, the Minneapolis Institute of Fine Arts, and the San Francisco Museum of Modern Art, all of which he documented at great length. He was especially interested in the professionalization of museum work, the gendered aspect of some facets of museum staffing, and what impact unionization might have on class identities. As he wrote in "Museums and Unionization," "the absence of blue-collar workers from museum groups is linked to the preference for forming associations rather than unions."[51] In this article, Alloway gets explicit, naming museum heads, discussing salaries, and wondering if newly professionalized groups such as clerical employees might forge solidarity with, say, high-level curators.

The question of how to organize effectively across social classes became especially tricky in the case of MoMA's staff union, the Professional and Administrative Staff Association (PASTA). PASTA had been created in 1971, drawing from the AWC's momentum to recognize all forms of artistic labor

Fig. 6.
"Issues Facing the Museum
Worker Today," flier for
event sponsored by the
Museum Workers Association
of New York, ca. 1973.
Los Angeles, Getty Research
Institute.

as *work,* and it undertook its second serious strike in the fall of 1973, in part to negotiate for a salary increase but also to advocate for greater staff input into policy and more transparent decision making. PASTA asked for a staff representative to be appointed to the controlling board of trustees and hoped to include all curators in the bargaining unit. It was this last demand that proved especially contentious, as the board refused to recognize curators—whom they understood as management—as part and parcel of the "workers" of the museum. To include curators in a group along with the staff that assisted them was perceived as a conflict of interest, but MoMA curators pushed back on this front, writing that "there is an implied lack of respect for the curatorial function in the suggestion that curators are managers."[52]

In the December 1973 issue of *Artforum,* which featured a photograph of the MoMA picket line on its front cover (fig. 7), Alloway and Coplans conducted interviews with PASTA members. Here questions of the disadvantages and the benefits of unionizing are explicitly addressed: "Don't you think it might have been more relevant for the PASTA not to have got into the classical trade union situation?"[53] Underpinning this particular question is the presumption that unions are a touch old-fashioned, and with their focus on manual labor, unsuited to the needs of museum workers. In fact, there was friction between trade unionists and PASTA members, as demonstrated by an unpublished letter to the editor of *Artforum* written by Peter Dworkin, a MoMA preparator and member of Local 30 1UOE, in the wake of Alloway's "Museums and Unionization":

Fig. 7.
Cover of *Artforum*, December
1973, featuring a photograph
of PASTA MoMA strike.
From *Artforum* 12, no. 4
(December 1973).

Alloway fails to mention what I consider to be a crucial component of
the labor-management relationship in art institutions: the relationship
between the professional associations and the blue collar unions. Here
at MOMA, the Professional and Administrative Staff Association con-
tinually betrays an elitist attitude born of intellectual delicacy which seems
to preclude a liaison between PASTA and the trades.... Although PASTA
had made one or two desultory attempts at initiating a dialogue with
trade union members, it has yet to demonstrate a willingness to adopt
a continuing policy of cooperation and respect, without which it must
always remain a frustrated and incoherent amalgamation of diffident

dissidents, waving toy swords at an increasingly sophisticated managerial arsenal.[54]

Dworkin starkly condemns the white-collar professionals within PASTA for maintaining stubborn divisions between themselves and those in the blue-collar trade unions. With this letter, Alloway's suspicion about the limits of such organizing efforts was confirmed, especially given the rigidity of museum structures.

The Present Complex

Despite such disenchantments and tensions, Alloway remained committed to the idea that artists could break out of the museum stranglehold to shake up contemporary culture. As Courtney J. Martin has perceptively written: "The art world was a 1960s thing that met its end with the downturn in the consumer market, the desire for artists to make objects that responded to a different set of circumstances, museums' inability to reconceive themselves in relation to new art, and a general discontent with the gallery system. Both nostalgic and forward looking, Alloway called for artists in the 1970s to 'make a real difference.'"[55] He also hoped that critics, curators, and students might "make a real difference." By turning his attention to questions of institutional currency, Alloway pointedly reshaped the role of the art critic. Alloway has long been understood as someone whose interest in the "network" of the art world bled into journalistic modes of writing; in the early 1970s, he further widened his scope to include anthropological analyses in which his own implication in the systems he described was explicitly addressed.

Without the wisdom of hindsight, how could any scholar or critic begin to describe seismic shifts in art, societal values, and politics, especially during the volatile period of U.S. history in the late 1960s and early 1970s? Producing a series of dispatches from the field of crucial cultural battlegrounds, he spoke from the position of a participant-observer in the museum/gallery/magazine network, fully aware that his affective stances, judgments, and interests, though created in the short-term art history of the here and now, would be resolved only in the long-term future. Alloway's work suggests that, given a complex present marked by upheavals within museums, protest movements, and alternative practices, only a blunt admission of our nervousness about—and our complicity within—the "present complex" will provide the possibility of remaining current.

Notes

1. Lawrence Alloway, "Whitney (seminar) 16 May 1974," typed notes, Lawrence Alloway Papers, Getty Research Institute, Los Angeles, acc. no. 2003.M.46, box 27, folder 31.

2. Writings include Alloway's regular "Art" column for *The Nation,* as well as "Network: The Art World Described as a System," *Artforum* 11, no. 1 (September 1972): 28–32; "Strike at the Modern," interviews between Lawrence Alloway, John Coplans, Susan Bertram, Jennifer Licht, Joan Rabenau, and Jane Fluegel, *Artforum* 12, no. 4 (December 1973): 41–47; "Museums and Unionization," *Artforum* 13, no. 6 (February 1975): 46–48; and "The Great Curatorial Dim-Out," *Artforum* 13, no. 9 (May 1975): 32–34.

3. Donald Kuspit, preface to Lawrence Alloway, *Network: Art and the Complex Present* (Ann Arbor: UMI Research Press, 1984), xiii.

4. Lawrence Alloway, "The Complex Present," *Art Criticism* 1, no. 1 (Spring 1979): 32–41.

5. James L. Reinish, "An Interview with Lawrence Alloway," *Studio International* 186, no. 958 (September 1973): 63.

6. Alloway also used this term in the title of a collection of his essays, *Network: Art and the Complex Present.*

7. Lawrence Alloway, "Anthropology and Art Criticism," *Arts Magazine* 45, no. 4 (February 1971): 22–23.

8. It is notable, then, that the academic school of the "sociology of art" was in the midst of being consolidated at this moment. See, for instance, Hanna Deinhard, *Meaning and Expression: Toward a Sociology of Art* (Boston: Beacon Press, 1970).

9. I considered putting "anthropological" in scare-quotes throughout this essay as a reminder that Alloway displays only a *resonance* with the field, rather than rigorously deploying its techniques. There is a broad literature about the so-called reflexive turn that occurred in anthropology around 1970, a development that had repercussions for the whole of cultural anthropology, not least in relationship to postcolonial and feminist methodologies. For one helpful overview that was written at this moment, see Bob Scholte, "Toward a Reflexive and Critical Anthropology," in *Reinventing Anthropology,* ed. Dell Hymes (New York: Pantheon, 1972), 430–49.

10. Lawrence Alloway, "The Long Front of Culture," *Cambridge Opinion* 17 (1959): 24–26; reprinted in John Russell and Suzi Gablik, eds., *Pop Art Redefined* (New York: Praeger, 1969), 41–43.

11. Lawrence Alloway, "Art and Politics: A New Place," handwritten, undated notes, Alloway Papers, box 10, folder 11.

12. On Frank Bowling, one of the artists in *5 + 1,* and his relationship to Alloway, see Courtney J. Martin, introduction to *Frank Bowling: Paintings 1967–2012,* exh. cat. (New York: Spanierman Modern, 2013).

13. Lawrence Alloway, with Sam Hunter, introduction to *5 + 1,* exh. cat. (New York: State University of New York at Stony Brook Art Gallery, 1969), n.p.

14. Lawrence Alloway, "Smithsonian Institution 21 February 1974," typed notes, Alloway Papers, box 27, folder 37.

15. Lawrence Alloway, "Art," *The Nation,* 13 March 1972, 349.

16. Stephen Moonie, "Mapping the Field: Lawrence Alloway's Art Criticism -as-Information," *Tate Papers,* no. 16 (1 October 2011), http://www.tate.org.uk /research/publications/tate-papers/mapping-field-lawrence-alloways-art -criticism-information.

17. Alloway, "The Great Curatorial Dim-Out," 34.

18. Alloway, "The Great Curatorial Dim-Out," 32.

19. Avram Kampf, "What Ails the Jewish Museum: An Institution Adrift," condensed from *Judaism, The Jewish Digest,* April 1969, 41–53; Emory Douglas, "To All Progressive Artists Who Are Struggling against the Racist US Government…World Enemy Number One," *The Black Panther,* Saturday, 29 August 1970, 20.

20. Ray Vickers, "No Easy Answers: Solutions to World Monetary Woes Appear Far Away as 'Group of Ten' Partners Meet," *Wall Street Journal,* 14 September 1971.

21. Joshua C. Taylor, "Why Should Anyone Go to Museums Anymore?," *New York Times,* 30 September 1973.

22. National Endowment for the Arts, *Museums USA: Highlights,* brochure (New York: National Endowment for the Arts, 1973), 19.

23. J. Michael Montias, "Are Museums Betraying the Public's Trust?," *Museum News* 51, no. 9 (May 1973).

24. Alloway, "Network: The Art World Described as a System," 31.

25. For more on the Art Workers' Coalition, see Julia Bryan-Wilson, *Art Workers: Radical Practice in the Vietnam War Era* (Berkeley: University of California Press, 2009).

26. See, for instance, Alloway's columns in *The Nation,* 19 October 1970, 381; and 30 November 1970, 573.

27. Lawrence Alloway, "Art," *The Nation,* 23 February 1970, 221.

28. Lawrence Alloway, "Art," *The Nation,* 30 June 1969, 837–38.

29. Alloway, "Art," *The Nation,* 30 June 1969, 837–38.

30. Alloway wrote about how the Art Workers' Coalition's My Lai poster was eventually printed without the promised cosponsorship of the Museum of Modern Art, *The Nation,* 19 October 1970, 381–82.

31. See Julia Bryan-Wilson, "Still Relevant: Lucy R. Lippard, Feminist Activism, and Art Institutions," in *Materializing "Six Years": Lucy R. Lippard and the Emergence of Conceptual Art,* ed. Vincent Bonin and Catherine Morris (Cambridge, Mass.: MIT Press; Brooklyn: Brooklyn Museum, 2012), 70–92; and Alloway, "Art," *The Nation,* 15 December 1970, 637–38.

32. Alloway, "Art and Politics: A New Place."

33. Lawrence Alloway, "Uses/Limits 3," typed, undated notes, Alloway Papers, box 27, folder 10. These were notes for three lectures, collectively titled "The Uses and Limits of Art Criticism," delivered at the Art Students League, New York, 1973, an expanded version of which was published in Alloway's *Topics in American Art since 1945* (New York: Norton, 1975), 251–70.

34. Alloway cited Mannheim in "Network: The Art World Described as a System," and owned a copy of Mannheim's *Essays on the Sociology of Knowledge,* ed. Paul Kecskemeti (London: Routledge and Kegan Paul, 1952).

35. Paul Cummings, oral history interview with John Coplans, 4 April 1975–4 August

1977, Archives of American Art, Smithsonian Institution.

36. Hilton Kramer, "Muddled Marxism Replaces Criticism at *Artforum,*" *New York Times,* 21 December 1975.

37. Kramer, "Muddled Marxism."

38. Typed, undated, anonymous letter, Alloway Papers, box 15, folder 8.

39. For more on the intense rancor between these writers, see Amy Newman, ed., *Challenging Art: Artforum 1962–1974* (New York: Soho Press, 2000).

40. Ian Burn, "The Art Market: Affluence and Degradation," *Artforum* 13, no. 8 (April 1975): 34–37.

41. Cummings, oral history interview with Coplans.

42. Lawrence Alloway, "The Function of the Art Critic," *New York University Education Quarterly* 5, no. 2 (Winter 1974): 28.

43. Cummings, oral history interview with John Coplans."

44. On the growth of cooperative galleries, see Lawrence Alloway, "Art," *The Nation,* 9 October 1972, 316; and Lawrence Alloway, "Art," *The Nation,* 3 January 1972, 29–30. For more on the founding of the Studio Museum and El Museo del Barrio, see Julie Ault, ed., *Alternative Art, New York 1965–1985: A Cultural Politics Book for the Social Text Collective* (New York: Drawing Center; Minneapolis: University of Minnesota Press, 2002). On the opening of the Whitney's downtown branch, see Lawrence Alloway, "Art," *The Nation,* 26 November 1973.

45. Lawrence Alloway, typed, undated notes on galleries, 9, Alloway Papers, box 27, folder 23.

46. Carter Ratcliff, "Making It in the Art World: A Climber's Guide," *New York,* 27 November 1978, 63.

47. Lawrence Alloway, "Art," *The Nation,* 26 January 1970, 92–93.

48. See the essay by Sleeman, this volume.

49. *Art in SoHo,* published by the students of Art 352 (Stony Brook: SUNY Stony Brook, 1976). Alloway served as an editorial adviser.

50. See, for instance, Marcia Tucker, "Bypassing the Gallery System" (1973), in Helena Reckitt and Peggy Phelan, eds., *Art and Feminism* (London: Phaidon, 2001), 206. Alloway reviewed exhibitions at A.I.R. but came under fire for this activity because of his personal connections with Sleigh, an A.I.R. member.

51. Alloway, "Museums and Unionization," 47.

52. Betsy Jones and Kynaston McShine to Richard Oldenburg, cc to Mrs. Rockefeller III, 2 October 1973, Alloway Papers, box 15, folder 11.

53. Alloway and Coplans, "Strike at the Modern," 44.

54. Peter Dworkin, unpublished letter to the editor of *Artforum,* 4 March 1975, Alloway Papers, box 9, file 5.

55. Courtney J. Martin, "Art World, Network and Other Alloway Keywords," *Tate Papers,* no. 16 (1 October 2011), http://www.tate.org.uk/research/publications /tate-papers/art-world-network-and-other-alloway-keywords.

SELECTED BIBLIOGRAPHY

This selected bibliography of works by Lawrence Alloway is limited to articles, books, and exhibition catalogs in which Alloway was the sole or primary author, as well as key anthologies. A more extensive bibliography of published works by Alloway is held in the Special Collections of the Getty Research Institute.

1953

Foreword to *Sylvia Sleigh,* n.p. Exhibition catalog. London: Kensington Art Gallery, 1953.

1954

Introduction to *Nine Abstract Artists: Their Work and Theory,* 1–20. Exhibition catalog. London: Alec Tiranti, 1954.

1955

Introduction to *Mark Tobey,* n.p. Exhibition catalog. London: Institute of Contemporary Arts, 1955.

Introduction to *New Sculptors and Painter-Sculptors,* n.p. Exhibition catalog. London: Institute of Contemporary Arts, 1955.

1956

"Caro and Gravity." In *Antony Caro: dal 19 al 28 Marzo 1956,* n.p. Exhibition catalog. Milan: Galerie del Naviglio, 1956.

"The Challenge of Post-War Painting." In *New Trends in Painting: Some Pictures from a Private Collection,* 2–6. Exhibition catalog. London: Arts Council of Great Britain, 1956.

"Design as a Human Activity." Introduction 1 to Theo Crosby, ed., *This Is Tomorrow,* n.p. Exhibition catalog. London: Whitechapel Art Gallery, 1956.

Foreword to *Magda Cordell,* n.p. Exhibition catalog. London: Hanover Gallery, 1956.

Introduction to *John McHale: Collages,* n.p. Exhibition catalog. London: Institute of Contemporary Arts Library, 1956.

"Technology and Sex in Science Fiction: A Note on Cover Art." *ARK* (Journal of the Royal College of Art) 17 (1956): 19–23.

1957

Background to Action: A Series of Six Articles on Post-War Painting. New York: Garland Publishing, 1957.

"*An Exhibit:* Richard Hamilton, Victor Pasmore, Lawrence Alloway." *Architectural Design* 27 (1957): 288–89.

Introduction to *The Exploration of Paint: Paintings by Karel Appel, Jean Dubuffet, Sam Francis, Paul Jenkins, Jean-Paul Riopelle, 15 January to 9 February 1957,* n.p. Exhibition catalog. London: Arthur Tooth & Sons, 1957.

Introduction to *New Trends in British Art (Nuove tendenze dell'arte inglese),* n.p. Presented by Sir Herbert Read and Lawrence Alloway. Exhibition catalog. Rome: Rome-New York Art Foundation, 1957.

Introduction to *New Trends in Painting: Some Pictures from a Private Collection,* 2–9. 2nd ed. Exhibition catalog. London: Arts Council of Great Britain, 1957.

"Introductory Notes." In *Statements: A Review of British Abstract Art in 1956,* n.p. Exhibition catalog. London: Institute of Contemporary Arts, 1957.

"A Note on William Turnbull's Technique." In *William Turnbull: New Paintings and Sculpture,* n.p. Exhibition catalog. London: Institute of Contemporary Arts, 1957.

Preface to *Between Space and Earth: Trends in Modern Italian Art,* 3–5. Exhibition catalog. London: Marlborough Fine Art Ltd., 1957.

Untitled essay. In *Leon Golub: Paintings from 1956 and 1957,* n.p. Exhibition catalog. Chicago: Allan Frumkin Gallery, 1957.

1958

"Art in New York Today." *The Listener* (1958): 647–48.

"The Arts and the Mass Media." *Architectural Design* 28, no. 2 (1958): 84–85.

Introduction to *The Exploration of Form: Paintings by René Guiette, Simon Hantaï, Asger Jorn, Antonio Tàpies, William Turnbull, 21 January to 15 February 1958,* n.p. Exhibition catalog. London: Arthur Tooth & Sons, 1958.

Introduction [in German] to *Young British Painters, 1958: Sandra Blow, Alan Davie, William Gear, Peter Kinley, Peter Lanyon, Louis Le Brocquy,* n.p. Exhibition catalog. Rotterdam: Rotterdamsche Kunstkring, 1958.

"Notes on the Paintings." In *Some Paintings from the E. J. Power Collection,* n.p. Exhibition catalog. London: Institute of Contemporary Arts, 1958.

"Some Notes on Abstract Impressionism." In *Abstract Impressionism: An Exhibit of Recent Paintings Arranged by Lawrence Alloway and Harold Cohen,* n.p. Exhibition catalog. London: Arts Council of Great Britain, 1958.

1959

"Class of '59: Commentary by Lawrence Alloway." In *Class of '59: Magda Cordell, Eduardo Paolozzi, John McHale; Paintings, Sculptures, Collages, 7–19 February 1959,* A-C. Exhibition leaflet. Cambridge: The Union with Cambridge Contemporary Art Trust, 1959.

"Great Britain." In Sam Hunter, ed., *European Art Today: 35 Painters and Sculptors,* 45–49. Exhibition catalog. Minneapolis: Minneapolis Society of Fine Arts, 1959.

Introduction to *Actualités: Contemporary Watercolours and Gouaches by Appel, Bluhm, Davie, Dubuffet, Francis, Jorn, Mathieu, Michaux, Riopelle, Stubbing, Wemaere, Wols, Wolvecamp, 20 January to 14 February 1959,* n.p. Exhibition catalog. London: Arthur Tooth & Sons, 1959.

Introduction to *Paintings from the Damiano Collection,* n.p. Exhibition catalog. London: Arts Council of Great Britain, 1959.

"The Long Front of Culture." *Cambridge Opinion* 17 (1959): 24–26.

"The New American Painting." *Art International* 3, nos. 3–4 (1959): 21–29.

1960

"Aphoristic and Monumental." In *William Turnbull: Sculpture,* n.p. Exhibition catalog. London: Molton Gallery, 1960.

"Chrysalis and Mummy." In E. R. Nele, *Sculptures,* n.p. Exhibition catalog. London: Molton Gallery, 1960.

"Dubuffet as Pastoral." In *Jean Dubuffet: Éléments botaniques (Août–Décembre 1959),* n.p. Exhibition catalog. London: Arthur Tooth & Sons, 1960.

Ettore Colla: Iron Sculpture. Rome: Grafica, 1960.

"Hassel Smith." In *Hassel Smith: Paintings; 1960,* n.p. Exhibition catalog. London: Gimpel Fils, 1960.

Introduction to *Gillian Ayres: Paintings; Anthea Alley: Sculpture,* n.p. Exhibition catalog. London: Molton Gallery, 1960.

Introduction to *Matter Painting: September 1960,* n.p. Exhibition catalog. London. Institute of Contemporary Arts, 1960.

Introduction to *Peter Stroud: Paintings,* n.p. Exhibition catalog. London: Institute of Contemporary Arts, 1960.

Introduction [in Italian] to *Toti Scialoja: dal 22 al 31 ottobre 1960,* n.p. Exhibition catalog. Milan: Galerie del Naviglio, 1960.

Introduction to *William Turnbull: Paintings,* n.p. Exhibition catalog. London: Molton Gallery, 1960.

"Junk Culture as a Tradition." In *New Forms-New Media 1,* n.p. Exhibition catalog. New York: Martha Jackson Gallery, 1960.

"Notes on Abstract Art and the Mass Media." *Art News and Review* 12 (1960): 12.

Preface to *West Coast Hard-Edge: Four Abstract Classicists,* n.p. Exhibition catalog. London: Institute of Contemporary Arts, 1960.

"Sign and Surface: Notes on Black and White Painting in New York." *Quadrum X* 9 (1960): 49–62.

"Toti Scialoja Two Pages from a Journal: 1958," *ARK* (Journal of the Royal College of Art) 25 (1960): 21–23, 43.

1961

"Architecture and the Modern Cinema." *The Listener,* 22 June 1961, 1085–86.

"Artists as Consumers." *Image* 3 (1961): 14–19.

"Grande-Bretagne." In *Deuxième biennale de Paris: Manifestation biennale et international des jeunes artistes du 29 septembre au 5 novembre 1961, Musée d'art moderne de la ville de Paris,* 43–45. Exhibition catalog. Paris: Musee d'Art Moderne, 1961.

Introduction and catalog notes to *Jackson Pollock: Paintings, Drawings and Watercolors from the Collection of Lee Krasner Pollock,* n.p. Exhibition catalog. London: Marlborough Fine Art, 1961.

Introduction to *Asger Jorn: Luxury Paintings,* n.p. Exhibition catalog. London: Arthur Tooth & Sons, 1961.

Introduction to *The Integration of the Arts: 6th Congress of the International Union of Architects,* n.p. London: Exhibition for the 6th Congress of the International Union of Architects, 1961. Exhibition pamphlet inserted in Theo Crosby, ed., *The Architecture of Technology.* London: Whitefriars Press, 1961.

Introduction [in German] to *Jackson Pollock,* 5–12. Rüdiger von Schmeidel, trans. Exhibition catalog. Zurich: Kunsthaus Zurich, 1961.

Introduction to *John Plumb,* n.p. Exhibition catalog. London: Molton Gallery, 1961.

Introduction to *Modern American Painting,* n.p. Exhibition catalog. London: American Embassy, USIS Gallery, 1961.

Introduction to *Richard Smith,* n.p. Exhibition catalog. New York: Green Gallery, 1961.

Introduction to *Robyn Denny,* n.p. Exhibition catalog. London: Molton Gallery, 1961.

Introduction to *6 American Abstract Painters: Ellsworth Kelly, Alexander Liberman, Agnes Martin, Ad Reinhardt, Leon Smith, Sidney Wolfson,* n.p. Exhibition catalog. London: Arthur Tooth & Sons, 1961.

"Juror as Witness." In *Young Contemporaries 1961 Exhibition,* 3. Exhibition catalog. London: Royal Society of British Artists, 1961.

"Man on the Border." In *Lucio Fontana: Ten Paintings of Venice,* n.p. Exhibition catalog. New York: Martha Jackson Gallery, 1961.

"Two Europeans." In *Two Painters from Europe: Vera Haller, Wolfgang Hollegha,* n.p. Exhibition catalog. London: Institute of Contemporary Arts, 1961.

1962

Introduction to *Alexander Liberman,* n.p. Exhibition catalog. New York: Betty Parsons Gallery, 1962.

Introduction to *André Bloc: Recent Works,* n.p. Exhibition catalog. London: Drian Galleries, 1962.

Introduction to *Antoni Tàpies,* n.p. Exhibition catalog. Caracas: Museo de Bellas Artes, 1962.

Introduction to *British Art Today,* n.p. Exhibition catalog. San Francisco: San Francisco Museum of Art, 1962.

Introduction to *British Constructivist Art: Victor Pasmore, Kenneth Martin, Mary Martin, Anthony Hill, Stephen Gilbert, John Ernest,* n.p. Exhibition catalog. New York: American Federation of Arts, 1962.

Introduction to *Ellsworth Kelly,* n.p. Exhibition catalog. London: Arthur Tooth & Sons, 1962.

Introduction to *Helen Frankenthaler,* n.p. Exhibition catalog. Bennington, Vt.: Bennington College, 1962.

Introduction to *Leon Golub, Colossi: 21 March–19 April 1962,* n.p. Exhibition catalog. London: Hanover Gallery, 1962.

"'Pop Art' since 1949." *The Listener* 68, no. 1761 (1962): 1085–87.

1963

"Commentary." In *Eduardo Paolozzi: The Metallization of a Dream,* compiled by John Munday, 11–63. London: Lion and Unicorn, 1963.

Introduction to *Francis Bacon,* 12–25. Exhibition catalog. New York: Solomon R. Guggenheim Foundation, 1963.

Introduction to *Guggenheim International Award 1964,* 12–25. Exhibition catalog. New York: Solomon R. Guggenheim Museum, 1963.

Introduction to *Six More,* n.p. Exhibition catalog. Los Angeles: Los Angeles County Museum of Art, 1963.

"Latham's Objects." In *John Latham: Noit and Skoob,* n.p. Exhibition catalog. New York: Alan Gallery, 1963.

"Notes on Morris Louis." In *Morris Louis, 1912–1962, Memorial Exhibition: Paintings from 1954–1960,* n.p. Exhibition catalog. New York: Solomon R. Guggenheim Foundation, 1963.

Six Painters and the Object. Exhibition catalog. New York: Solomon R. Guggenheim Foundation, 1963.

Untitled essay [in French]. In *Jim Dine,* n.p. Exhibition catalog. Paris: Ileana Sonnabend Gallery, 1963.

"Whatever Happened to the Frontier?" *Minneapolis Institute of Arts Bulletin* 52, no. 2 (1963): 54–56.

1964

"Bacon le convulsif ou l'angoisse sied aux héros." *XXe Siècle* 23 (1964): 27–34.

"Interview: Lawrence Alloway and Alexander Liberman, February 1964." In *Alexander Liberman: Paintings; April 1964, Bennington College, Vermont,* n.p. Exhibition leaflet. Bennington, Vt.: Bennington College, 1964.

Introduction to *Alexander Liberman,* n.p. Exhibition catalog. Milan: Galleria dell'Ariete, 1964.

Introduction to *American Drawings,* 12–17. Exhibition catalog. New York: Solomon R. Guggenheim Foundation, 1964.

Introduction to *Maxfield Parrish: May 4–26, 1964,* n.p. Exhibition catalog. Bennington, Vt.: Bennington College, 1964.

Introduction to *The New Art,* n.p. Exhibition catalog. Middletown, Conn.: Davison Art Center, Wesleyan University, 1964.

Introduction to *Phillip Hefferton,* n.p. Exhibition catalog. New York: Gallery Bonino, 1964.

Introduction to *The Shaped Canvas,* n.p. Exhibition catalog. New York: Solomon R. Guggenheim Foundation, 1964.

"Notes on the Painters." In *Nine Contemporary Painters: USA,* n.p. Exhibition catalog. Washington, D.C.: Pan American Union, 1964.

"Paul Feeley: Introduction and Interview." *Living Arts* 3 (1964): 26–47.

"Roberto Crippa." In *Pittura a Milano dal 1945 al 1964: Milano, Palazzo Reale, giugno–luglio 1964,* 91. Exhibition catalog. Milan: Edizioni dell'Ente Manifestazioni Milanesi, 1964.

1965

"Alexander Liberman." In *7 Sculptors,* 20–22. Exhibition catalog. Philadelphia: University of Pennsylvania, Institute of Contemporary Art, 1965.

"Allan Jones." In *Premio nacional e internacional Instituto Torcuato di Tella,* 56. Buenos Aires: Centro de Artes Visuales, Instituto Torcuato di Tella, 1965.

"The Biomorphic 40s." *Artforum* 9, no. 4 (1965): 18–22.

Introduction to *Eleven from the Reuben Gallery,* n.p. Exhibition catalog. New York: Solomon R. Guggenheim Foundation, 1965.

Introduction to *William Baziotes: A Memorial Exhibition,* 11–17. Exhibition catalog. New York: Solomon R. Guggenheim Foundation, 1965.

Introduction to *Word and Image,* n.p. Exhibition leaflet. New York: Solomon R. Guggenheim Foundation, 1965.

"Lawrence Alloway: Curator, The Solomon R. Guggenheim Museum. New York." In *The Critic and the Visual Arts: Papers Delivered at the 52nd Biennial Convention of the American Federation of Arts in Boston, April 1965,* 12–15. New York: American Federation of Arts, 1965.

"Reflections on Michaux's Retrospective, Musée National d'Art Moderne, Paris, 1965." In *Henri Michaux,* n.p. Exhibition catalog. New York: Cordier and Ekstrom, 1965.

1966

"Art and the Communications Network." *Canadian Art* 23, no. 100 (1966): 35–37.

"The Development of British Pop." In Lucy R. Lippard, ed., *Pop Art,* 27–68. New York: Praeger; London: Thames & Hudson, 1966.

Introduction to *Barnett Newman: The Stations of the Cross; Lema Sabachthani,* 11–16. Exhibition catalog. New York: Solomon R. Guggenheim Foundation, 1966.

Introduction to Dr. Louise Averill Svendsen, ed., *Gauguin and the Decorative Style,* n.p. Exhibition catalog. New York: Solomon R. Guggenheim Foundation, 1966.

Introduction to *European Drawings,* 11–18. Exhibition catalog. New York: Solomon R. Guggenheim Foundation, 1966.

Introduction to *Jean Dubuffet: Recent Paintings; Ustensiles Utopiques,* n.p. Exhibition catalog. London: Robert Fraser Gallery, 1966.

Introduction to *Jean Dubuffet, 1962–66,* 15–21. Exhibition catalog. New York: Solomon R. Guggenheim Foundation, 1966.

Introduction to *The Photographic Image,* n.p. Exhibition catalog. New York: Solomon R. Guggenheim Museum, 1966.

Introduction to *Systemic Painting,* 11–21. Exhibition catalog. New York: Solomon R. Guggenheim Foundation, 1966.

Introduction to *20th Anniversary, 1946–1966: Pattern Art: Betty Parsons Gallery,* n.p. Exhibition catalog. New York: Betty Parsons Gallery, 1966.

"Notes on Pop Art." In Gregory Battcock, ed., *The New Art,* 83–91. New York: E. P. Dutton, 1966.

Samaras: Selected Works, 1960–1966. New York: Pace Gallery, 1966. Exhibition catalog.

Trova: Selected Works, 1953–1966. Exhibition catalog. New York: Pace Gallery, 1966.

1967

"The Artist as Bookmaker." *Arts Magazine* 41, no. 8 (1967): 22–23.

"An Introduction: Museums and Masses" and "The Changing Role of the Modern Museum," with William C. Seitz and Bruce Glaser. In *Arts Yearbook 9: The Museum World,* 8–10, 12–19. New York: Art Digest, 1967.

Introduction to *Asger Jorn: Recent Works, February 21–March 18, 1967,* n.p. Exhibition catalog. New York: Lefebre Gallery, 1967.

Introduction to *Roy Lichtenstein: Exhibitions of Paintings and Sculpture,* n.p. Exhibition catalog. Cincinnati, Ohio: Contemporary Arts Center, 1967.

"Roy Lichtenstein's Period Style: From the Thirties to the Sixties and Back." *Arts Magazine* 42, no. 1 (1967): 24–29.

"Serial Forms." In Maurice Tuchman, ed., *American Sculpture of the Sixties,* 14–15. Exhibition catalog. Los Angeles: Los Angeles County Museum of Art, 1967.

1968

"The Art of Betty Parsons" and "Interview with Betty Parsons (1968)." In *Betty Parsons: Painting, Gouaches and Sculpture, 1955–68,* 6–11, 14–16. Exhibition catalog. London: Whitechapel Art Gallery, 1968.

Introduction to *Options: Directions 1,* 3–7. Exhibition catalog. Milwaukee: Milwaukee Art Center, 1968.

Introduction to *Leon Polk Smith,* 3–11. Exhibition catalog. San Francisco: San Francisco Museum of Art, 1968.

"Melpomene and Graffiti." *Art International* 12, no. 4 (1968): 21–24.

"Science Fiction and Artifacts: Science Fiction Is Global Thinking's Pop Culture." *Arts Magazine* 43, no. 3 (1968): 39–41.

The Venice Biennale, 1895–1968: From Salon to Goldfish Bowl. Greenwich, Conn.: New York Graphic Society; London: Faber & Faber, 1968.

1969

"Abstract Painting." In *For Concept,* n.p. Booklet in the exhibition catalog *Concept: Vassar College Art Gallery, April 30–June 11 '69.* Poughkeepsie, N.Y.: Vassar College Art Gallery, 1969.

"Arakawa's Paintings: A Reading." *Arts Magazine* 44, no. 2 (1969): 26–29.

Christo. London: Thames & Hudson; New York: Abrams; Stuttgart: Gerd Hatje, 1969.

"The Expanding and Disappearing Work of Art." *Auction* 3, no. 2 (1969): 34–37.

Introduction, with Sam Hunter, to *5 + 1,* n.p. Exhibition catalog. New York: State University of New York at Stony Brook Art Gallery, 1969.

"Lawrence Alloway on Art Education, interview by Diana David." *Harvard Art Review* 3, no. 2 (1969): 49.

"Popular Culture and Pop Art." In Richard Crossman, Lawrence Alloway, and Sir Paul Chambers, eds., *Three Studies of Modern Communication. Granada Guildhall Lectures for 1969,* 45–67. London: Panther Books, 1969.

1970

"Elitist vs. Popular Criticism." In Lydia Silman, ed., *Conference on Art Criticism and Art History,* 7–9. New York: New York University, 1970.

"The Graphic Art of Robert Rauschenberg." In *Robert Rauschenberg: Graphic Art,* 5–9. Exhibition catalog. Philadelphia: University of Pennsylvania, Institute of Contemporary Art, 1970.

"Fiberglas and Sculptors." In *Tony DeLap, Frank Gallo, Eva Hesse: "Trio,"* n.p. Exhibition catalog. New York: Owens-Corning Fiberglas Center, 1970.

Introduction and "Arakawa Annexed: Interview by Lawrence Alloway." In Kathe Gregory et al., *Stolen,* n.p. New York: Colorcraft Lithographers, Dwan Gallery, and Multiples, 1970.

Introduction to *Artists and Photographs,* 3–6. Exhibition catalog. New York: Multiples, Inc., in association with Colorcraft, Inc., 1970.

Introduction to *Cleve Gray: A Retrospective Exhibition,* n.p. Exhibition catalog. Princeton, N.J.: The Art Museum, Princeton University, 1970.

Introduction to *Stanley Landsman,* n.p. Exhibition catalog. Houston, Tex.: Contemporary Arts Museum, 1970.

"Leon Polk Smith's Geometric Paintings, 1945–1953." In *Leon Polk Smith,* n.p. Exhibition catalog. New York: Galerie Chalette, 1970.

Untitled essay. In *Monumental Art,* n.p. Exhibition catalog. Cincinnati, Ohio: Contemporary Arts Center, 1970.

1971

"Anthropology and Art Criticism." *Arts Magazine* 45, no. 4 (February 1971): 22–23.

"Art." *The Nation* 202, no. 21 (1971): 668–69.

Introduction to *II Bienal de Arte Coltejer,* n.p. Exhibition catalog. Medellín, Colombia: Coltejer, 1971.

Introduction [in German] to *Mechanismus der Bedeutung (Werk im Entstehen: 1963–1971),* 5–23. Munich: Bruckmann, 1971.

Violent America: The Movies, 1946–1964. New York: Museum of Modern Art, 1971.

1972

Introduction to *Frank Gallo: Small Sculptures, Original Graphics,* 5. Exhibition catalog. New York: Bernard Danenberg Contemporaries, 1972.

Introduction to *The Marat Series: Arnold Belkin,* n.p. Exhibition catalog. New York: Lerner-Misrachi Gallery, 1972.

Introduction to *New York Women Artists,* n.p. Exhibition catalog. Albany: State University of New York at Albany, University Art Gallery, 1972.

Introduction to *Roy Lichtenstein,* 7–8. Exhibition catalog. Houston, Tex.: Contemporary Arts Museum, 1972.

"Network: The Art World Described as a System." *Artforum* 11, no. 1 (1972): 27–31.

"Robert Smithson's Development." *Artforum* 11, no. 3 (1972): 52–61.

1973

"Agnes Martin." *Artforum* 11, no. 8 (1973): 32–37.

"European Painting." In Ethel Moore, ed., *Contemporary Art 1942–1972: Collection of the Albright-Knox Art Gallery,* 193–203. New York: Praeger, 1973.

Introduction to *Agnes Martin,* 9–12. Exhibition catalog. Philadelphia: Falcon Press; Institute of Contemporary Art, 1973.

Introduction to *May Stevens,* n.p. Exhibition catalog. Ithaca, N.Y.: Herbert F. Johnson Museum of Art, Cornell University, 1973.

Introduction to *Otto Piene 9. 12. 1973–27. 1. 1974,* xxii–iv. Exhibition catalog. Starnberg: Keller, 1973.

Introduction to *Photo-Realism: Paintings, Sculpture and Prints from the Ludwig Collection and Others,* n.p. Exhibition catalog. London: Arts Council of Great Britain, Serpentine Gallery, 1973.

Introduction to *The 9: A Co-operative Group of Young Women Artists,* n.p. Exhibition catalog to accompany *Nine Days Wonder* exhibition. Stony Brook: The State University of New York Humanities Art Gallery, 1973.

Preface to Daniel Newman, ed., *Rudolf Baranik: Napalm Elegy,* 3. Exhibition catalog. New Brunswick, N.J.: Rutgers University, Livingston College, 1973.

"Viva Zero [in English/German]." In Otto Piene and Heinze Mack, eds., *Zero,* ix–xiv. Howard Beckman, trans. Cambridge, Mass.: MIT Press, 1973.

1974

American Pop Art. Exhibition catalog. New York and London: Collier Books and Collier MacMillan Publishers; New York: Whitney Museum of American Art, 1974.

"Artists as Writers, Part One: Inside Information." *Artforum* 12, no. 7 (1974): 30–35.

"Artists as Writers, Part Two: The Realm of Language." *Artforum* 12, no. 8 (1974): 30–35.

"The Function of the Art Critic." *NYU Education Quarterly* 5, no. 2 (1974): 24–28.

Introduction to *New York Eleven,* n.p. Exhibition catalog. Greenvale, N.Y.: C. W. Post Center Art Gallery, Long Island University, 1974.

"Leon Golub: The Development of His Art." In *Leon Golub: A Retrospective Exhibition of Paintings from 1947 to 1973,* n.p. Exhibition catalog. Chicago: Museum of Contemporary Art, 1974.

"Talking with William Rubin: The Museum Concept is Not Infinitely Expandable." With John Coplans. *Artforum* 13, no. 2 (1974): 51–57.

Untitled essay. In *Max Bill,* 11–18. Exhibition catalog. Buffalo, N.Y.: Buffalo Fine Arts Academy and Albright-Knox Art Gallery, 1974.

1975

"The Great Curatorial Dim-Out." *Artforum* 13, no. 9 (1975): 32–34.

Introduction to *Autobiography of Alan Sonfist,* n.p. Exhibition catalog. Ithaca, N.Y.: Herbert F. Johnson Museum of Art, Cornell University, 1975.

Introduction to *Benny Andrews: The Bicentennial Series,* 6–13. Exhibition catalog. Atlanta: High Museum of Art, 1975.

Introduction to *Heléne Aylon: Paintings That Change in Time,* n.p. Exhibition catalog. New York: Betty Parsons and Susan Caldwell Galleries, 1975.

Introduction to *Lucy Sallick,* n.p. Exhibition catalog. Hackensack, N.J.: Edward Williams College, Fairleigh Dickinson University, 1975.

Michelle Stuart: An Illustrated Essay. Oneonta: State University of New York College at Oneonta, Fine Arts Center Gallery, 1975.

"Piene as Painter." In *Otto Piene: Paintings, Gouache, Drawings,* 1–4. Exhibition catalog. Cambridge, Mass.: MIT Press, 1975.

"Sol LeWitt: Modules, Walls, Books." *Artforum* 13, no. 8 (1975): 38–43.

Topics in American Art since 1945. New York: Norton, 1975.

1976

"Alex Katz's Development." *Artforum* 14, no. 5 (1976): 45–51.

Anne Healy. Newport, R.I.: Monument '76, 1976.

Foreword to Lawrence Alloway, ed., *Art in SoHo.* Stony Brook, N.Y.: SUNY Stony Brook, 1976.

Introduction to *Artists' Choice: Figurative Art in New York,* n.p. Exhibition catalog. New York: Green Mountain Gallery, Bowery Gallery, Prince Street Gallery, First Street Gallery, and Soho Center for Visual Arts, 1976.

Introduction to *Malcolm Morley,* n.p. Exhibition catalog. Long Island, N.Y.: The Clocktower, Institute of Art and Urban Resources, 1976.

Introduction to *The Roots of Creativity: Women Artists Year 6,* n.p. Exhibition catalog. New Brunswick, N.J.: Rutgers University, Mabel Smith Douglass Library, 1976.

"Site Inspection." *Artforum* 15, no. 2 (1976): 49–55.

"SoHo as Bohemia." In *SoHo Downtown Manhattan,* 142–50. Exhibition catalog. Berlin: Akademie der Künste and Berliner Festwochen, 1976.

"Textual Criticism." In *Bernar Venet,* 2–3. Exhibition catalog. La Jolla, Calif.: La Jolla Museum of Contemporary Art, 1976.

"Women's Art in the '70s." *Art in America* 64, no. 3 (1976): 64–72.

1977

"Carl-Henning Pedersen." In *Carl-Henning Pedersen: Watercolors & Drawings,* n.p. Exhibition catalog. New York: Lefebre Gallery, 1977.

Introduction to *Ten from the File: An Invitational Exhibition,* 1–4. Exhibition catalog. Columbus, Ohio: Columbus Gallery of Fine Arts, 1977.

Introduction to *16 Projects/4 Artists: Siah Armajani, Larry Bell, Lloyd Hamrol, Pat Steir,* 5–7. Exhibition catalog. Dayton, Ohio: Wright State University Art Galleries, 1977.

"Rauschenberg's Development." In *Robert Rauschenberg,* 3–23. Exhibition catalog. Washington, D.C.: National Collection of Fine Arts, Smithsonian Institution, 1977.

"Time and Nature in Sonfist's Work." In *Alan Sonfist,* n.p. Exhibition catalog. Boston: Museum of Fine Arts, 1977.

1978

Introduction to *Art in Western Europe: The Postwar Years 1945–1955,* 5–18. Exhibition catalog. Des Moines: Des Moines Art Center, 1978.

Introduction to *Audrey Flack: "Vanitas,"* n.p. Exhibition catalog. New York: Louis K. Meisel Gallery, 1978.

Untitled transcript of a symposium at Montclair State College. In Lawrence Alloway, ed., *Landscape Views,* 5–21. Upper Montclair, N.J.: Department of Fine Arts, Montclair State College, 1978.

"100 Studios." In *10 Downtown, 10 Years: 1968 1969 1970 1971 1972 1973 1974 1975 1976 1977,* 3–7. Exhibition catalog. New York: 10 Downtown, 1978.

1979

"The Complex Present." *Art Criticism* 1, no. 1 (1979): 32–41.

Introduction to *Roy Lichtenstein: Mirrors and Entablatures,* 4–10. Exhibition catalog. Stony Brook: State University of New York at Stony Brook Art Gallery, Fine Arts Center, 1979.

Introduction to *5 Artists/5 Technologies,* n.p. Exhibition catalog. Grand Rapids, Mich.: Grand Rapids Art Museum, 1979.

1980

"Aspects of Collecting." In *Housatonic Museum of Art: Selections from a Growing Permanent Collection,* n.p. Exhibition catalog. Bridgeport, Conn.: Housatonic Museum of Art, 1980.

"Fabrications." In *American Fiber Art: A New Definition,* 8–12. Exhibition catalog. Houston, Tex.: Sarah Campbell Blaffer Art Gallery, University of Houston, 1980.

Introduction to *Contemporary Naturalism: Works of the 1970s,* n.p. Exhibition catalog. Roslyn Harbor, N.Y.: Nassau County Museum of Fine Art, 1980.

Introduction to *Joan Semmel,* 6–7. Exhibition catalog. Kutztown, Pa.: Kutztown State College, Sharadin Gallery; J. N. Jacobson and Son, 1980.

Introduction to *Leon Polk Smith: Constellations, 1967–1973,* n.p. Exhibition catalog. New York: Washburn Gallery, 1980.

Introduction to *Malcolm Morley: Matrix 54,* n.p. Exhibition catalog. Hartford, Conn.: Wadsworth Atheneum, 1980.

Introduction to Otto Piene and Elizabeth Goldring, eds., *Centerbeam*, 5–6. Exhibition catalog. Cambridge, Mass.: Center for Advanced Visual Studies, MIT, 1980.

Introduction to *Realism and Latin American Painting: The 70's*, 5–27. Exhibition catalog. New York: New York Center for Inter-American Relations, 1980.

"Park Slope: The Urban Subject." In *Interior Exterior: Figurative Artists of Park Slope, April 27–June 8, 1980*, n.p. Exhibition catalog. Brooklyn, N.Y.: Park Slope Civic Council, 1980.

"Problems of Iconography and Style." In *Urban Encounters: Art, Architecture, Audience*, 15–20. Exhibition catalog. Philadelphia: University of Pennsylvania, Institute of Contemporary Art, 1980.

"Rauschenberg's Development [in English/German]." *Robert Rauschenberg: Werke, 1950–1980*, 48–55. Exhibition catalog. Berlin: Staatliche Kunsthalle, 1980.

1981

"Adolph Gottlieb and Abstract Painting." In *Adolph Gottlieb: A Retrospective*, 54–62. New York: The Arts Publisher, in association with Adolph and Esther Gottlieb Foundation, 1981.

"The Constant Muse: Alex Katz' 20 Year Cycle of Images of His Wife Ada." *Art in America* 69, no. 1 (1981): 110–18.

Introduction to *Audrey Flack on Painting*, 14–27. New York: Abrams, 1981.

Introduction to *Ira Joel Haber: Sculpture, 1969–1980*, n.p. Exhibition catalog. Stony Brook: State University of New York Art Gallery, Fine Arts Center, 1981.

Introduction to *Jean Hélion: Paintings and Drawings from the Years 1939–1960*, n.p. Exhibition catalog. New York: Robert Miller Gallery, 1981.

Introduction to *Leon Polk Smith: Large Paintings, 1979–1981*, n.p. Exhibition catalog. Stony Brook: State University of New York Art Gallery, Fine Arts Center, 1981.

"Necessary and Unnecessary Words." In Joseph Newland, ed., *The Idea of the Post-Modern: Who Is Teaching It?*, 7–12. Seattle: Henry Art Gallery, University of Washington, 1981.

"Sites/Nonsites." In Robert Hobbs, *Robert Smithson: Sculpture*, 41–45. Ithaca, N.Y.: Cornell University Press, 1981.

1982

Introduction to *Cecile Abish: From the Marble Works, 1974–1979*, n.p. Exhibition catalog. Stony Brook: State University of New York Art Gallery, Fine Arts Center, 1982.

Introduction to *4 Sculptors: Maureen Connor, Donna Dennis, Irene Krugman, Eileen Spikol*, n.p. Exhibition catalog. Stony Brook: State University of New York Art Gallery, Fine Arts Center, 1982.

"Painting, Sculpture, and the Unity of the Arts." In *Marjorie Strider: 10 Years, 1970–1980*, 35–42. Exhibition catalog. Greenvale, N.Y.: Hillwood Art Gallery, Long Island University, 1982.

1983

"Alan Sonfist." In Muriel Emanual et al., eds., *Contemporary Artists*, 865–66. 2nd ed. New York: St. Martin's Press, 1983.

Introduction to *Mary Joan Waid: Paintings and Pastels, September 27–October 22, 1983*, n.p. Exhibition catalog. New York: G. W. Einstein, 1983.

"Notes as a Sitter." In *Sylvia Sleigh Paints Lawrence Alloway*, n.p. Exhibition catalog. New York: G. W. Einstein, 1983.

Roy Lichtenstein. New York: Abbeville Press, 1983.

"14 Sculptors." In *Then & Now: 10th Anniversary Exhibition*, n.p. Exhibition catalog. New York: 14 Sculptors Gallery, 1983.

1984

Introduction to *Ann Chernow: New Paintings and Drawings, May 4 through June 2, 1984*, n.p. Exhibition catalog. New York: Alex Rosenberg Gallery, Transworld Art, 1984.

Introduction to *Ursula Von Rydingsvärd*, n.p. Exhibition catalog. New York: Bettē Stoler Gallery, 1984.

Network: Art and the Complex Present. Edited by Donald Kuspit. Ann Arbor: UMI Research Press, 1984.

"Sculpture, Nature, the Environment." In *Land Marks: New Site Proposals by Twenty-Two Original Pioneers of Environmental Art*, 57–60. Exhibition catalog. Annandale-on-Hudson, N.Y.: Bard College Center, 1984.

Untitled essay. In *The Expendable Ikon: Works by John McHale*, 31–35. Exhibition catalog. Buffalo, N.Y.: Albright-Knox Art Gallery, 1984.

1985

Introduction to *Michelle Stuart: Voyages,* 49–53. Exhibition catalog. Syracuse, N.Y.: Everson Museum of Art, 1985.

1986

"Rauschenberg on Paper." In *Robert Rauschenberg Drawings, 1958–1968,* n.p. Exhibition catalog. New York: Acquavella Contemporary Art, 1986.

"Type, Gesture, and Color in Selina Trieff's Work." In *Selina Trieff: Paintings and Works on Paper, May 1–May 30, 1986,* n.p. Exhibition catalog. New York: Graham Modern Gallery, 1986.

1987

Introduction to *Anne MacDougall: Watercolors and Monotypes,* 1–3. Exhibition catalog. Andover, Mass.: Howard Yezerski Gallery, 1987.

"Notes on Fahlström." In *Öyvind Fahlström: 9 April to 16 May 1987,* n.p. Exhibition catalog. New York: Arnold Herstand & Co., 1987.

"Reflections on Pop Art." In *Pop Art: U.S.A.–U.K.,* 16–18. Exhibition catalog. Tokyo: Pop Art U.S.A.–U.K. Catalogue Committee, 1987.

1988

"Emily Barnett's *Studio.*" In *Emily Barnett: Multi-panel Figure Paintings, November 29–December 18, 1988,* n.p. Exhibition catalog. New York: NoHo Gallery, 1988.

Introduction to *Diane Burko: 1985–1987,* n.p. Exhibition catalog. Philadelphia: Marian Locks Gallery, 1988.

1989

"Roy Lichtenstein's Mirrors." In *Roy Lichtenstein: "The Mirror Paintings,"* 21 October to 18 November 1989, n.p. Exhibition catalog. New York: Mary Boone Gallery, 1989.

1990

"The Independent Group: Postwar Britain and the Aesthetics of Plenty" and other miscellaneous writings. In David Robbins, ed., *The Independent Group: Postwar Britain and the Aesthetics of Plenty,* 33, 37, 40, 43, 48, 49–53, 164–68, 187. Exhibition catalog. Cambridge, Mass.: MIT Press, 1990.

"Interview of 1983 [in Italian]." In Nina Sundell, ed., *Lichtenstein: La grafica,* 37–41. Exhibition catalog. Milan: Electa, 1990.

2001

"Packages." In *Christo and Jeanne-Claude: Early Works, 1958–1969,* 56–62. Exhibition catalog. London: Taschen, 2001.

2006

Imagining the Present: Context, Content, and the Role of the Critic. Edited by Richard Kalina. London: Routledge, 2006.

BIOGRAPHICAL NOTES ON CONTRIBUTORS

LUCY BRADNOCK is assistant professor in history of art at the University of Nottingham. A specialist in post-1945 American art, she is coeditor of *Pacific Standard Time: Los Angeles Art, 1945–1980* (2011) and author of a forthcoming monograph on American art and the legacy of Antonin Artaud.

JULIA BRYAN-WILSON is associate professor of contemporary art at University of California, Berkeley. She is author of *Art Workers: Radical Practice in the Vietnam War Era* (2009) and editor of *OCTOBER Files: Robert Morris* (2013).

MICHAEL LOBEL is professor of art history at Purchase College, State University of New York. His publications on modern and contemporary art include monographs on Roy Lichtenstein, James Rosenquist, and John Sloan, as well as numerous exhibition catalog essays and articles in scholarly journals. His curatorial projects include the Neuberger Museum of Art exhibition *Fugitive Artist: The Early Work of Richard Prince, 1974–1977* (2007).

COURTNEY J. MARTIN is assistant professor of modern and contemporary art in the history of art and architecture department at Brown University. A specialist in twentieth-century British art and sculpture studies, she is author of a forthcoming monograph on Rasheed Araeen's minimalist sculpture.

JENNIFER MUNDY is head of collection research at Tate, London, and founding editor of the online research journal *Tate Papers*. She has published widely on twentieth-century art and has curated many exhibitions, including *Surrealism: Desire Unbound* (2001) and *Duchamp, Man Ray, Picabia* (2008). She is author of *Lost Art: Missing Artworks of the Twentieth Century* (2013).

REBECCA PEABODY is head of research projects and programs at the Getty Research Institute. Her work focuses on race, gender, and nationality in American art and culture. She is editor of *Anglo-American Exchange in Postwar Sculpture, 1945–1975* (2011), the coeditor of *Pacific Standard Time: Los Angeles Art, 1945–1980* (2011), and author of a forthcoming monograph on Kara Walker.

JOY SLEEMAN is reader in art history and theory at UCL Slade School of Fine Art. Her research concerns the histories of sculpture and landscape, especially 1960s land art. She is author of *The Sculpture of William Tucker* (2007), cocurator of the exhibition *Uncommon Ground: Land Art in Britain 1966–1979* (2013), and author of a forthcoming monograph on Roelof Louw.

BEATRICE VON BISMARCK teaches art history, visual culture, and cultures of the curatorial at the Hochschule für Grafik und Buchkunst / Academy of Visual Arts Leipzig. Her research concerns modes of cultural production connecting theory and practice, curatorial practice, effects of neoliberalism and globalization on the cultural field, and postmodern concepts of the artist. She is author of *Auftritt als Künstler: Funktionen eines Mythos* (2010; Performance as artist: Functions of a myth) and coeditor of *Inter-archive: Archival Practices and Sites in the Contemporary Art Field* (2002), *Cultures of the Curatorial* (2012), and *Timing—On the Temporal Dimension of Exhibiting* (2014).

VICTORIA WALSH is head of the Curating Contemporary Art Programme at the Royal College of Art, London. A specialist in post-war British art, her published works include *Nigel Henderson: Parallel of Life and Art* (2001), *Francis Bacon* (2008), *Francis Bacon: Visual Culture in Britain* (2009), and *Richard Hamilton* (2014). She is cocurator, with Claire Zimmerman, of the Tate Britain research display *New Brutalist Image 1949–55* (2014–15).

ILLUSTRATION CREDITS

Every effort has been made to identify and contact the copyright holders of images published in this book. Should you discover what you consider to be a photo by a known photographer, please contact the publisher. Photographs of items in the holdings of the Research Library at the Getty Research Institute are courtesy the Research Library. The following sources have granted additional permission to reproduce illustrations in this book.

Walsh
Fig. 1. Alloway Papers. Gift of Sylvia Sleigh and the Estate of Sylvia Sleigh Alloway.
Fig. 2. © The National Gallery, London.
Fig. 3. © Whitechapel Art Gallery.
Figs. 4–6. Courtesy of the Richard Hamilton Estate.

Peabody
Fig. 1. Margaret Herrick Library, Academy of Motion Picture Arts and Sciences.
Fig. 2. Architectural Press Archive / RIBA Library Photographs Collection.
Fig. 3. John Maltby / RIBA Library Photographs Collection.
Fig. 4. Special Collections & Archives, UCR Libraries, University of California, Riverside.
Figs. 5, 6. Royal College of Art Archive.
Fig. 7. Cover: Ed Emshwiller par autorisation du Magazine of Fantasy and Science-fiction. Catalog: © 1967 Auteurs et Musée des Arts décoratifs, Paris. Photo: Getty Research Institute.

Bradnock
Fig. 1. © 1971 The Museum of Modern Art, New York.
Fig. 3. Courtesy of the Richard Hamilton Estate.
Fig. 4. Alloway Papers. Gift of Sylvia Sleigh and the Estate of Sylvia Sleigh Alloway.
Fig. 5. John Maltby / RIBA Library Photographs Collection.
Fig. 6. Courtesy London Metropolitan Archives / Corporation of London.

Lobel
Fig. 1. © Fred W. McDarrah / Getty Images.
Fig. 2. Alloway Papers. Gift of Sylvia Sleigh and the Estate of Sylvia Sleigh Alloway.
Fig. 3. 50th Anniversary Gift of the Gilman Foundation Inc., The Lauder Foundation, A. Alfred Taubman, Laura-Lee Whittier Woods, and purchase 80.32.
Fig. 4. © The Roy Lichtenstein Foundation.
Fig. 5. Cover: © Museum Associates / LACMA.

Martin
Figs. 1–6. Robert E. Mates © SRGF, NY.

Sleeman
Fig. 1. Getty Research Institute, Sylvia Sleigh Papers, 2004.M.4, box 48, folder 3. Gift of Sylvia Sleigh and the Estate of Sylvia Sleigh Alloway.
Fig. 2. © Artforum, November 1972 [spread].
Fig. 3. © Artforum, October 1976 [spread].

Mundy
Figs. 1, 3. Alloway Papers. Gift of Sylvia Sleigh and the Estate of Sylvia Sleigh Alloway.
Fig. 2. Photo: Getty Research Institute.

von Bismarck
Fig. 1. Box: © Multiples, Inc., 1970. Photo: Getty Research Institute.
Fig. 2. Box: © Multiples, Inc., 1970. Art: courtesy Jessica Gormley. Photo: Getty Research Institute.
Fig. 3. Box: © Multiples, Inc., 1970. Art: © Robert Rauschenberg Foundation / VG Bild-Kunst, 2014. Photo: Getty Research Institute.
Fig. 4. Box: © Multiples, Inc., 1970. Art: © and courtesy Mel Bochner. Photo: Getty Research Institute.
Fig. 5. Box: © Multiples, Inc., 1970. Photo: Getty Research Institute.
Fig. 6. Box: © Multiples, Inc., 1970. Art: © VG Bild-Kunst, 2014. Photo: Getty Research Institute.
Fig. 7. Box: © Multiples, Inc., 1970. Art: © Ed Ruscha. Photo: Getty Research Institute.

Bryan-Wilson
Figs. 1–6. Alloway Papers. Gift of Sylvia Sleigh and the Estate of Sylvia Sleigh Alloway.
Fig. 7. Cover: © Artforum, December 1973.

INDEX

Page numbers in *italics* refer to figures; those followed by "n" refer to notes, with note number.

abstract classicism, 93
abstract expressionism, 72–73, 86, 93, 97
abstract painting, 78, 93–94
action painting, 73, 91, 93
advertising
 Alloway on, 10, 18
 for movies, Alloway's interest in, 56, 66n40
"After Art History" (Alloway), 135
A.I.R. gallery, 181, 187n50
Aldiss, Brian W., 110, 122
Alloway Papers, 4–6
Amarillo Ramp (Smithson), 118
American Action Movie: 1946–1964, The (1969 film series), 49, 62–63, 119, 120, 122
American art, Alloway's focus on, 3
Americanization of Alloway, 90
Analysis of Beauty, The (Hogarth), 16
Andre, Carl, 95, 118, 124n7, 173
anthropology, influence on Alloway, 62–63. *See also* sociological/anthropological approach of Alloway
"Anthropology and Art Criticism" (Alloway), 60, 135
antielitism of Alloway
 lack of formal training and, 129
 movie criticism and, 50, 52, 54
 and popular *vs.* high culture distinction, 60
 science fiction and, 26–27, 39–40, 44
Anxious Object, The (Alloway), 137
architecture, Alloway's interest in, 84n8
Archives of American Art, 108, 112
ARK (periodical), 23, 35, 55
Arnason, H. Harvard, 74, 93, 104n31
Art and Communication (Bennington course), 130, 132
Art and Art Criticism (Stony Brook course), 140
"Art and the Communication Network" (Alloway), 91
art as communication, ix, 34–35. *See also* communication theory
art criticism
 crisis in (1960s–70s), 134–39, 166
 Greenberg's influence on, 3, 137–38
 recent criticisms of, 134

rise of public interest in, 128, 134–35, 140
 Vietnam-era politics and, 135–36
Art Criticism (periodical), *141*, 141–42, 147n57
art criticism, Alloway on
 broad focus, importance of, 139, 143–44
 critiques of contemporary practices, 133–34, 137–38, 144
 as genre without a methodology, 128
 lack of extended thesis on, 128, 144
 merging of with art history, 133, 144
 and openness to new art, 138, 139
 and popular-art-fine-art continuum, 137
 proper practices, 114, 133, 138–39
 purpose and function of, 128, 135, 136–37
 quality judgments and, 114, 138, 144, 167
 schematic drawing of field, *143*
 and social change, 184
 university courses on, 130, 139–40, 142, 144
 views on crisis in, 134–35, 136–37, 139, 166
art criticism by Alloway
 approach of, 3, 114
 currency as focus of, 107, 117, 170–73, 175–77, 179–81, 182–83, 184
 as data-driven, 133, 138–39, 167, 169
 focus on after 1966, 3
 interplay with movie criticism, 50, 55, 64
 major contributions of, 9
 and racial and gender inclusiveness, 168–69
 Stony Brook experience and, 139
 traces of formalism in, 78
"Art Critic Is Not . . . , An" (Alloway), 135
Artforum (periodical)
 advocacy of pluralism in, 177, 178
 Alloway articles in, 108, 112, *113*, 115, 116, *116*, 117, 124n9, 128, 166, 173, 177, 181
 Alloway's role at, 178, 179
 critics writing for, 135–36
 and critiques of art institutions, 178
 decentralization of art world and, 179–80
 editorial board, 178
 and museum unionization, 182–83, *183*

Smithson articles in, 110, 111
art history, Alloway on
 on broadening of focus, 139, 143–44
 desire to shape, 110
 merging of with art criticism, 133, 144
 short-term, call for, 116, 133, 166, 167, 184
 status of film in, 63
 views on proper practice, 109, 137
artificial intelligence, as issue, 50
"Art in New York Today" (Alloway), 72
Art in SoHo (Stony Brook student project), 179–80, *180*
art institutions. *See also* museums
 Alloway's complicity in, as issue, 167, 171
 Alloway's critique of, 161
 crisis of 1960s–70s, 166–67, 175–77, 176, 178, 179–81, 184
 currency of, 166–67, 169, 170
 and decentralization of art world, 149–54, 155–57, 179–81
 involvement in art market, as issue, 167
Art International (periodical), 111
artists
 Alloway's collaboration with, 3–4, 5, 94
 reading and writing by, Alloway's interest in, 114, 115, 133
"Artists and Consumers" (Alloway), 76
Artists and Photographs (1970 boxed set of multiples), 108, *148*, 149, 157, 162
 Alloway's essay for, 149, 154–55, 158–59
 Alloway's roles in, 149, 154–55
 artists and art in, 149, 159, 162–63n3
 blurring of traditional roles and categories in, 155–57, 159–60
 box of, 149, *153*, 159
Artists and Photographs (1970 exhibition), 149, 162–63n3
"Artists as Writers" (Alloway), 108, 114, 115, 135
artists of color
 Alloway's stress on inclusion of, 168, 169
 and art criticism, Alloway on, 135, 177
 demands for greater inclusion by, 173
 exhibitions by, curated by Alloway, 168
 sources of Alloway's interest in, 2
"Art Market: Affluence and Degradation, The" (Burn), 178

Titles in the ISSUES & DEBATES series